A Fiber Artist's Guide to
Color & Design
by Heather Thomas

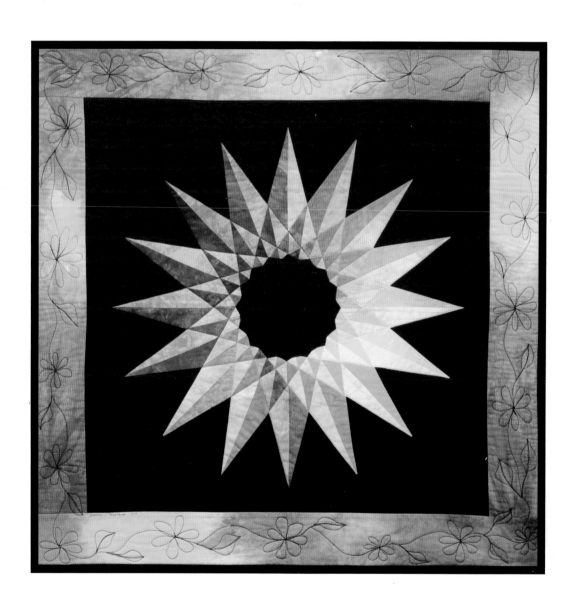

The basics & beyond

A Fiber Artist's Guide to

Color & Design

by Heather Thomas

The basics & beyond

Copyright © 2011 by Landauer Publishing, LLC

This book was designed, produced, and published by Landauer Publishing, LLC
3100 101st Street, Urbandale, IA 50322
515-287-2144 / 800-557-2144; www.landauercorp.com

President/Publisher: Jeramy Lanigan Landauer
Vice President of Sales & Administration: Kitty Jacobson
Editor: Jeri Simon
Art Director: Laurel Albright
Designer, A Fiber Artist's Guide to Color & Design The basics & beyond: Lyne Neymeyer
Photography: Sue Voegtlin

Library of Congress Control Number: 2011929084
ISBN 13: 978-1-935726-09-8
ISBN 10: 1-935726-09-9

This book is printed on acid-free paper.
Printed in China by C&C Offset Printing Co., Ltd.
10 9 8 7 6 5 4 3 2 1

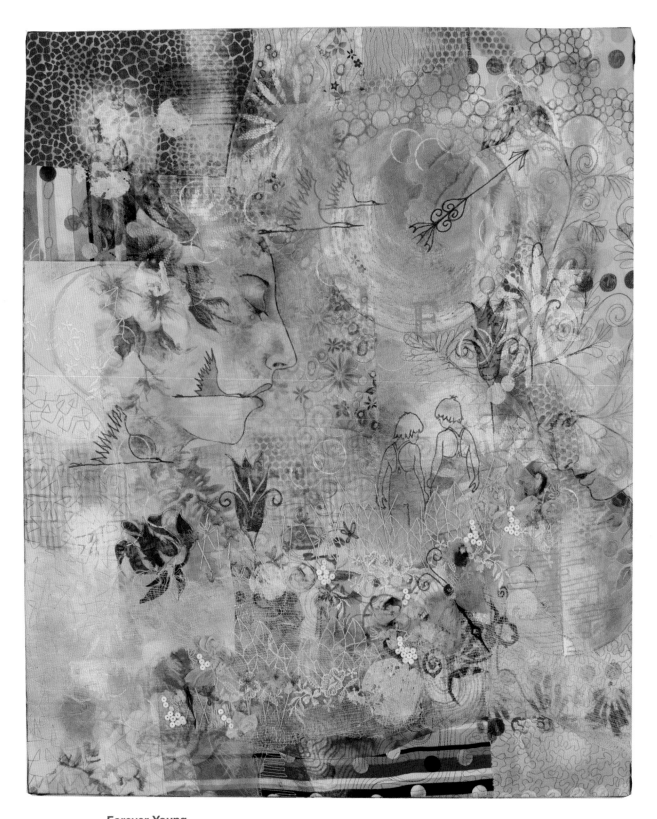

Forever Young

by Robin Sruoginis

22-1/2" x 27-3/4"

Collage with hand painting, machine and hand stitching

About the Author

My name is Heather Thomas and I am a mixed media fiber artist. I make and teach art for a living and I have been doing so most of my adult life. I am in love with art, both making it and viewing it.

My first artistic venture was quilting. I began like most, making traditional patterns, but found out quickly that pattern books and my dyslexia did not go hand in hand. So, I began designing my own quilts, which led me to teaching my designs and publishing my patterns. I wanted more. I wanted to immerse myself in the art I was making and I wanted to be better at it.

I began to study color approximately 15 years ago and once I felt I had a small grasp of it, I started teaching what I knew to others. I consider myself to be a classic colorist, relying on the Painter's primary of red, yellow and blue and the theories derived by the famous colorists Joseph Albers and Johannes Itten. I am entirely self-taught and have given myself what I consider to be an excellent arts education. I have immersed myself in the teachings of Albers, Itten, Kandinsky and many others. I have studied art history and technique and relish the work of Picasso, Klee, Kandinsky and most of the modern masters.

I work in my home studio and in a sales position outside the home. I teach three to four times a week and travel upon occasion to teach and lecture. In my spare time, I read about art. I visit art museums and galleries and I meet with other artists. I balance this out with time with my family. All of my friends are artists, so time with them is easy to come by. Through making art, teaching art and writing about art technique, I am living the life of my dreams.

I believe all humans are innately creative. I do not believe talent is a gift. I believe it comes from hard work. I believe that knowledge is power and power is freedom. Understanding color and design will help you achieve the freedom that making good art has to offer. I invite you to take this life changing journey with me.

Living the Creative Lifestyle

Choosing to be creative on a regular basis is really an easy decision. It does require however a change in thinking followed by a change of habit. When I first decided to make this change I read a book called "The Creative Habit" by Twyla Tharp. It was a wonderful book and just what I needed to help me make the changes I was seeking. The title really said it all. I had to change my habits. Get rid of the bad ones and replace them with ones that could support my new lifestyle goals.

Time plays a major role in creativity. Being realistic about our time can be difficult and the only way to really ascertain how much time we have is to see how we spend it. Look at your day to day life and see how you are really spending your time. Determine where you are wasting time that could be better spent in creative endeavors. Not all relaxing activities are time wasters. Reading certainly isn't a waste of time nor is watching your child play soccer. Living a creative lifestyle requires dedication. Immersing one's self in art can be very exciting, stimulating and life affirming. I try to schedule time every week to meet with other artists or see the work of other artists. This helps me to connect with art other than my own. This exposure adds to my knowledge and skill base which in turn adds to my artistic abilities.

I am involved with three groups, each very different from the other; an Exploratory Fiber Arts Group (EFAGS), an Artist Support Group and a First Monday Art Talk (FMAT) group.

In addition to these groups I also try to visit one or two museums or galleries each month. I find it is good to view art made in many different mediums and not just my own. It is useful to see how other artists use color, value and texture and handle composition, light and space. It is a great way to find inspiration. I also read and look through lots of art books. All these endeavors enrich my artistic lifestyle choices.

Creative Space

It is important for an artist to have a dedicated space in which to create. Though having a separate room to call your studio is a wonderful idea, it isn't always practical. Whether it is a room or a corner, it is very important that the space is set aside for your creative activity only. It is a lot easier to get down to the process of making art if you don't have to put everything away and take it back out again every time you have a creative impulse.

I am very organized, but it took me years to get that way. Because my studio is quite small and quite full, I have to keep it relatively neat and tidy. I believe it is important to have your medium, whether it is fabric or beads, paper or paint, out in the open so you can see it on a regular basis. This way you are enticed to use it. It also helps you remember what supplies you have on hand. Storing things hidden away in closets, opaque tubs or cardboard boxes is not conducive to your creativity.

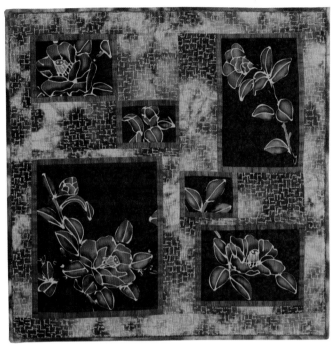

Batik Flowers
by Heather Thomas
29" x 28-1/2"

Art Journaling

Some artists find journaling to be a very important aspect of their creative journey. Some artists keep journals that are filled with simple ideas, line drawings, photos for inspiration and bits and pieces they find along their way. Others make journals that are works of art themselves. These journals are filled with pages of new techniques or mediums the artist has tried.

I have started a journal/notebook for the artist support group that I am in. I find it a very useful way to keep track of that particular journey. I suggest a journal for the color journey you are about to embark on. Fill it full of all of the delights, little tragedies and victories you experience along this road of creative discovery.

Heather Thomas

Visit my website at: wildheatherdesigns.com

Contents

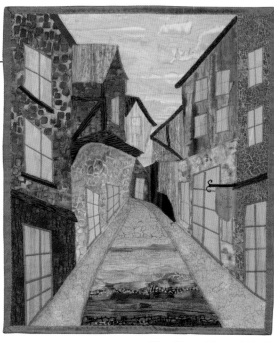

The Shambles of York
by Dona McGregor
18" x 42"

12

The Language of Color

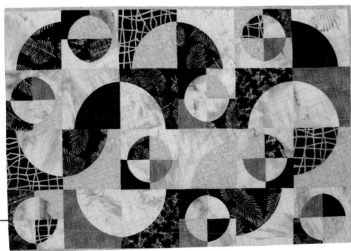

Rusted Circles
by Gail Eamon
40-1/2" x 27-1/4"

How to Use This Book

A Fiber Artist's Guide to Color & Design is filled with both theory and inspiration.

The materials in this book are divided into two general areas. In the first half of the book you will be exposed to the "learning" area of color and design. In the second half you will find the "doing" workshop areas of the book. Throughout each area you will notice a variety of help boxes and "Quick Key" boxes that are designed to highlight important information about each topic. These Quick Keys may reoccur in other areas of the book as helpful reminders of what you have previously learned. You will also find boxes with page numbers to guide you in a quick review of information in other parts of the book.

The subjects of color and design can be a challenging learning experience so I have also included many diagrams and illustrated references to help you visualize in-depth concepts in a simple way so you can put it to use in your own personal projects.

When you reach the Workshop pages in the book you will immediately find a "Project" box listing your creative goals for the project and a list of reference pages to review the concepts you will be working with in that workshop. Each workshop also includes a detailed description of the project and a list of Self-analysis questions to help you learn how to evaluate your finished project.

Here are some of the tools that will help you get the most out of your color and design journey.

Quick Keys

Think of Quick Keys as handy reminders of what you have already learned. Quick Keys are a fast reference and simplify a variety of information, from color combination reminders to color wheels related to specific examples.

Quick Key
Double split complement
Four colors. Two pairs of direct complements that are each separated by a color

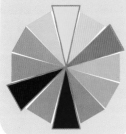

Quick Key
Elements of Design
physical qualities

Quick Key
Principles of Design
structural qualities

Quick Key
Neutral or Achromatic
Includes true neutrals—black, gray and white. Can contain tan, off white, taupe, and other pale brown based colors

Quick Key
Hue- color
Shade- add black
Tone- add gray
Tint- add white

Concept Diagrams

Throughout the book you will find complex concepts shown in easy to understand illustrations and diagrams.

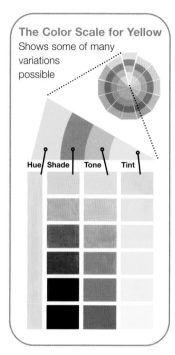

The Color Scale for Yellow
Shows some of many variations possible

Hue | Shade | Tone | Tint

Color Categories

Painter's Primary Color Wheel

Primary group —————
yellow, red and blue

Secondary group —————
violet, orange and green

Tertiary group —————
yellow orange, red orange
red violet, blue violet, blue
green and yellow green

Active Learning Boxes

These boxes offer ideas and guidelines you can apply to your own projects and artwork.

Neutrals Project

Goal: learn about value and texture as you create something interesting using a neutral palette

Review:

Self-analysis

Ask yourself these questions to help you analyze your finished project.

1. How did I use value in my piece?

2. Did I rely on visual or tactile texture and if so, how?

3. What kind of balance did I use and how did I achieve it?

Learning Activity

Look at your own artwork, artwork in books, magazines or at a gallery or museum and determine how the artist used line, shape, color and value. Is there enough variety to keep you engaged? What kind of energy do these elements of design give off? What do you like or dislike about how the artist used these design elements?

How to Use This Book

Showing concept with fabric

Look for examples of fabric swatches and color wheels used to illustrate both color and design concepts.

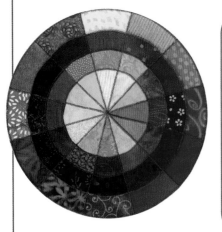

The Analogous Complement

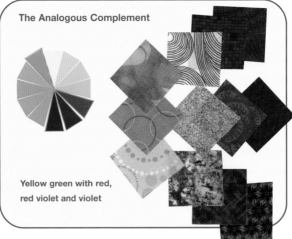

**Yellow green with red,
red violet and violet**

Shades

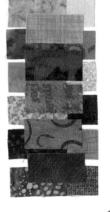

Neutral Warm

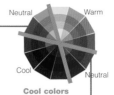

Cool Neutral

Warm, Cool and Neutral Temperature Colors

The color wheel can be divided somewhat in half in terms of visual temperature. One half is generally considered to be cold or cool while the other half is hot or warm.

Warm colors **Neutral temperature colors** **Cool colors**

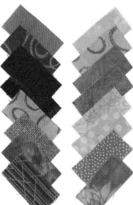

...standing Pattern Scale and Design

...rics below show lots of various visual textures. Take note of the scale ...esigns printed on the surface. A variety of motif styles is important, ...as having a variety in scale or size.

...ch square in a square block has a blue violet background and a ...reen center which provides good contrast and spatial delineation. ...r, the first block is not nearly as interesting as the second block and ...nd block is not as interesting as the third. The two fabrics in the first ...have very similar visual textures and appear almost solid. The two ...ferent from each other in style and scale. The smaller scale is used in the center and depletes the vibrancy of the large scale print in the background. The block on the right features a background fabric with a bold black print, but it is much smaller than the circles printed on the yellow green center fabric. The circles are getting lots of attention because they are larger than the background print and are in the center of the block.

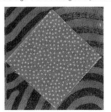

Color and Design Concepts Carried Through from Beginning to End

Quick Keys and other references pull concepts together so you can easily understand how they build upon each other to give you a full working knowledge of color and design.

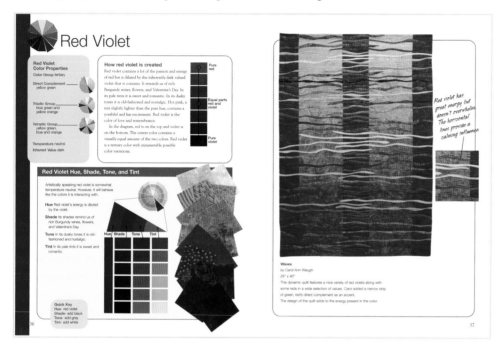

Information introduced in the early part of the book…

…is carried through to the final project section. This will help guide you through the completion of your workshop project.

He who wants to become a master of color must see, feel, and experience each individual color in its many endless combinations with all other colors." Johannes Itten

The Language of Color

The first step to learning about color is to become familiar with the language used to describe its many attributes. It is a language that is often misused and misunderstood. As you become familiar with these terms you will grow to understand their unique meanings and will learn to personalize them with your own artistic adventure. In this section, you will be introduced to the essence of color as a system, part of a universal visual language. If need be, re-read the section until you fully understand the meaning of each and every term. As you look at the artwork included on each page, try to really see it and how it describes the terminology being explained. This is the beginning of your journey!

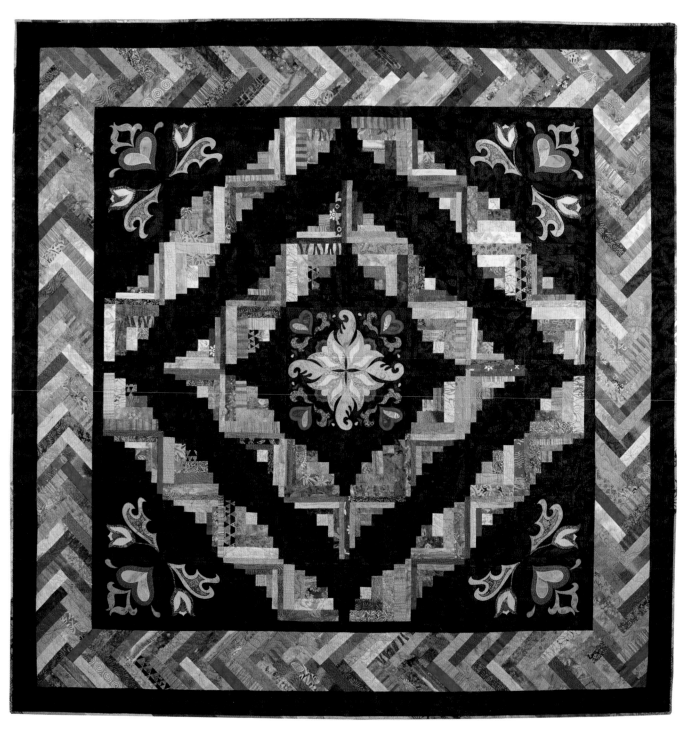

Some Enchanted Evening

by Heather Thomas

82" x 82"

The Language of Color

Why Study Color Theory?

Color theory is a set of ideas or principles with a scientific/correlative basis that is used to create artistic harmonious color combinations. That's it. Learning about color and the energy it generates will help you become a better artist. Does this mean all great art comes only from those who are masters of color? Of course it doesn't. However, harnessing the energy of color and learning about its behavior, will help you, the artist, become better at your craft.

Color is best understood through physical experience. It is one thing to hear or read the word "red". It is another to see it and yet another to work with it. To better understand color so we may use it more effectively, we need to train our eyes, our minds and our hearts so that we can begin to see and feel the differences between colors and their interaction with other colors.

• Color changes constantly. It changes according to how it is being used and what colors and shapes it is being used with.

• Colors interact with their surroundings and their viewers.

• Color is energy. It is alive and it generates power.

As artists, part of our role is to harness that power and there is no better way to accomplish that than learning about color interactions. When viewing the works of two successful artists, one trained in the use of color and the other not, it may be difficult to differentiate between the two. However, the untrained artist will likely use color in a superficial, conventional manner whereas the trained artist will likely use it to create a cohesive, relatable color story. Basically, the artist trained in color simply has more possibilities at hand. As I continue to learn more and more about color interaction, my artwork gets better and better. Yours can too.

Learning about color will help you become a better artist

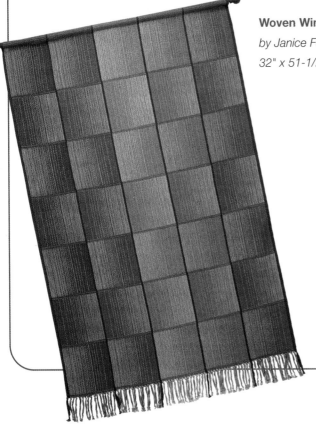

Woven Windows
by Janice Ford
32" x 51-1/2

Visions II; Dreamscape
by Katie Fowler
44" x 44"

What is Color?

When I think about the scientific explanation of color it pretty much blows my mind. Scientifically speaking, color doesn't really exist. Color is merely a human interpretation of vibrations that exist in the atmosphere. Our minds create color, shape, sounds and smells as a means of comprehending these vibrations. Pulsing, electromagnetic waves make up everything that exists in our world.

These waves have a huge range from tiny cosmic waves to gamma rays. The human eye can only detect a small percentage of these waves. We can see wavelengths that measure between 0.00038 and 0.00075 millimeters. This small section is known as visible light. The sensation of color is formed in the human mind by the way our sense of sight responds to these various wavelengths. Where there is little light, there is little color. Where there is lots of light, the colors will be bold. The human eye can differentiate somewhere around ten million variations within the spectrum of visible light. When the whole range of visible light is seen at once, our eyes see it as white. We see it as color when some of the wavelengths are missing.

Additive and Subtractive Color
We can simplify this phenomenon into two categories of color; additive and subtractive. However different, these two types of color are closely related and both are important to color perception.

What are Primary and Secondary Colors?
Primary colors are three main colors in a color method that cannot be mixed from any other color. Example: red, yellow and blue
Secondary colors are colors that can be mixed from the primary colors. Example: yellow and red can be mixed to create orange.

Additive Color Method

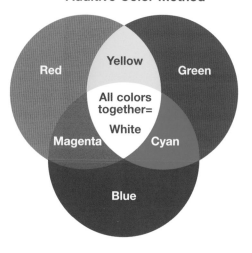

The Additive method can be explained by starting with black, the absence of light where no visible wavelengths are present, then adding light to create a composite color.

Uses Additive color is used primarily on television, computer monitors and stage lighting.

Primaries- red, green and blue

Secondaries- yellow, magenta and cyan.

Subtractive Color Method

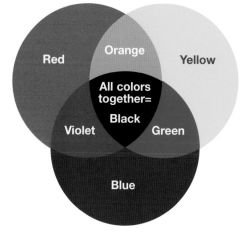

Subtractive color is somewhat the opposite. Begin with white (all of the visible wavelengths are present) and filter out the wavelengths you don't want to achieve the color that you do want.

Uses When studying color for artistic reasons, the subtractive process is used.

Primaries- red, yellow and blue

Secondaries- violet, green and orange.

Working with Color

Using the Subtractive Color Method all the colors we will be working with are derived from the Primary colors red, yellow and blue. These three colors will be mixed with each other to form nine addional colors that can be organized visually into a Color Wheel.

About the Color Wheel
Which Color Wheel?

There are two very distinct color wheels used today. One is based on red, yellow and blue as the primary colors and is often referred to as the Painter's Primary. The other is based on magenta, yellow and cyan and is referred to as the Printer's Primary or the Ives Color Wheel. There are many ongoing discussions about the value of each of these two color wheels. The Painter's color wheel is said to be historical and the Printer's color wheel is said to be scientific. I find that the Painter's is easier to use when using subtractive color and the Printer's is easier to use when using additive color.

I have been using the Painter's color wheel and will continue to do so unless someone can prove to me that the Printer's wheel is better.

This book is based on the Painter's Primary. Red, yellow and blue are the historical set of primary colors used for mixing pigments. This color wheel has been used in art, arts education and manufacturing for hundreds of years. Its use pre-dates the "scientific" color theory of the MCY, or Ives color wheel.

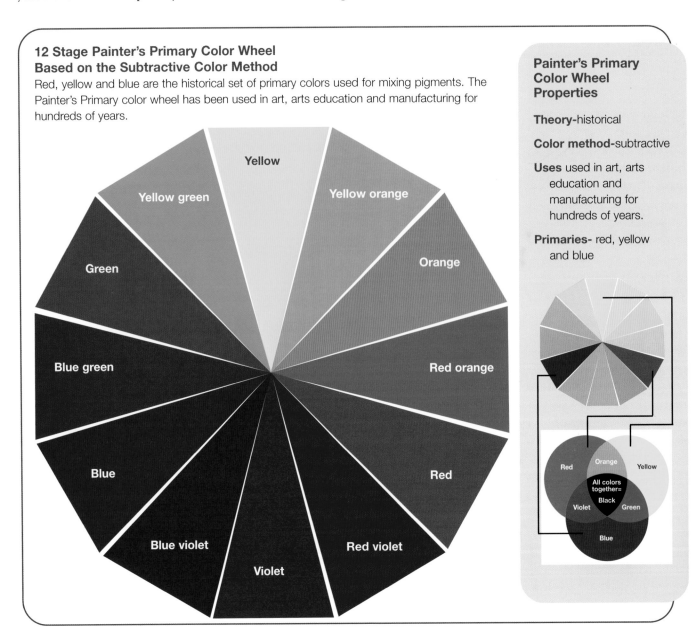

12 Stage Painter's Primary Color Wheel
Based on the Subtractive Color Method
Red, yellow and blue are the historical set of primary colors used for mixing pigments. The Painter's Primary color wheel has been used in art, arts education and manufacturing for hundreds of years.

Yellow

Yellow green

Yellow orange

Green

Orange

Blue green

Red orange

Blue

Red

Blue violet

Red violet

Violet

Painter's Primary Color Wheel Properties

Theory-historical

Color method-subtractive

Uses used in art, arts education and manufacturing for hundreds of years.

Primaries- red, yellow and blue

Red
Orange
Yellow
All colors together= Black
Violet
Green
Blue

Basic Color Terminology

The word "hue" is simply another name for color. The twelve names for color shown on the color wheel are the following pure hues;

Yellow, Yellow Orange, Orange, Red Orange, **Red**, Red Violet, Violet, Blue Violet, **Blue**, Blue Green, Green, Yellow Green

All other color names you can think of are varieties of these 12 colors. These original 12

are colors we can easily understand and imagine when we hear their names mentioned. However when you read the color word "red" it is likely that each reader is thinking of a different variety of red such as apple red, fire engine red, red wine, etc. Not even these basic color names have a finite meaning for each reader. These words, no matter how limited, are the means by which we can talk about and discuss color.

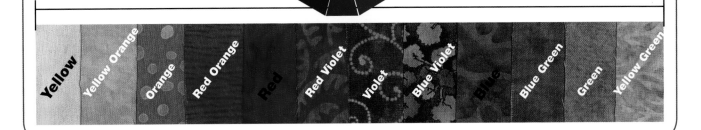

Color is Relative

The color wheel is made up of the 12 colors listed above. It is an effective tool to use to study color. But, it is not the "be all, end all" last word in color. Because all color wheels, whether stand alone or in a book, have been mass produced on color printing equipment and have been designed by a human, they can vary in color from manufacturer to manufacturer. Therefore, we need to remember that color is relative. It is relative to the media, to the viewer and to the manufacturer. What I see as red, you may see as red orange or red violet. What you call blue, I may call blue green or blue violet. Though we have standards, even those standards cannot pass every test.

These 12 colors can be separated into 3 important categories; primary, secondary and tertiary. These categories are a way to understand how

the basic 12 colors are formed. The primary colors are the basis of all other colors. The secondary colors are formed by mixing two primaries and the tertiary colors are made by blending a primary color with a

secondary color. In addition the 12 pure hues can be modified by adding black, gray or white to produce Shades, Tones and Tints.

A Brief History of the Painter's color wheel

The Painter's primary color wheel became the foundation of classic color theory because it held true the fundamental sensory qualities of physical colors and in the physical mixture of paints and dyestuff. Goethe and Chevreul, both artists and colorists, worked to prove these theories in their historic, scientific works of the early 1800's, *Theory of Color and The Law of Simultaneous Color Contrast*. Their investigations included a variety of perceived, psychological color effects, especially with the relationship between contrasting colors and the afterimages or contrasting shadows produced in colored light.

World-renowned colorists continue to use the Painter's primary. Johannes Itten and Josef Albers both relied upon it when they taught at the famous Bauhaus in Germany at the beginning of the 20th century. Albers brought his color instruction with him when he came to the United States and started Black Mountain College and used it when he became the head of the art department at Yale University in the 50's and 60's. Art instructors and artists alike continue to use the Painter's primary color wheel as the basis of study and use because of its aesthetic quality and ease of use. I use it here for the same reason.

Color Categories

The 12 colors of the color wheel can be separated into three important categories; primary, secondary and tertiary. These categories are a way to understand how the basic 12 colors are formed. The primary colors are the basis of all other colors. The secondary colors are formed by mixing two primaries and the tertiary colors are made by blending a primary color with a secondary color.

All 12 Colors

The Primary Colors

The primary colors are yellow, red and blue. These colors cannot be made by mixing together any of the other colors. However they are used to make every other color. These colors are visually strong in their pure hues.

Primary group
yellow, red and blue

The Secondary Colors

The secondary colors are violet, orange and green. Violet is made by mixing visually equal amounts of red and blue. Orange is made by mixing red and yellow in the same manner and green is made by mixing yellow and blue. These colors are less visually strong than the primaries that form them as more of the visible spectrum is subtracted.

Secondary group
violet, orange and green

The Tertiary Colors

The tertiary colors are made by blending a primary and secondary color. Each of these colors has two words in its name, describing the two colors used to make it up. The primary color's name is used first. These colors are, yellow orange, red orange, red violet, blue violet, blue green and yellow green. These colors are visually less strong than both the primary and secondary colors.

Tertiary group
yellow orange, red orange red violet, blue violet, blue green and yellow green

Are Black and White Colors?

Black and white are both entities often utilized by artists. Whether or not they are colors has been hotly debated by artists and scientists for a long time. Most artists believe black is a color and white is not, whereas most scientists believe the opposite. The answer might depend on how you are seeing or using the color. If we think about the color of an orange that we hold in our hand, that color is being formed by the way the skin of the orange is absorbing visible light or molecular wavelengths. However, an orange being viewed on a TV or computer screen has color that is created by photons of light transmitted within an electronic system.

For artists who use color that exists as tangible pigments, black is a color. It can be formed by mixing together all of the primary colors. In subtractive color lingo, all of the wavelengths have been covered by added color which reduces the visible color to blackness. White is not a color. It is in this case, the absence of color. Scientifically speaking however, the opposite is true.

No matter what you call them, color or non-color, black and white are entities utilized by nearly all artists. Artists who use pigments whether through paint or print on fabric or paper all rely on black and white as useful personalities in the creation of art.

Below is a diagram showing how gray is formed through the blending of black with white.

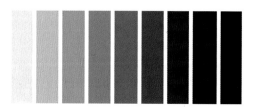

Gray Scale from White to Black

Expanding the Color Wheel

The Color Scale

Color can be expanded into what is called the color scale: **pure hue, shade, tone** and **tint**. Using color scale terminology can be a good way to describe value as the two are closely linked. The color scale is used to describe the millions of variables of the 12 colors of the color wheel.

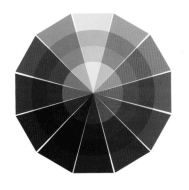

The Color Scale for Yellow
An example of some of the possible variations

Hue	Shade	Tone	Tint

How to read the Color Scale Wheel
The fabric color wheel below shows the pure hues modified by adding black, gray or white to the color.

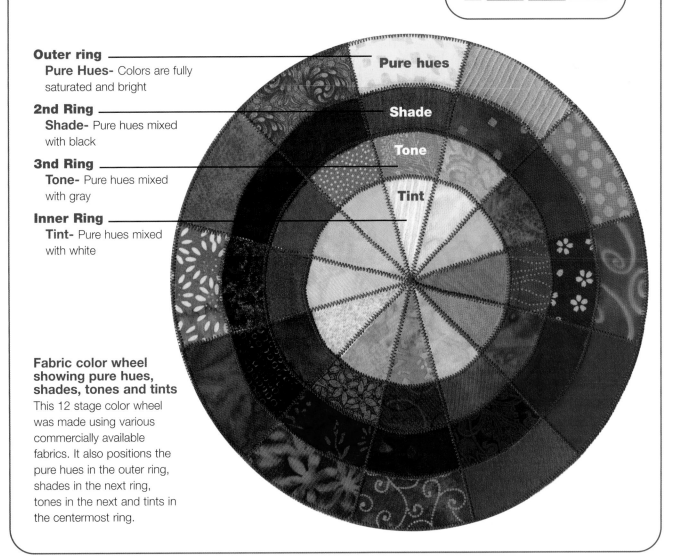

Outer ring
Pure Hues- Colors are fully saturated and bright

2nd Ring
Shade- Pure hues mixed with black

3nd Ring
Tone- Pure hues mixed with gray

Inner Ring
Tint- Pure hues mixed with white

Pure hues

Shade

Tone

Tint

Fabric color wheel showing pure hues, shades, tones and tints
This 12 stage color wheel was made using various commercially available fabrics. It also positions the pure hues in the outer ring, shades in the next ring, tones in the next and tints in the centermost ring.

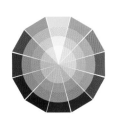

Pure Hues

Pure colors are referred to as hues. Hues are fully saturated, bright colors that have nothing added to them to deplete their visual prowess. Colors are considered pure when they are not diluted in any way. We use the basic names of the twelve colors to describe pure hue. A pure-hued green implies fresh green grass. A pure-hued red is that of a fire engine and a pure-hued yellow is the color of a ripe lemon.

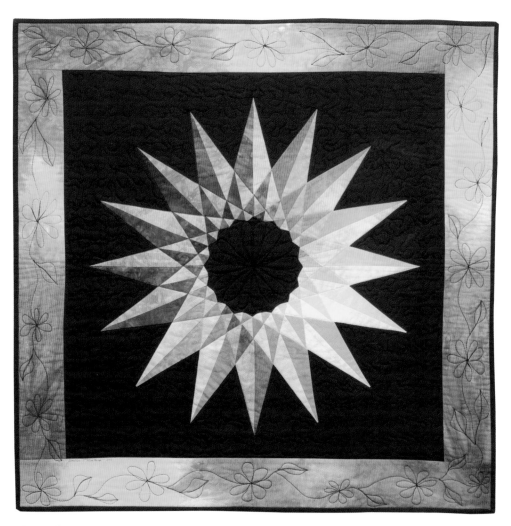

Magna Chroma

by Heather Thomas

30" x 30"

This quilt uses hand-dyed fabric in pure hued versions of all twelve colors. Some of the sections are filled with highly saturated color while others use the pure hues in a lighter, lower saturation. All the colors play well off the dark, black background.

Shades

When black is added to pure hues, shades are created. Shades can range in value from just slightly darker than the pure hue to extremely dark, all depending on the amount of black that is added. All shades are darker than the pure hues that form them. Shades are usually rich and dramatic, crisp and clear rather than dull and subdued like tones. Shades can be described as warm or cool. The cool shades are deep and rich such as navy, forest green and grape. The warm shades include the colors of autumn; pumpkin, rust, brown, burnt sienna and olive.

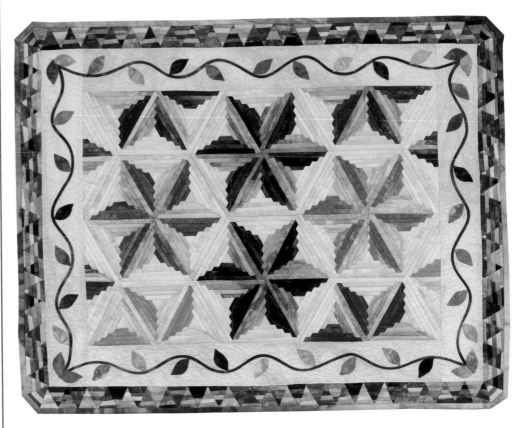

Star Flowers

by Heather Thomas

28-1/2" x 22-1/2"

This quilt features rich shades along with shaded tints. The colors sit boldly on the neutral, parchment colored background.

Tones

Tones are hues that have gray added to them. Because gray comes in so many varieties there are also many, many varieties in tones. Gray can be formed by mixing black and white or by mixing pairs of direct complements to make brownish grays. With mixing just the pairs of direct complements alone, we can come up with a huge variety of grays. That number increases dramatically when we add the versions of gray that can be made when mixing black and white. Tones can range in value from light to dark depending on the original hue and how much and what type of gray has been added. They can be darker than or lighter than the hue they originate from and will always be duller or less intense. Some of the names we give to tones are sage, terra cotta and mauve.

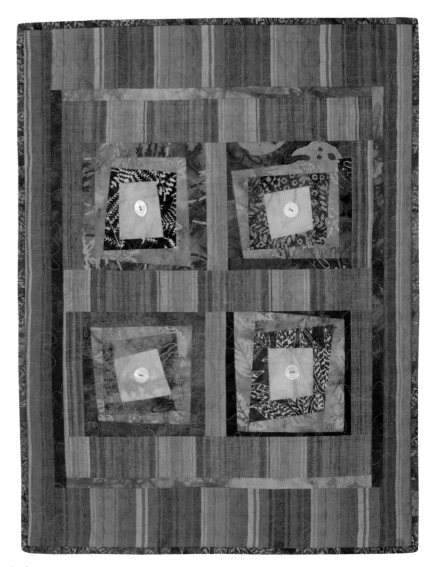

Simple Squares

by Chris Lawson

19" x 25"

This quilt features warm, soft tones in a variety of colors and contrasting warm and cool temperatures.

Tints

Tints are lighter valued versions of pure hues and are made by adding white to a color. Tints can range in intensity from the palest hint of color to colors that are only slightly lighter than their pure hues. Tints are not just pastels. The color names melon, pink and periwinkle are all names we give to tints. These colors are always lighter in value than the pure hues they originate from. Gray can also be added to a tint making it a toned tint. These variations of colors are always duller and lighter than the pure hue. Some examples of names we give to toned tints are, light gold, pale sienna, dove blue and butter.

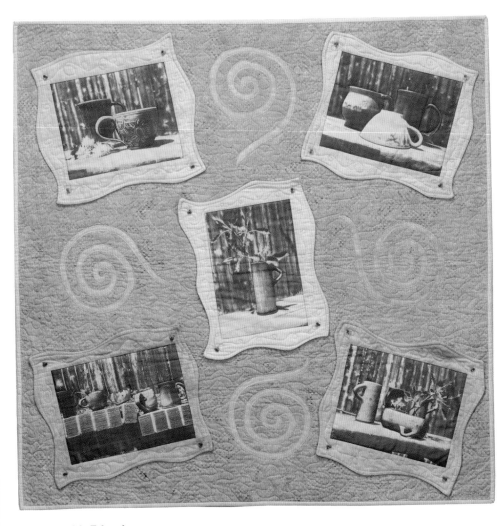

Coffee with Friends

by Heather Thomas

35" x 34-1/2"

This quilt features both tints and toned tints. The colors are all lighter than the pure hues they come from. The tints are clear and the toned tints are dull or murky. Featured, are black and white photographs hand tinted with colored pencils.

A Look at Each Color

Color is energy. It is a visual language. It is a tool that we as artists and craftspeople use to express our feelings, dreams, desires and our experiences in the world. Each color has its own power or lack thereof. Each color evokes in us emotional and psychological responses. Getting to know the personalities of each of the twelve colors can help us to harness their energy so we can use them in predictable ways. One does not really know the color yellow until she uses it in its delicious varieties of creamy butter, bright sunshine and ripe olive. We do not understand the power of red until we have experienced it in its many incarnations of pure hue, shade, tone and tint. It is difficult to use a tool that we are unfamiliar with, even more difficult to become friends with or fall in love with something that we don't understand. The following pages offer you the opportunity to better understand each color and what it has to offer you as a tool. Here is your chance to get acquainted with 12 distinct personalities. Have fun getting to know them, they may become the best friends you have ever had.

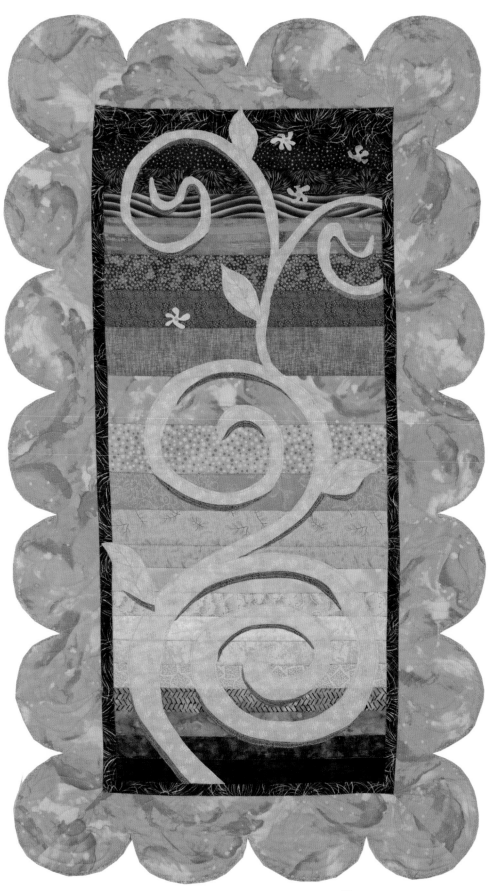

Evergreen
by Rhonda Lambatos
34-1/2" x 19-3/4"

Yellow

Yellow
Color Properties

Color Group primary

Direct Complement ——————
 violet

Triadic Group ——————
 with red and blue

Tetradic group ——————
 with violet, red orange
 and blue green

Temperature warm

Inherent Value lightest

The Psychology of Yellow

Yellow is the color of the sun. It is said to be the most cheerful color of the spectrum. It represents positive energy, happiness, hope and wisdom. It is optimistic, warm and light. Psychologically speaking it motivates, stimulates and promotes creative thought and energy.

Eyes see yellow first before any other color in a composition. This makes it the perfect color for marketers to use in point of sale displays. Babies cry more often if left in a bright yellow room because it is over stimulating. Couples fight more when surrounded by yellow. Yellow is great to use when you're looking for attention.

Yellow's most negative connotation is that of weakness or cowardliness as in "yellow bellied".

Yellow Hue, Shade, Tone, and Tint

Yellow is the lightest color on the color wheel. Your eye is drawn to yellow before any other color in a composition.

Hue Light, pure, lemon yellow is the most visually fatiguing color. More light is reflected off it than any other color.

Shade In shades it becomes what is often referred to as "olive". When black is added, yellow looks more like green.

Tone In its tones it becomes dull and much less powerful.

Tint In its tinted form it is soft and mellow.

Quick Key
Hue- yellow
Shade- add black
Tone- add gray
Tint- add white

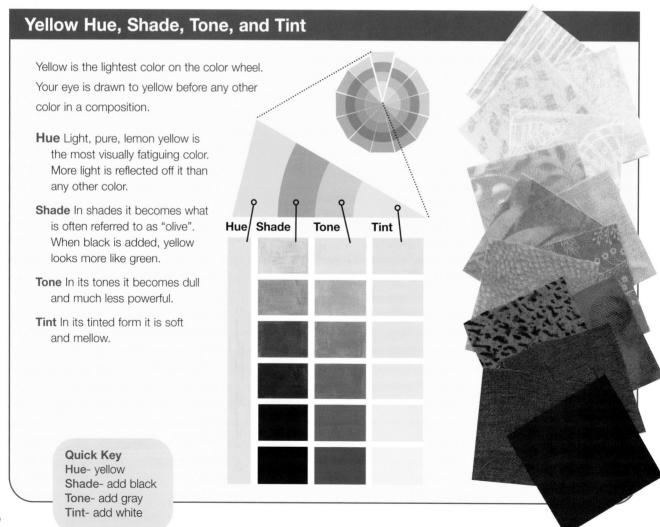

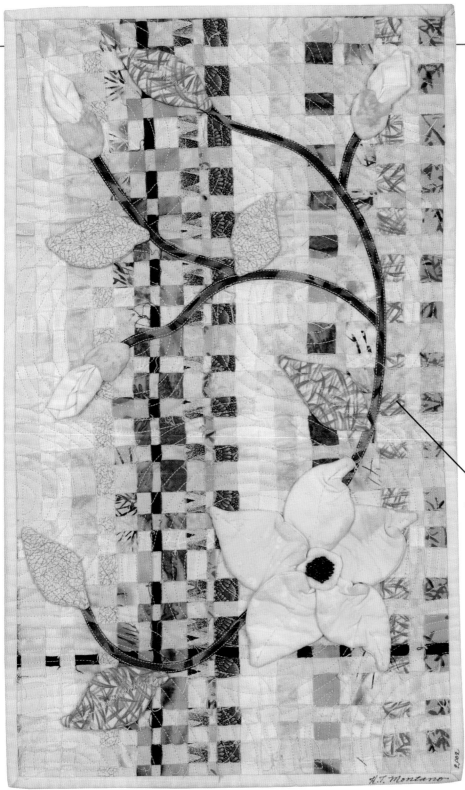

The neutral fabrics woven with the yellow provide a resting place for the eye.

One Yellow Flower

by Heather Thomas

11" x 19"

This woven quilt features yellow in its pure hues and tints playing with an array of white, gray and
black. The neutrals provide a place for the eye to rest so the piece does not overwhelm the viewer.
Little bits of yellow orange are present here and there to add additional warmth.

Yellow Orange

Yellow Orange Color Properties

Color Group tertiary

Direct Complement ———
blue violet

Triadic Group ———
red violet, blue green

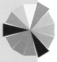

Tetradic Group ———
blue violet, red and green

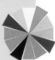

Temperature warm

Inherent Value light

How yellow orange is created

Yellow orange carries some of the traits of yellow. However they are softened and warmed by the addition of orange blended with the yellow.

In the diagram you can see how the two colors come together. Pure yellow is at the top and pure orange is at the bottom. Each of the remaining five sections is a blend of both yellow and orange. The sections closer to yellow contain more yellow and the sections closer to orange contain more orange. The section in the middle has visually equal amounts of both colors and is a true hue of yellow orange.

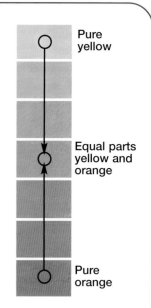

Pure yellow

Equal parts yellow and orange

Pure orange

Yellow Orange Hue, Shade, Tone, and Tint

Yellow orange lacks the visual power of yellow but is a close second. Because it is a tertiary color it has many variations, each dependent on the amount of yellow or orange that is present prior to the change in color scale.

Hue Yellow orange is vibrant and energetic.

Shade In its shades it becomes delicious, chocolate brown.

Tone In its tones it is rich and golden.

Tint In its tinted form it becomes soft and buttery.

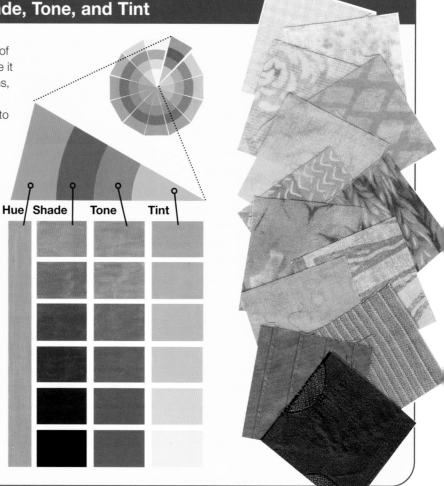

Hue Shade Tone Tint

Quick Key
Hue- yellow orange
Shade- add black
Tone- add gray
Tint- add white

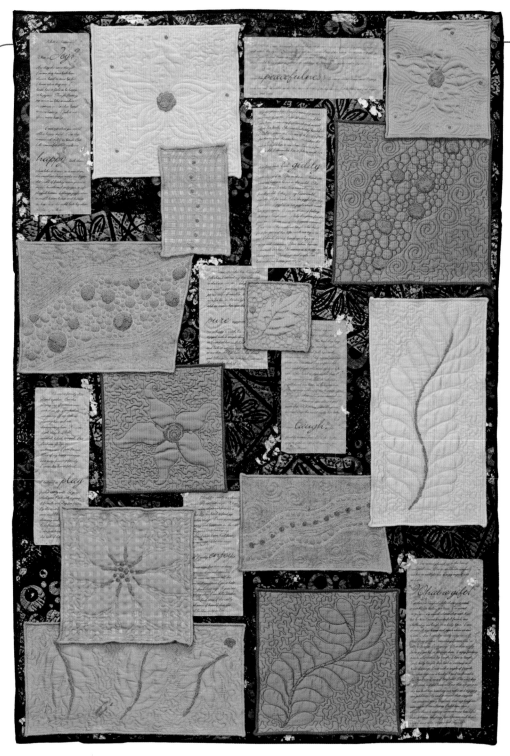

Tones of gold give the artwork a rich, warm feel.

Telling Stories of Happiness and Joy

by Heather Thomas

27" x 39"

The warm, vibrant mini quilts are made from a large variety of yellow orange in raw and Dupioni silk. Lots of varieties of yellow orange are present, from the very yellow to the very orange and everything in between. There are deep shades of rust along with subtle tones of gold, making the quilt rich and lustrous. The black background provides a visual resting place.

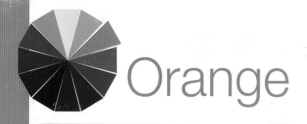

Orange

Orange Color Properties

Color Group Secondary

Direct Complement _____
blue

Triadic Group _____
violet and green

Tetradic Group _____
blue, red violet and yellow green

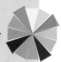

Temperature very warm

Inherent Value medium light

The Psychology of Orange

In its pure hue, the color orange exudes cheerfulness. It is exuberant and fun and promotes creativity and vitality. In its darker tones and shades it becomes earthy and exotic. It contains the creativity of yellow and the passion of red. Orange can be very gregarious and child-like and it is often used in kid's toys and book covers. It is not well received in its bright neon version. In fact more people claim neon orange as their least favorite color over any other. Orange is the color of change, of autumn, of deepening, of arousal. It indicates abundant energy, structure and organization. Orange has a friendly warmth. It is most popular in its lighter tints and darker shades such as apricot, tangerine, pumpkin and chocolate. Orange makes us think of its namesake, sweet, juicy and tangy. We also associate the color with Halloween and often see it paired with black.

Orange Hue, Shade, Tone, and Tint

Orange is made by mixing equal amounts of red and yellow. It is less visually strong than the primary colors used to create it.

Hue Exuberant and fun, orange promotes creativity and vitality.

Shade In its shades it is the color of change, of autumn, of deepening, of arousal.

Tone In its tones it is earthy and exotic

Tint In its tinted form it becomes apricot and tangerine.

Quick Key
Hue- orange
Shade- add black
Tone- add gray
Tint- add white

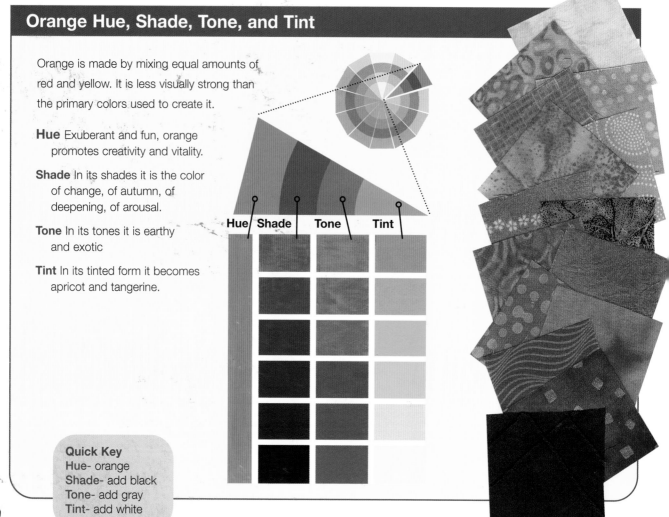

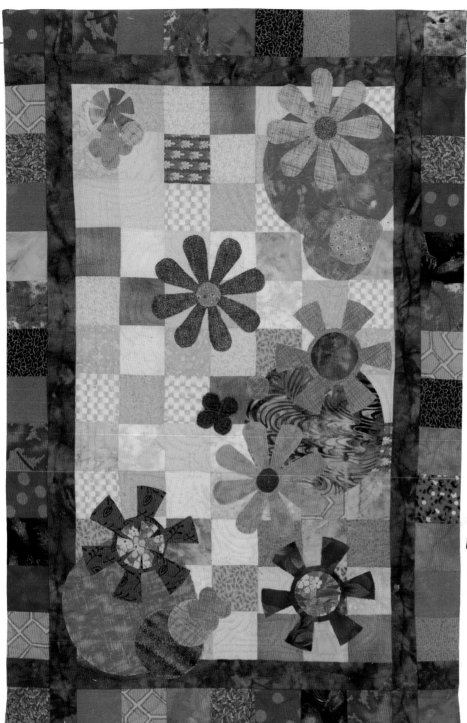

With its unusual visual texture and additional colors, the fabric in this circle becomes a focal point.

Terra

by Crystal Zagnoli

19" x 29-1/2"

Crystal outdid herself with the wide array of orange fabrics she used in her quilt. She included many different versions in light, medium and dark, hues, shades, tones and tints. The use of a deep tone as the inner border was just what the quilt needed. The piece is warm and inviting.

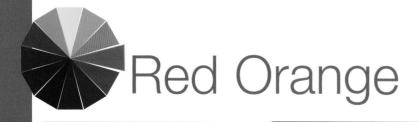

Red Orange

Red Orange Color Properties

Color Group tertiary

Direct Complement _____
blue green

Triadic Group _____
blue violet and
yellow green

Tetradic Group _____
blue green, violet
and yellow

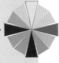

Temperature hot

Inherent Value medium

How red orange is created

As a tertiary color red orange is made by the visually equal mix of red and orange. In the diagram you can see how the two come together to form this exciting color. The varieties of red orange are endless depending on how much of each color is present. This is the color of deep autumn, falling leaves and fire. Red orange is sexy like red, but is backed by orange's friendliness. Visually speaking it is also the warmest of all the colors.

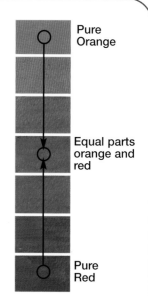

Pure Orange

Equal parts orange and red

Pure Red

Red Orange Hue, Shade, Tone, and Tint

Red orange is created by mixing visually equal amounts of red and orange. It is the warmest of all the colors.

Hue Red orange has a powerful exuberance in its pure hue.

Shade In its shade it is the color of deep autumn, falling leaves and fire.

Tone Its tones are the color of earth and brick.

Tint In its tinted form it becomes coral-like.

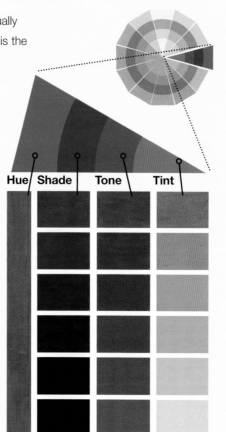

Hue | Shade | Tone | Tint

Quick Key
Hue- red orange
Shade- add black
Tone- add gray
Tint- add white

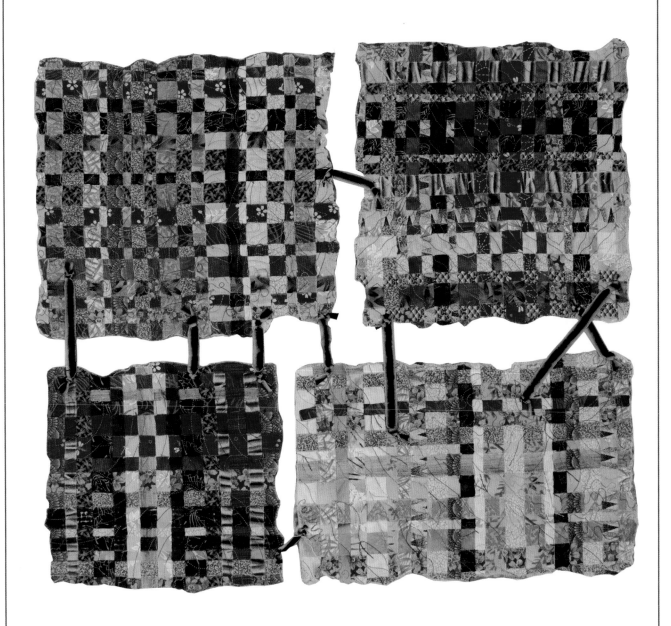

Burnt Sienna

by Heather Thomas

21" x 21"

This woven quilt is filled with the pure hues, shades, tones and tints of red orange along with gray and black neutrals. Red orange is a tertiary color and therefore has a great number of variances. The strips of red, red orange, orange and orange red make the piece somewhat warm while the pale grays cool it off.

 # Red

Red Color Properties

Color Group primary

Direct Complement _____
green

Triadic Group _____
yellow and blue

Tetradic Group _____
green, blue violet
and yellow orange

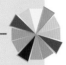

Temperature neutral

Inherent Value medium dark

The Psychology of Red

Red is the most passionate and dynamic of all colors. It can symbolize love as well as rage. Red is associated with danger, anger, violence and indebtedness but also with passion and courage. It is a highly arousing color. Red demands attention and carries a great emotional impact. It can indicate aggressiveness, energy and impulsiveness. Pure red reads as constant activity. Shades of red relate to blood, tints of red are melon rather than true pink.

Being in the presence of red activates the pituitary gland and increases heart rate making it proactive and attention grabbing. Red will make you hungry.

Red makes us think of toy wagons, fire engines, crisp apples, sexy lingerie and lipstick. In advertising it's often used provocatively in a sexual manner to sell everything from cars to perfumes.

Red Hue, Shade, Tone, and Tint

Red is a high energy color that demands attention. However, in art it is considered temperature neutral because it neither advances or recedes; it sits in the mid plane.

Hue Pure red is the most dynamic of all the colors.

Shade In shades it becomes less aggressive and warmer.

Tone In its tones it loses some of its passion.

Tint In its tinted form, red is melon rather than true pink.

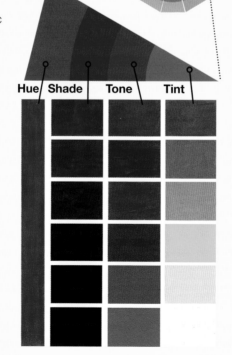

Hue | Shade | Tone | Tint

Quick Key
Hue- red
Shade- add black
Tone- add gray
Tint- add white

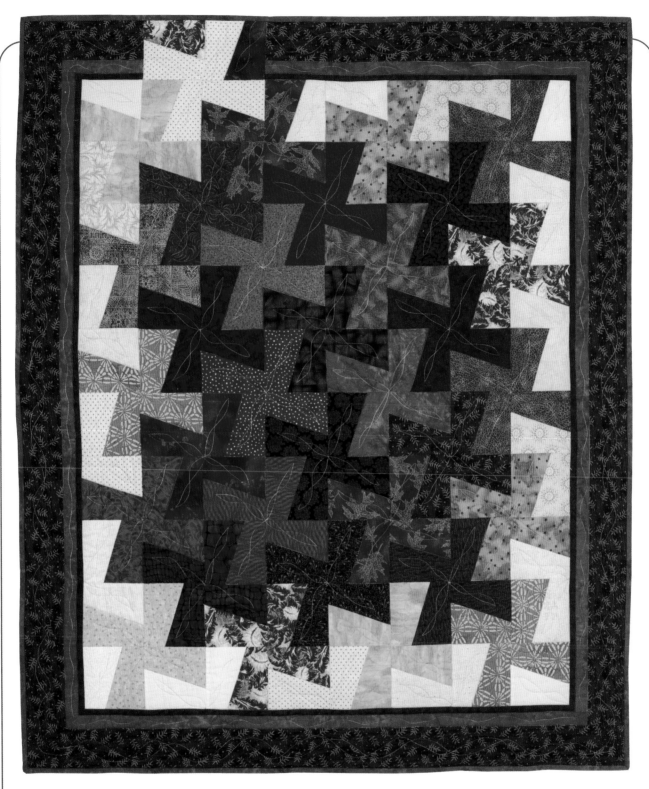

Red Pinwheels

by Gail Eamon

44" x 53"

This wonderful quilt is filled with high energy reds in many varieties of pure hues, shades, tones and tints. The use of pale tints of red along the inside edges next to the pinwheels read as negative space because the value is so much lighter than the other reds that make up the pinwheels.

Red Violet

Red Violet Color Properties

Color Group tertiary

Direct Complement _____
 yellow green

Triadic Group _____
 blue green and
 yellow orange

Tetradic Group _____
 yellow green,
 blue and orange

Temperature neutral

Inherent Value dark

How red violet is created

Red violet contains a lot of the passion and energy of red but is diluted by the inherently dark valued violet that it contains. It reminds us of rich Burgundy wines, flowers, and Valentine's Day. In its pale tints it is sweet and romantic. In its dusky tones it is old-fashioned and nostalgic. Hot pink, a tint slightly lighter than the pure hue, contains a youthful and fun excitement. Red violet is the color of love and remembrance.

In the diagram, red is on the top and violet is on the bottom. The center color contains a visually equal amount of the two colors. Red violet is a tertiary color with innumerable possible color variations.

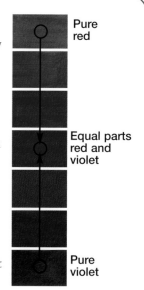

Pure red

Equal parts red and violet

Pure violet

Red Violet Hue, Shade, Tone, and Tint

Artistically speaking red violet is somewhat temperature neutral. However, it will behave like the colors it is interacting with.

Hue Red violet's energy is diluted by the violet.

Shade Its shades remind us of rich Burgundy wines, flowers, and Valentine's Day.

Tone In its dusky tones it is old-fashioned and nostalgic.

Tint In its pale tints it is sweet and romantic.

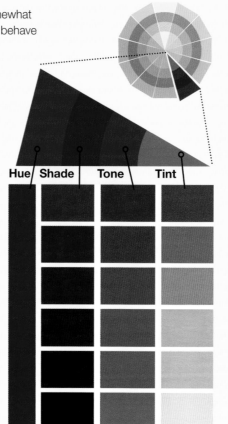

Hue | Shade | Tone | Tint

Quick Key
Hue- red violet
Shade- add black
Tone- add gray
Tint- add white

36

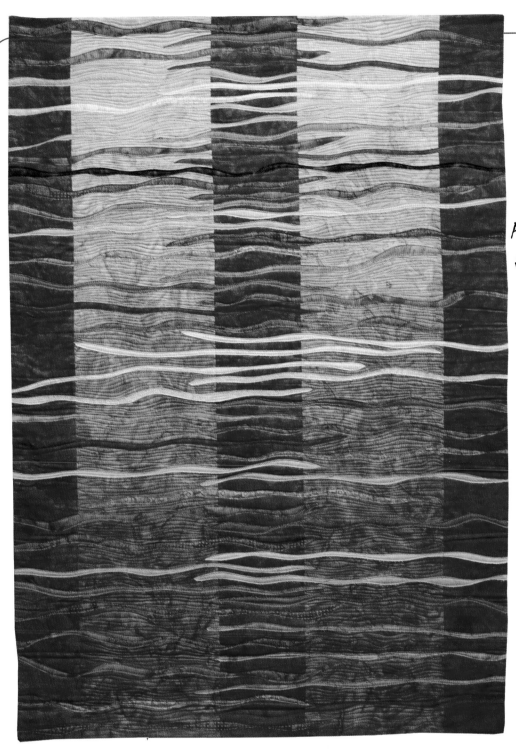

Red violet has great energy but doesn't overwhelm. The horizontal lines provide a calming influence.

Waves

by Carol Ann Waugh

29" x 40"

This dynamic quilt features a nice variety of red violets along with some reds in a wide selection of values. Carol added a narrow strip of green, red's direct complement as an accent.

The design of the quilt adds to the energy present in the color.

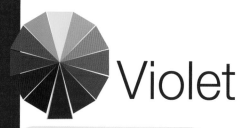

Violet

Violet Color Properties

Color Group secondary

Direct Complement _____
 yellow

Triadic Group _____
 green and orange

Tetradic Group _____
 yellow, blue green
 and red orange

Temperature cool

Inherent Value darkest

The Psychology of Violet

Violet is the darkest inherent valued color and is the closest color to black. Because it is a blend of tempestuous red and tranquil blue, it is both sexual and spiritual. If you have ever heard the term "shrinking violet" which pertains to a shy, but attractive woman, you will understand violet's inherent weakness. For this color to shine, it needs to be used in its pure hue or slight tints. When used in dark shades or muddied tones, violet loses much of its power.

Violet represents royalty, wealth and power and symbolizes luxury. Kings wore it as well as religious leaders. Psychologically speaking violet induces creativity, a sense of mystery, sophistication and spirituality. In its pale tints such as lavender, it evokes nostalgia and sentimentality as well as sweet smells and tastes.

Violet Hue, Shade, Tone, and Tint

Violet is made by mixing visually equal amounts of red and blue.

Hue In its pure hue violet represents royalty, wealth and power.

Shade In its dark shades it loses power.

Tone In its tones it becomes muddy and loses its visual punch.

Tint In its pale tints it evokes nostalgia and sentimentality as well as sweet smells and tastes.

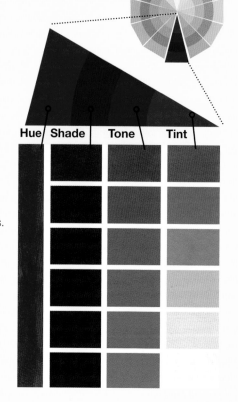

Hue	Shade	Tone	Tint

Quick Key
Hue- violet
Shade- add black
Tone- add gray
Tint- add white

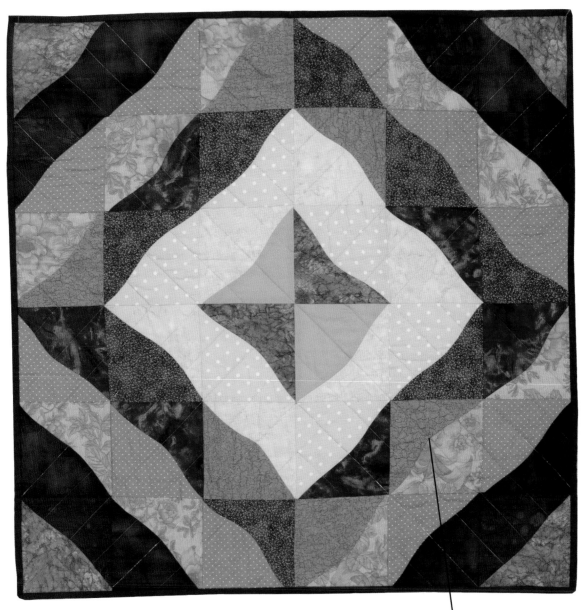

Grape Twizzler

by Brenda Diaz

24" x 24"

In this fun, little quilt, Brenda uses a nice variety of violets including shades, tones and tints. The various values included add great spatial delineation helping to form the simple yet effective design.

This quilt is no shrinking violet! Its wavy lines bring energy and a sense of movement to an otherwise simple design.

Blue Violet

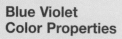

Blue Violet Color Properties

Color Group tertiary

Direct Complement _____
 yellow orange

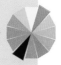

Triadic Group_____
 red orange and
 yellow green

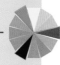

Tetradic Group_____
 yellow orange,
 red and blue

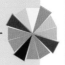

Temperature cool to cold

Inherent Value dark

How blue violet is created

This tertiary color is calm and cool like blue but contains the luxurious feel of violet. In its paler versions such as periwinkle, blue violet is delicate, evoking sentimentality and gentleness. In its dark shades such as midnight, it is rich and mysterious carrying violet's sophistication.

Because it is a tertiary color its varieties are endless depending on the amount of violet or blue that is present. In the diagram you see just a few of these possibilities.

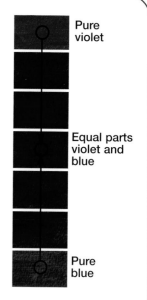

Pure violet

Equal parts violet and blue

Pure blue

Blue Violet Hue, Shade, Tone, and Tint

Blue violet is a tertiary color with endless color variations.

Hue It is calm and cool just like blue yet contains the luxurious feel of violet.

Shade Its shades are rich and mysterious carrying violet's sophistication.

Tone In its tones it is less intense and takes on the color of the added gray.

Tint In its tinted form it is delicate, evoking sentimentality and gentleness.

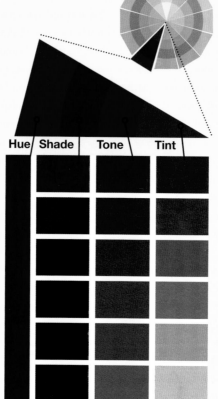

Hue	Shade	Tone	Tint

Quick Key
 Hue- blue violet
 Shade- add black
 Tone- add gray
 Tint- add white

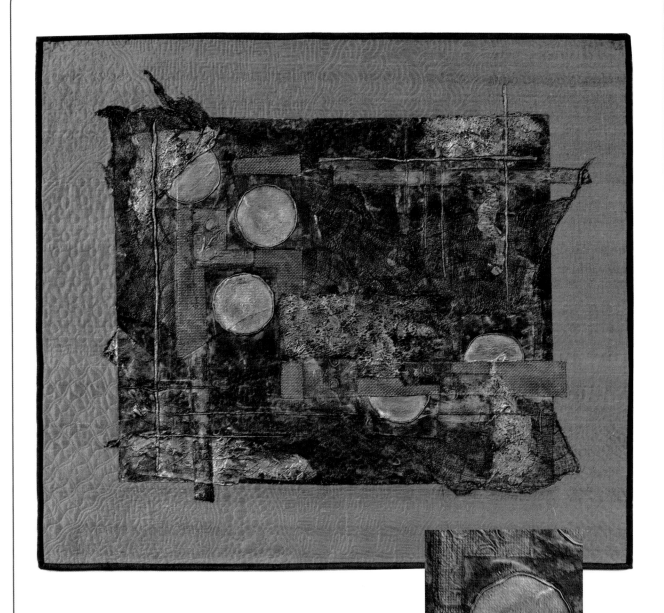

Sculptural Quilt #5

by Heather Thomas

27-1/4" x 23-1/4"

Though this piece of art includes many colors, it is dominated by blue violet. The dark background in the center of the work is a deep, dusky shade of violet and the outer border is a lovely tone of blue violet just slightly grayed from the pure hue. There are bands of pure blue violet that seem to weave through the center.

The circle elements in this quilt are light, shimmery and multi-colored. The quiet blue violet background allows them to glow.

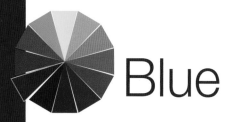

Blue

Blue Color Properties

Color Group primary

Direct Complement _____
orange

Triadic Group _____
red and yellow

Tetradic Group _____
orange, red violet
and yellow green

Temperature cool to cold

Inherent Value medium dark

The Psychology of Blue

Blue is the color of water and sky. It is soothing, calming and symbolizes freshness and purity. Psychologically speaking, blue gives off a sense of trust, dependability and stability. The statement "true blue" reminds us that someone is honest and loyal. Blue is a popular color for financial institutions as its message of stability promotes trust.

Very few blue foods exist in nature making the color blue a great appetite suppressant. Blue can also be dreary and dull especially when it is toned with gray. We say we are "feeling blue" when we are sad. On the other hand, blue is one of the most common "favorite" colors.

Blue Hue, Shade, Tone, and Tint

Blue is a soothing color that can become depressing when gray is added.

Hue In its pure hue, blue is honest and loyal.

Shade In its shades it gives a message of integrity and trust.

Tone In its tones it can be depressing.

Tint In its tinted form it becomes soft and tranquil.

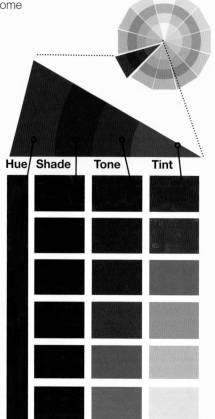

Hue	Shade	Tone	Tint

Quick Key
Hue- blue
Shade- add black
Tone- add gray
Tint- add white

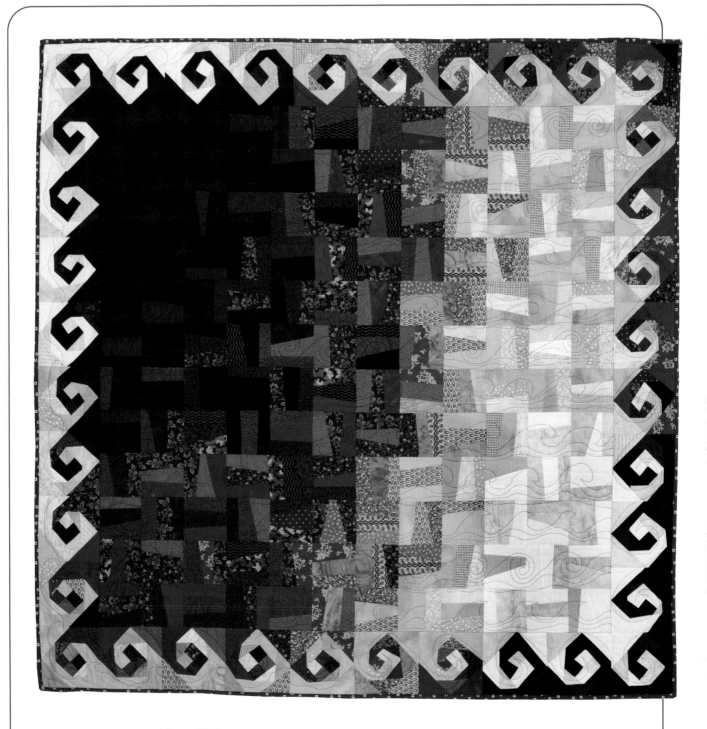

Water Whimsy

by Collette Schneider

60" x 59"

This wonderful quilt is filled with many varieties of blue
including pure hues, shades, tones and tints. The value play
creates a gradation diagonally across the surface of the quilt.
Notice how the outer edges contrast nicely with the areas they
surround giving the work a very effective frame.

Blue Green

Blue Green Color Properties

Color Group tertiary

Direct Complement _____
red orange

Triadic Group _____
yellow orange and
red violet

Tetradic Group _____
red orange,
yellow and violet

Temperature cold

Inherent Value medium

How blue green is created

This tertiary color is nature based, as are the colors that form it. Both blue and green remind us of nature's sky, water, trees and grasses. Blue green has the soothing calmness of blue but lacks its tendency to be depressing. It contains green's restfulness but again, it lacks green's negative symbolism of jealousy. Blue green is delightful in its pure hues and tints and has a gentle strength in its darker shades. It seems weak and depleted of its strong natural elements when toned.

As a tertiary color blue green has many varieties. Turquoise, teal, and aqua are all used to describe different versions of blue green.

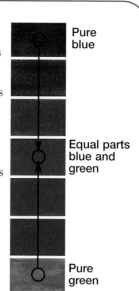

Pure
blue

Equal parts
blue and
green

Pure
green

Blue Green Hue, Shade, Tone, and Tint

Blue green connects us with nature and its elements of sky, water, trees and grasses.

Hue In its hue, blue green has a soothing calmness.

Shade In its shades it has a gentle strength.

Tone In its tones it becomes weak and depleted of its strong natural elements.

Tint In its tinted form it resembles clear cool water.

Hue	Shade	Tone	Tint

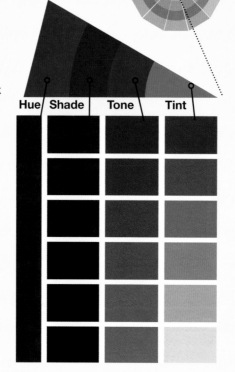

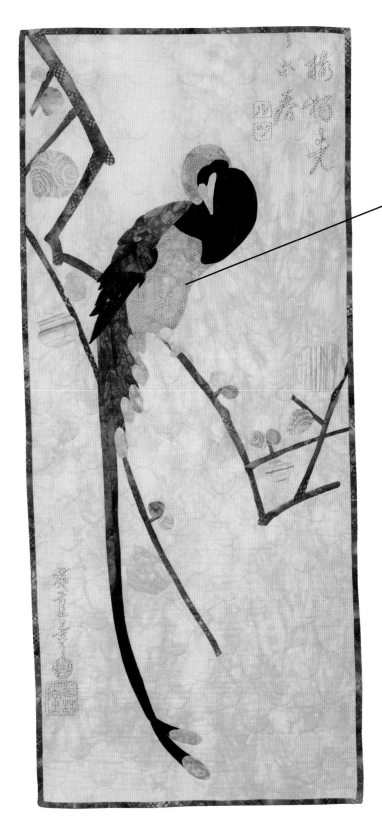

Ruth uses the hand-dyed fabrics splendidly to create a picture that evokes calmness and serenity.

Paradise Fly Catcher

by Ruth Chandler

15" x 45"

The bird in this beautiful piece is made from one piece of blue green fabric that was hand-dyed from light to dark. It includes just one color in various levels of saturation which yields a nice variety of values.

The hand-dyed fabrics in this piece, as well as those in many of the other pieces in this book, were made by Cardwell Spiller.

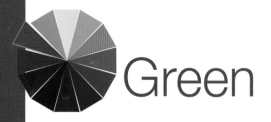

Green

Green Color Properties

Color Group secondary

Direct Complement _____
red

Triadic Group _____
violet and orange

Tetradic Group _____
red, blue violet
and yellow orange

Temperature neutral

Inherent Value medium light

The Psychology of Green

Green is considered to be the most restful of all the colors. It is the color of nature, plants, grass, and new life. It symbolizes freshness, growth and serenity. Its negative connotation is that of jealousy and envy as well as stomach sickness. We can be "green with envy" or dealing with "the green-eyed monster" or "green at the gills".

In Celtic myth, the "Green Man" was the god of fertility leading early Christians to ban the color green because it had been used in pagan ceremonies.

The color green was sacred to the Egyptians because it represented hope and the joy of spring. Muslims consider green to be a sacred color.

Green Hue, Shade, Tone, and Tint

Green is made by mixing visually equal amounts of yellow and blue. It is considered temperature neutral because it does not advance like warm colors or recede like cool colors.

Hue In its pure hue, green symbolizes freshness, growth and serenity.

Shade In its shades it takes on a more earthy feel.

Tone In its tones it becomes dull and muddy.

Tint In its tinted form it is restful and soothing.

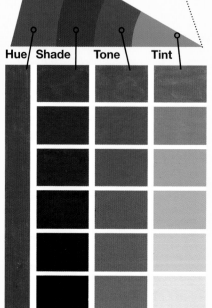

Hue	Shade	Tone	Tint

Quick Key
Hue- green
Shade- add black
Tone- add gray
Tint- add white

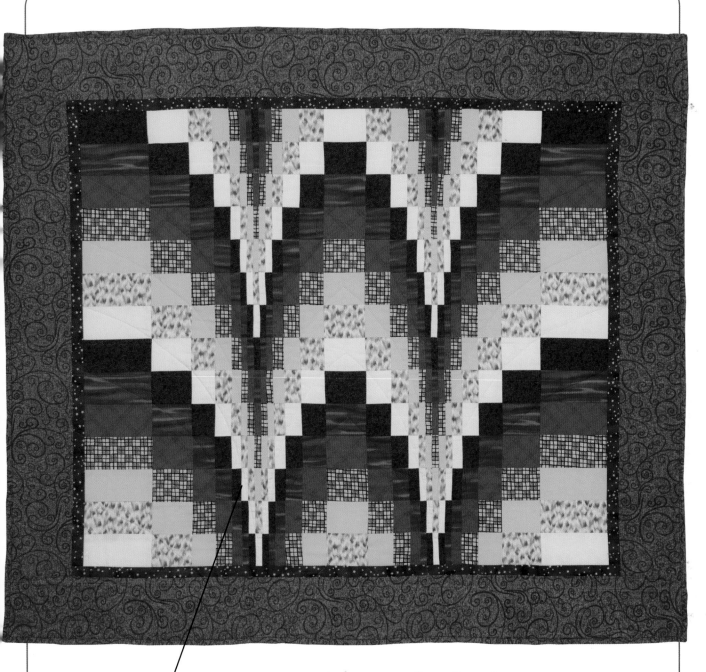

Though the diagonal lines of this Bargello quilt are powerful and energetic, the green color provides a calming effect.

Green Mountains

by Terry Simm

42" x 37"

This Bargello style quilt features a lovely array of greens in a mix of values from very dark to very light. It also has a good variety of visual textures which adds interest.

Yellow Green

Yellow Green Color Properties

Color Group tertiary

Direct Complement _____
red violet

Triadic Group _____
blue violet
and red orange

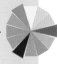

Tetradic Group _____
red violet,
blue and orange

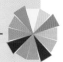

Temperature neutral

Inherent Value light

How yellow green is created

Yellow green is a tertiary color. In the diagram, we see it as it is formed by its parent colors yellow and green. As a tertiary color, its varieties are endless depending upon how much of each color is present. We often call this color chartreuse, spring green, and lime. It contains yellow's exuberance and green's freshness. It is the color of early spring, new growth and sourness. It is vivid without being as overwhelming as yellow. In its tones and shades it reminds us of old growth forests and hikes in the mountains.

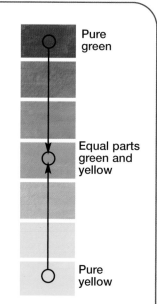

Pure green

Equal parts green and yellow

Pure yellow

Yellow Green Hue, Shade, Tone, and Tint

Yellow green reminds us of early spring. Like its parent color green, it is neutral and behaves like the colors it is mixing with.

Hue It contains yellow's exuberance and green's freshness.

Shade In its shades it is dark like a forest's undergrowth.

Tone In its tones it reminds us of old growth forests and hikes in the mountains.

Tint In its tinted form it is the color of early spring and new growth.

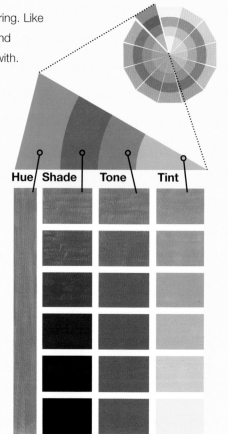

Hue | Shade | Tone | Tint

Quick Key
Hue- yellow green
Shade- add black
Tone- add gray
Tint- add white

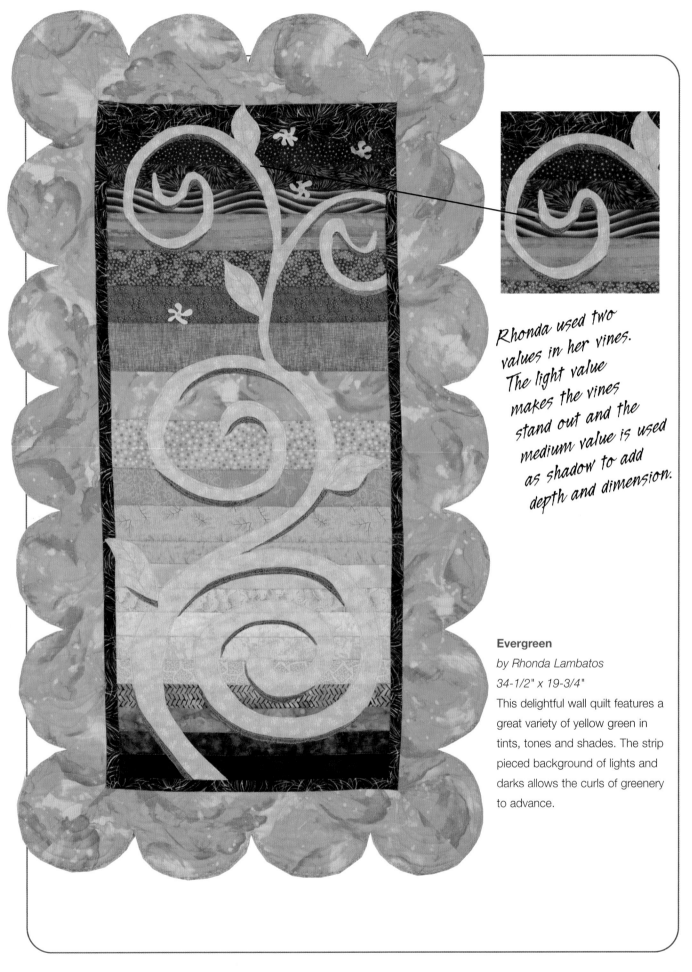

Rhonda used two values in her vines. The light value makes the vines stand out and the medium value is used as shadow to add depth and dimension.

Evergreen

by Rhonda Lambatos
34-1/2" x 19-3/4"

This delightful wall quilt features a great variety of yellow green in tints, tones and shades. The strip pieced background of lights and darks allows the curls of greenery to advance.

Brown, Black, Gray and White

Most Often Referred to as Neutrals

Black, gray and white are considered true neutrals. Many artists also include brown and other brown-based colors, such as tan, taupe and off-white in their neutral palette. Successful use of these colors can be supported by using them in varying values and intensities and in combination with textures.

Brown

- Browns are often compound colors containing various mixtures of all three primaries. They can also be formed by adding black to the warmer colors of yellow orange, orange and red orange. True browns, ones that you cannot easily identify as having a particular color base, are the color of Hershey's® milk chocolate.

- The color brown helps us identify with the earth, wood and stone. It symbolizes humility and durability.

- Using brown as a neutral or backdrop in artwork will often dull the colors surrounding it, especially if you are using warm or toned colors. Quilters have often relied on natural muslin as a backdrop for traditional quilts. When using reproduction fabrics, tan or light brown is a great choice for the negative space, while bright pure hues and clear tints will look out of place sitting on top of a warm tan background.

Black

- Black's sophistication is what often draws artists to use it, both in positive and negative space. Black backgrounds will make the colors in the foreground sing. The colors will appear more intense.

- Black has mostly negative connotations. It makes us think of darkness, death, witchcraft, evil, fear and sorrow. It is serious, bold and powerful and filled with drama and sophistication.

- Black comes in innumerable varieties. When shopping for black, whether in fabric, paint or other mediums, you will quickly see that all blacks are not created equal. Some blacks have a distinct color base, an underlying color you can just barely see. You will find red-based blacks, blue blacks, green blacks, brown blacks and gray blacks among your many choices. Each of these will have a different effect on the colors used with them. To understand how your black choice will affect the colors in your composition, sit the other colors directly on top of it to see if and how the color changes.

A selection of brown-based neutrals

Please Don't Eat Me
by Wanda Lynne
35" x 36-1/2"

This fabulous quilt uses a complex selection of achromatic (neutral) entities including black, white and gray along with rich browns, golds and russets. This work shows how elegant and effective a neutral-based palette can be. Through the use of visual and tactile texture, as well as contrast, Wanda has created a lifelike quilted experience with a strong visual message.

The cool, glittery white and gray with the added warmth of black make this piece very sophisticated.

Beaded Antler
by Linda Grey

This beaded antler by Linda Grey is made from a large variety of white, black, gray and silver beads. It is a stunning way to celebrate what nature leaves behind. The neutral beads glitter and glow as they play off of each other and make the piece shine with life.

Gray

- Gray is a wonderful neutralizer. It has the ability to deplete power from just about any color. Use great care when using it as a backdrop for your compositions. It will dull pure color and weaken shades and tints. It can entirely decimate tones, making them all but disappear.

- The color gray makes us think of metal, stone, clouds and our elders. We talk of 'gray days' in winter when the sun never shines. Gray can make us feel depressed and lackluster.

- Pure gray is made by blending white and black. This mixture will form an endless variety of gray values depending on how much white or black is added. These pure grays are easier to use than grays made by mixing complements. Pure light gray will play nicely with intense, pure hues. Darker pure grays will add a sophisticated style if used sparingly with deep shades.

- Grays with distinct color bases can be formed by mixing direct complements with each other. However, these grays can be very colorful and can cease to feel neutral. These colors are best used sparingly and mixed in with other colors in a design rather than as a backdrop.

White

- Crisp, clean white will make colors around it seem a little duller. It is the color of bright light and it is this light that will always try to dominate even the brightest, most intense color. Use it in backgrounds where you want to subdue bright colors or provide a quiet simplicity.

- White is the color of snow, wedding dresses and other religious garments. It is clean and symbolizes purity, peace, simplicity and goodness. Because of this, it is often used in marketing for infant and health related products. In China and other Asian countries it is the color of mourning and is therefore not used in weddings.

True neutrals—white, gray and black

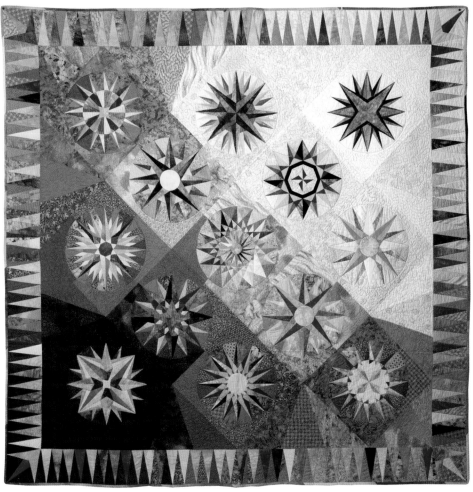

The varied backgrounds in this piece changes its mood. The crisp white corner feels light and upbeat, while the gray areas are moody and the black corner is somber.

Worlds of Color

by Heather Thomas

76" x 76"

This Mariner's Compass quilt features compasses pieced from all 12 colors on the color wheel in pure hues, slight shades and tints. The background variegates from black to gray to white. We can see how the background colors are affecting the colors in the compasses. The colors jump off the surface of the square with the blackest background. Even the darker gray backgrounds allow the surface colors to glow. However, the medium and light grays across the diagonal center seem to dull or mask the colors in the rays. The crisp white backgrounds seem to lord over the bright colors in the compasses, making them seem smaller than the other compasses and the background area larger.

How Colors Work Together

Getting to know the unique personalities of each of the 12 colors is the beginning of understanding color. However, it is gaining an understanding of how colors interact and relate to each other that will really help us create better art. As I've said before, color is a system. It is an integration of varied energies that we use to convey meaning. The following section is filled with information that describes color interaction. Whether it is understanding the inherent value of each color or learning about the six pairs of direct complements in the color system, experiencing the interaction of colors will help us to become more fluent as we make our art. We can learn how to balance the high energy of a little yellow with a lot of pure violet or how to cool down warm orange by surrounding it with blue green. Exploring the interaction of colors in their various pure hues, shades, tones, tints, values and intensities can move us toward color maturity which in turn can set us free as artists.

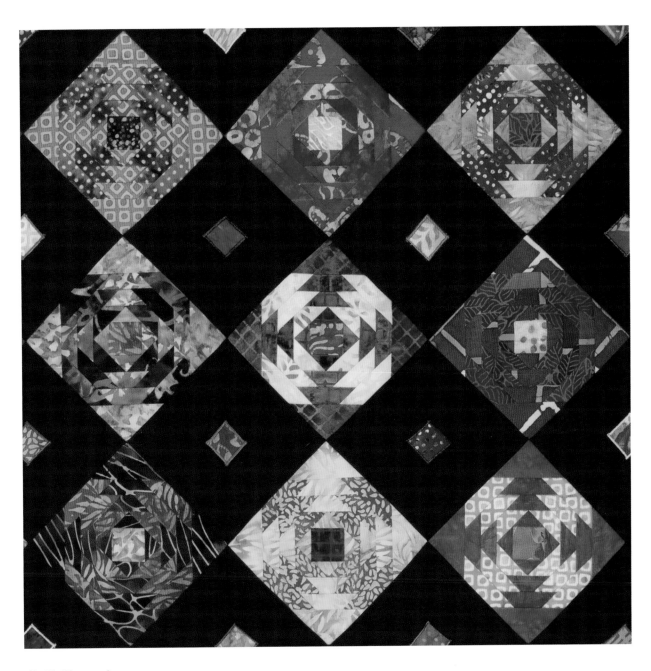

Batik Pineapples

Close-up

by Char Lempke, in the collection of Heather Thomas

24" x 30-1/4"

The Inherent Values of the 12 Colors on the Color Wheel

The word value refers to the lightness or darkness of a color. The value of a color can only be determined if you have another color to compare the first color against. Each of the 12 colors has its own inherent value, that is, its value compared to all of the other 11 colors. Its value is derived by comparing its lightness or darkness to the other colors on the wheel. Yellow is the closest color to white giving it the lightest inherent value. Violet is the closest color to black giving it the darkest inherent value. Black, deep rich browns and dark grays all have a dark value while bone, pale gray and light taupe are all light in value. When the color wheel is straightened we can assign the inherent values to the 12 colors.

Quick Key

Each colors inherent value

Lightest- yellow

Light- yellow green and yellow orange

Medium light- green and orange

Medium- blue green and red orange

Medium dark- blue and red

Dark- blue violet and red violet

Darkest- violet

Color Values

Here, we have straightened out the color wheel to better examine the way color values relate to each other across the specturm.

Pure Hue Values

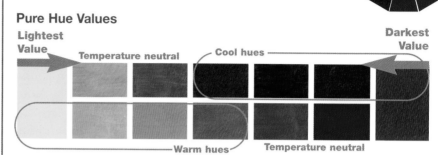

These are the pure hues of the 12 colors. Yellow, the lightest inherent valued color, is on the far left and violet, the darkest inherent valued color, is on the far right. The cooler colors sit on top and the warmer colors below. With the pure hues, one can easily see the colors on the left side are lighter and the colors on the right side are darker. Lighter inherent valued colors will appear to be larger than they actually are. It is wise to use these colors in their pure hues carefully.

Shade Values

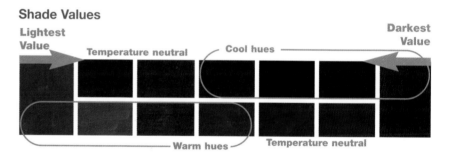

Above is a diagram showing all 12 colors as shades. Black has been added to the pure hues. These versions of the colors are rich and deep. The yellow based colors on the left hand side are still lighter than the violet based colors on the right hand side. It is easy to use lots of the lighter valued colors in their shaded versions in a composition but as with the tones below, too much of the darker shades may leave a composition looking dark and dreary.

Tone Values

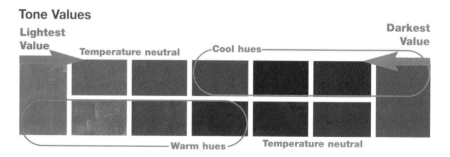

This diagram shows the 12 colors as tones. As tones they are duller than both the pure hues and the tints seen above. The yellow, yellow green and yellow orange on the left hand side remain lighter than the violet based colors on the right hand side. Tones are much gentler on the eye so one can use quite a bit more of the inherently light colors. Because of this dullness however, the darker inherent valued colors can become dreary and lifeless if too much of them are used.

Tint Values

Lightest Value →

Temperature neutral

Cool hues

Darkest Value ←

Warm hues

Temperature neutral

The diagram above shows the 12 colors as tints. Tints are lighter than the pure hue but usually remain clear unless gray is also added. Here again, it is easy to see that the colors on the left are lighter and brighter and the colors on the right are darker. One can also notice that even though the yellow, yellow green and yellow orange are lighter, they are more gentle to look at in their tinted form than in their pure hues. Tints of these colors are less powerful than their pure hues and you can use more of them in your compositions.

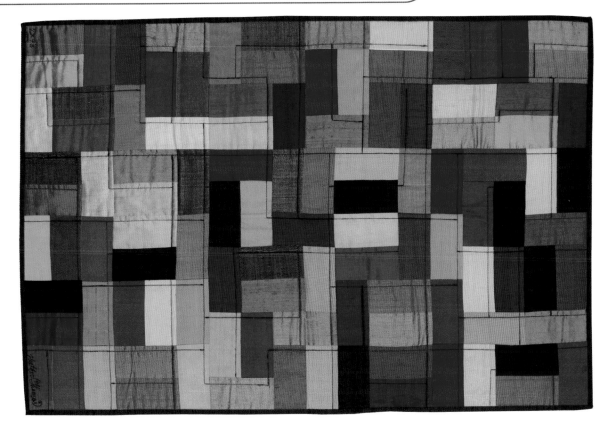

2 x 4's

by Heather Thomas

35" x 24"

This quilt, made from Dupioni silk solids includes all of the colors on the color wheel in various pure hues, shades, tones and tints. Using all 12 colors in a mix of color scale adds great variety to the quilt. Keeping the blocks the same size and using only solids adds unity.

Visual Temperature

Visual temperature is a way to describe one of the many ways that color can affect the human. We can have many different physical responses to color. One of the more common affects of color is how the temperature of a color can make us feel, both physically and emotionally.

The color wheel can be divided somewhat in half in terms of visual temperature. One half is generally considered to be cold or cool while the other half is hot or warm. The warm colors include red orange, orange, yellow orange and yellow. The cool colors include blue green, blue, blue violet and violet.

The colors red, red violet, green and yellow green are not included in either the warm or cool categories. They are considered by some to be temperature neutral. They have no strong visual temperature on their own. They do however tend to behave like the colors they are interacting with. Place red in a mixture of warm colors and it will usually read as warm, but place it with cool colors and it will try to act cool.

Hot or warm colors seem to advance, coming off the surface to occupy positive space. They grab attention, sizzle and stimulate. Cold or cool colors recede, stay in the background, occupying negative space. They are soothing, calm and peaceful.

Red, red violet, green and yellow green tend to neither advance nor recede. Rather, they sit in the midline of a composition. It is for this reason they are considered temperature neutral.

Colors can be expected to behave in the warm or cool way described when they are in their pure hues. However, when they are changed into other parts of the color scale by adding white, black or gray, their temperatures can change greatly. Adding white to any color, making it a tint, will cool it off. It won't make a warm color cold, but it will deplete some of its heat. Adding black to any color, making it a shade, will warm it up. Black won't turn a cool color warm, but it will raise

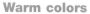

Warm, Cool and Neutral Temperature Colors

The color wheel can be divided somewhat in half in terms of visual temperature. One half is generally considered to be cold or cool while the other half is hot or warm.

Warm colors

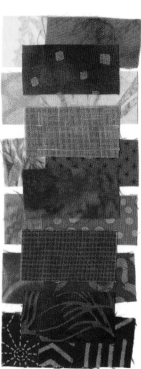

Neutral temperature colors

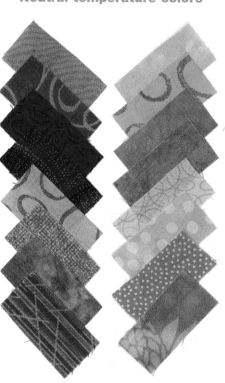

Cool colors

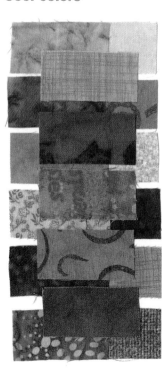

its temperature a few degrees. Adding gray to any color tends to deplete it of visual temperature, therefore depleting it of any readable visual temperature.

Orange in its pure hue is warm. Add white to orange and it becomes tangerine which is much less warm than the original orange. Conversely, if you add black to orange then it becomes rust which is even warmer than the original orange. Blue is a cool color. Add white to it and it becomes much cooler, even icy. Add black to

blue and it becomes a somewhat warm navy.

Visual temperature is relative. A navy blue may appear cool when placed with a warm cinnamon, but the same navy blue will appear warm next to a bright pure-hued violet. Like value, visual temperature can affect color dominance in a composition. Warm colors will always try to overwhelm cooler colors. Visual perception is enhanced by the use of color temperature. Using colors

correctly can help you to attain a great sense of depth in a composition. Remember, cool colors recede whereas warm colors advance.

Cold or cool colors are perceived as passive. They promote feelings of austerity, coldness, freshness, cleanliness serenity, trust and relaxation.

Warm colors are active. They stimulate physical and sexual activity. They can be aggressive and powerful or comforting and warming.

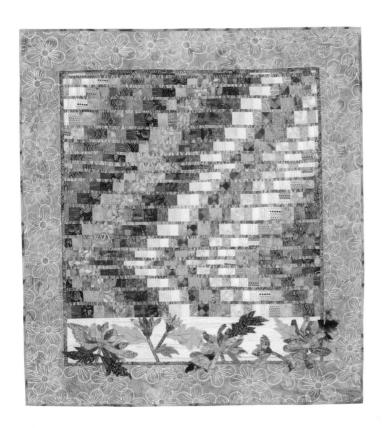

Chrysanthemums

by Heather Thomas

41" x 44"

This quilt uses yellow, yellow orange, orange and red orange as well as yellow green and bits of red violet. It has exuberant warmth. It feels like a hot summer's day. The Bargello styling allows the colors to sizzle as they move across the surface.

Crazy Panes

by Heather Thomas

21" x 17"

This fun little quilt is filled with the cool hues of violet, blue violet, blue and blue green as well as green. Black is used as an accent but it doesn't seem to warm up the colors much. They read as cool if not cold.

Color Dominance

Dominant colors are the first colors we take notice of in a piece of artwork. Dominance is relative. Which color will dominate depends on the combination of colors at play. However there are some tools that will help you predict which color will take control of a composition.

What makes color dominance work?

- Pure colors dominate over grayed tones
- Yellow is the lightest inherent valued color and is therefore the most dominant pure hue
- Warm colors advance and will dominate cool colors
- Dark values will recede
- Sparse use of light values will add sparkle
- Advancing, warm colors have more visual weight than receding, cool colors
- Warm hues are active whereas cool hues are passive

Radiant Sun Cuff

by Linda Grey

1-3/4" x 3"

Here you can see how yellow dominates. It is physically taking up less space than the blues and blue violets but it is the first thing you notice.

A Few Simple Lines

by Heather Thomas

16" x 21-1/2"

The flower in the center of this piece is one of many design elements but it dominates because of its sheer size, centralized position and its surround of clear, bright blue. The checkerboard sections and bright yellow green sections command attention thus weakening the flower as a focal point. However, the flower is still emphasized over the other elements due to scale, color and positioning.

Complex Colors

Complex colors are formed by mixing three or more colors together. The colors used can be primary, secondary and the neutrals black, white and gray. Complex colors are not as bright as primary or secondary colors. The more colors used to form a color, the duller that color will be because more light is subtracted from it. Complex colors are often described as dark or muddy, but are usually not as dull as normal tones. Though we use them often, recognizing complex colors can be difficult. The easiest way to determine if a color is a complex color and what colors it is made from is to first determine which colors it is not made from. If you are looking for a pre-colored medium in a particular hue and you happen upon a color you cannot easily identify as a version of one of the 12 colors of the color wheel then it is probably a complex color. Place it next to the color it most closely resembles on the color wheel and try to determine if it is a variety of that color, or has that color as a base with two other colors or one color and a neutral added to it.

Creating complex colors

These diagrams show complex colors made by mixing varying amounts of the three primary colors blue, red and yellow.

Mixture #1
Equal mix of the three colors which yielded **black**.

Mixture #2
Equal amounts of blue and yellow then added a small amount of red to yield a rich dark forest **green**.

Mixture #3
A small amount of both blue and yellow and a larger amount of red achieved a deep, tone of **violet**

Mixture #4
A small amount of red and a bit of blue with a larger amount of yellow to yield a rich golden **brown**.

Leaves
by Heather Thomas
25-1/2" x 37-1/2"

All the colors in this quilt began with a pale gold, hand-dyed fabric. Small bits of both yellow and blue were added to a pure red to achieve the red shown. To get the green shown, I mixed yellow and blue then added a drop of red. To achieve the light orange color, I began with yellow and added small amounts of red and a drop of blue. To get the mustardy yellow, a tiny amount of both red and blue were added to the yellow along with some gray. These complex colors are duller than the pure hue, but they are also more interesting.

Intensity and Saturation

The word saturation refers to the brightness or dullness of a color. This reference is relative. One cannot claim that a particular color has a high saturation unless there is another color to compare the first color to. The word purity pertains to the intensity of a color. The intensity of a color can be controlled by its saturation making these two descriptive words closely linked. A color is very intense and highly saturated when it is in its purest hue. Nothing has been added to it to deplete it of its power. The more the color is changed, the more its intensity will be affected.

It is easiest to compare saturation when looking at colors that are in the same hue group. Candy apple red has a higher saturation and intensity than melon. One is a pure red the other is a tint of red. Some highly saturated, intense colors go by names such as grass green, bright turquoise, cherry red and hot pink. Low saturation, less intense colors go by names such as sage, olive, wine and powder blue.

The difference between value and saturation and intensity is value has to do with the lightness or darkness of a color where as intensity and saturation has to do with the purity of a color. The color hunter green has a dark value with a low intensity. Black has been added to green to both darken and dull it. It may be easier to understand this concept if you think of it using the words clear or muddy. Clear colors are pure and intense while muddy colors are dirty and dull.

Adding colors with both high and low intensity or saturation to your work will give it more complexity and may yield a sense of movement in the piece. Remember, like value, intensity and saturation are relative. A color may appear dull when placed among other more intense, pure colors. The same color, when placed with duller, low intensity colors may in turn appear more intense. Classic color theory suggests using highly intense or saturated colors in small areas of a design or as an accent.

Quick Key
Value- the lightness or darkness of a color
Saturation and Intensity- brightness or dullness of a color

Comparing intensity and saturation with value

The difference between value and saturation and intensity is that value has to do with the lightness or darkness of a color where as intensity and saturation has to do with the purity of a color.

High Saturation colors are intense and fully saturated

Low Saturation colors are less intense and appear "muddy"

Light value colors have white added to them

Dark value colors have black added to them

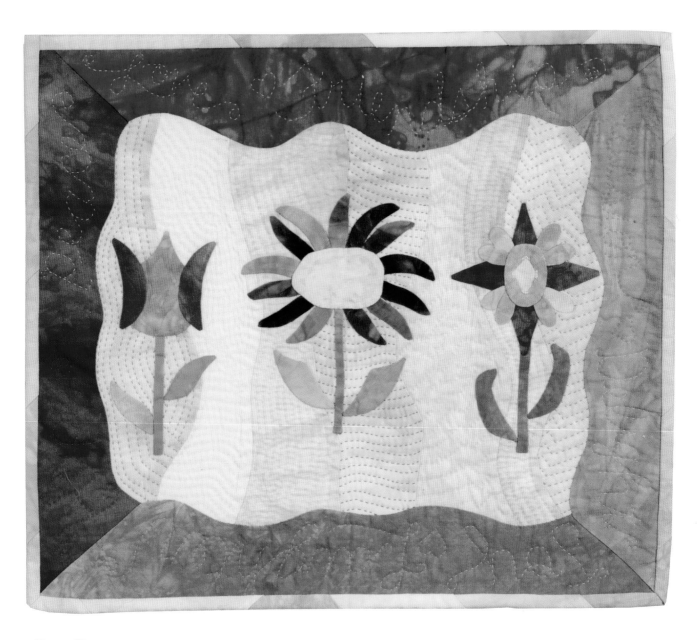

Happy Flowers

by Heather Thomas

15-1/2" x 13-1/2"

This small quilt features hand-dyed fabrics in various saturations
and intensities. The fabrics were dyed in a gradation of light to
dark, yielding multiple values which in turn yielded the varied
saturation/intensity levels present.

Classic Color Combinations

Artists have been studying color and design for hundreds of years. Remember, there is more to learn about color than the characteristics of individual color. It is more about relationships and the interaction of colors. Experimenting will help you learn more about the ways colors play together, how they react to each other and how they behave in groups. Almost all of the characteristics of a color can change depending on which other colors are present. Learning about the interaction will provide you with the tools and skills you need to make better art, and make it easier to be successful in your artistic attempts.

Color Harmonies

Experimenting with these color combinations will help you learn more about the ways colors play together, how they react to each other and how they behave in groups.

Neutral or Achromatic
Includes true neutrals—black, gray and white. Can contain tan, off white, taupe, and other pale brown based colors

Monochromatic
One color varied by value, color scale, intensity or saturation.

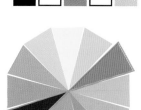

Direct complement
Any two colors that are directly across from each other on the color wheel

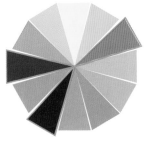

Split complement
Three colors. Select one color and then the two colors on either side of its direct complement

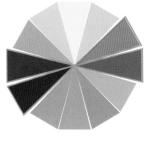

Double complement
Four colors. Select two adjacent colors and their direct complements

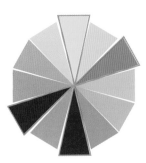

Double split complement
Four colors. Two pairs of direct complements that are each separated by a color

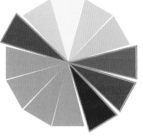

Analogous complement
Four to eight colors. One color and an analogous run whose middle color is the direct complement of the first color

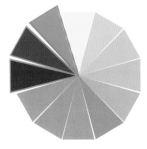

Analogous
Three to seven colors that are next to each other on the color wheel with only one primary included.

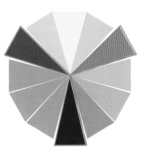

Triad
Three colors. Any three colors that are spaced evenly around the color wheel.

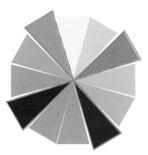

Tetrads
Four colors equidistant apart

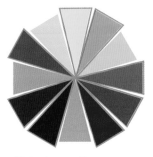

Polychromatic
70 to 100 percent of the colors on the color wheel.

Neutral or Achromatic

True neutrals are black, gray and white. Neutrality refers to
the absence of color. Most artists have expanded the list of
neutrals to include tan, off white, taupe, and other pale,
brown based colors. Quilts with a neutral color scheme rely
on the use of materials with varied contrasts in value and
intensity as well as a good mix of pattern and scale.

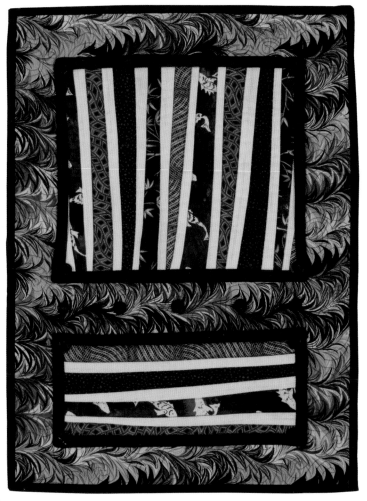

Neutral Bars

by Heather Thomas

19" x 14"

This small quilt uses just nine different fabrics, but each one is doing a lot of work. The stark
white bars separate the various grays in the two pieced rectangles. Each is then surrounded
by an almost black gray. Each of the gray fabrics has a different style and scale of print on it
which provides for plenty of variety. The feathered background fabric contains a large variety of
grays, black and white. Its curvilinear design provides a nice contrast to the straight lines in the
pieced rectangles.

Monochromatic
One color varied by
value, color scale,
intensity or saturation.

Monochromatic
yellow orange

Monochromatic

The word monochromatic means one color. A monochromatic color scheme relies on value, color scale and intensity or saturation rather than color to convey the design.

A successful monochromatic artwork is made from using only one color family that contains great contrast in value, intensity, texture and pattern. All values of the color, light, medium and dark, should be present otherwise the work may look flat and lack movement. Works created using a monochromatic colorway can be soft and soothing or filled with lots of contrast and movement.

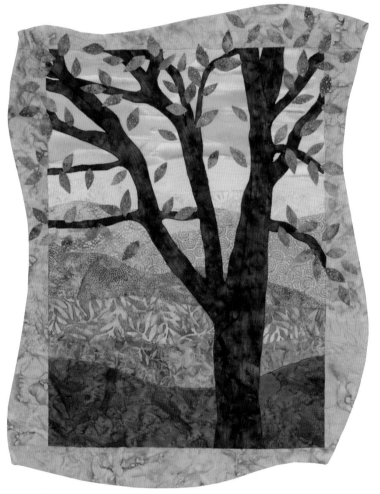

A Tree Grows in Morrison

by Lisa Sullivan

18" x 24"

This quilt was made in the monochromatic colorway of yellow orange. Yellow orange is a tertiary color made of yellow and orange and therefore has a huge number of varieties. Here, Lisa uses yellow oranges that have more yellow than orange and orange yellows that contain more orange than yellow. She has also used a wide variety of the color and value scales.

Direct Complement

Art made with a color scheme of direct complements will use two colors that are directly across from each other on the color wheel, such as red and green, orange and blue, yellow and violet. Because of the naturally high contrast in direct complements, works made with these color combinations are often visually striking and powerful. The word complement means to complete. To the eye, red completes green and so forth.

Generally accepted ratios of usage of some of the common complimentary color combinations are 3/4 violet to 1/4 yellow, 2/3 blue to 1/3 orange, equal amounts of red and green. These are good ratios to use when using lots of fully saturated color. If you plan to include lots of light values and low intensity colors, these guidelines do not necessarily apply.

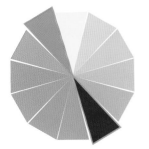

Direct Complement
Two colors directly across from each other on the color wheel.

Direct Complement
red violet, yellow green

Sweet Baby

by Nancy Magnen

34" x 43"

This delightful quilt is filled with shades, tones and tints of the direct complement pairing of red violet and yellow green. Nancy steered clear of using the pure hues of either color to maintain the soft palette. She used a large variety of interesting prints which provides great visual texture and added interest.

Split Complement

This combination is a three color scheme. It uses one color and the colors that lie on either side of the first color's direct complement. Two examples are red with blue green and yellow green or blue with yellow orange and red orange.

To soften this type of color scheme, add lots of medium and light valued fabrics with mild to medium intensity. This combination is generally softer, less powerful than a direct complement.

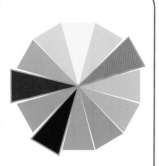

Split Complement
One color and the colors that lie on either side of its direct complement.

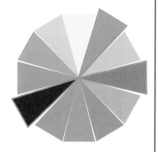

Split Complement
blue, red orange, yellow orange

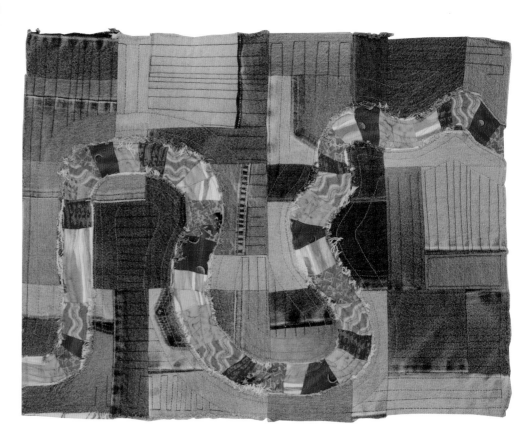

The Road to Gees Bend
by Lori Nicholson
19" x 24"

This funky wall quilt made from recycled jeans and quilting cottons features the split complementary grouping of blue with red orange and yellow orange. The variety of blue in the background makes an interesting fieldscape with the meandering river of rich, warm yellow oranges and red oranges wandering through it.

Double Complement

This is a four color combination that uses two adjacent colors and their direct complements. Choices could be blue, blue green and orange, red orange or violet, red violet with yellow and yellow green.

This scheme has a much more harmonious feel to it than a direct complement. The adjacent colors are analogous in feel and soften each other.

Double Complement
Two colors that sit next to each other and their direct complements.

Three Scarabs

by Heather Thomas

34-1/2" x 14-3/4"

This silk quilt features hand painted, batik scarabs painted in a mix of red violet, violet and their direct complements of yellow and yellow green. The three small bug quilts sit atop a quilted background that is a deep, shade of yellow (remember, yellow goes to olive when black is added). The colors are a mix of pure hues and shades providing a bold, dramatic yet fun statement.

Double Complement
red violet, violet and yellow, yellow green

Double Split Complement
Two pairs of direct complements separated by a color.

Double Split Complement

This is another four color combination. It uses two pairs of direct complements that are each separated by a color. Choose a color, skip the color next to it and choose the next color then choose those two colors' direct complements. You could begin by choosing blue, skip blue violet and choose violet then pick the direct complements of blue and violet which are orange and yellow.

These combinations are less powerful than direct complements, have greater variety in inherent values and make for visually stunning artwork.

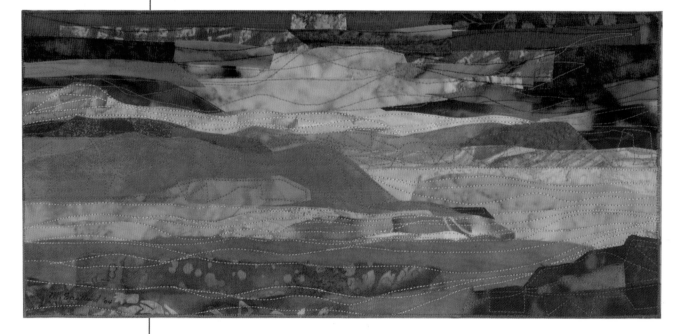

Mini Landscape #1
by Marjorie Eastlund
16" x 8"

This beautiful landscape was created using the double split complementary grouping of blue violet and blue green and their direct complements of yellow orange and red orange. Marjorie used a nice blend of tones and tints for the blue green ocean waters, dark shades and tones of yellow orange for the rolling hills and rock formations and a nice mix of shades and tones of blue violet for the sky. She used a long strip of red orange to represent the sun going down. Notice the area where the reflection of the sun is glowing in the water, it is filled with very pale red orange.

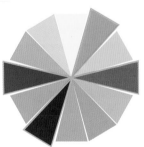

Double Split Complement
blue violet, blue green and yellow orange and red orange

Analogous Complement
One color and an analogous run whose middle color is its direct complement

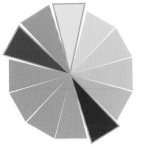

Analogous Complement
red violet with yellow, yellow green and green.

Analogous Complement

This combination can contain from 4 to 8 different colors. It uses one color and an analogous run whose middle color is the direct complement of the first color, such as red violet with the short analogous run of yellow, yellow green (red violet's direct complement) and green.

Before using an analogous run larger than three colors, get to know the particulars of working with analogous color schemes. This grouping is similar to the split complement except instead of ignoring the first color's direct complement, you use it.

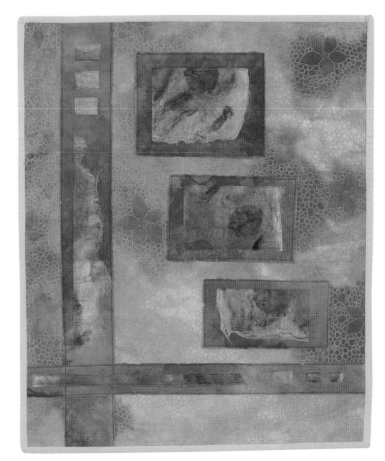

Dream, Play, Create
by Heather Thomas
15" x 18"

This little quilt features the analogous complement of red violet with yellow, yellow green and green. The rectangles and strips of red violet hand dye are topped with a silk fusion fabric that was made from a mixture of red violet and yellow green silk fibers. The background fabric was dye painted using yellow, green and red violet paints. The result is a lovely mixed background that contains shades, tones and tints of all four colors of the grouping.

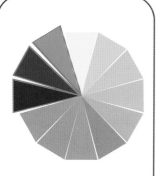

Analogous
All colors used have a primary color in common and only one primary color can be included.

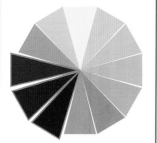

Analogous
blue green, blue and blue violet

Analogous

The word analogous comes from the word analogy which means to be alike. Therefore all of the colors used in an analogous color scheme should have one primary color in common.

A true analogous scheme contains three colors all sharing a common color, such as blue green, blue and blue violet or red orange, red and red violet.

An expanded analogous scheme can contain all of the colors between two primaries and one of those primaries, such as blue, blue green, green and yellow green.

Expand the scheme even further by including all of the colors that contain one primary. Begin with one primary and add all of the colors to the left and to the right stopping at and not including the next primary. For example, start with red and then add red violet, violet, blue violet, red orange, orange and yellow orange. All of these colors contain some red.

This color scheme relies heavily on the use of varied values, intensities, pattern and design. To keep an analogous scheme from being too subtle, choose an intense version of one of the hues and use it as an accent.

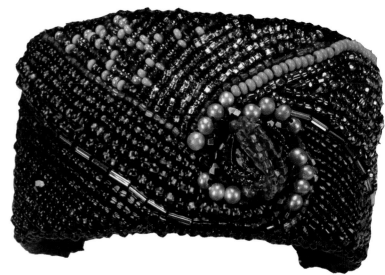

Cool Wave
by Linda Grey
3" x 2"
This elegant, beaded cuff was designed by Linda using a selection of blue green, blue and blue violet beads. It is a short, analogous run using a large selection of tints, tones, pure hues and shades of all three colors.

Triad

Triadic color schemes contain three colors that are equidistant from each other on the color wheel or every fourth color on the color wheel. Examples are violet, green and orange or blue green, yellow orange and red violet. To keep this color scheme pleasing to the eye, choose one of the colors as the lead and let the other two act in supporting roles. Remember to use lots of variety in color scale, value and intensity.

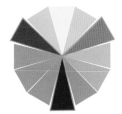

Triad
Three colors equidistant from each other on the color wheel.

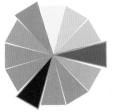

Column 1: violet, orange and green

Column 2: blue violet, red orange and yellow green

Column 3: blue, red and yellow

Column 4: red violet, blue green and yellow orange

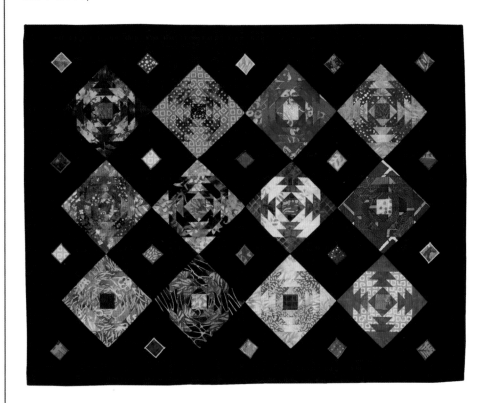

Batik Pineapples

by Char Lempke, in the collection of Heather Thomas
24" x 30-1/4"

This quilt was made using all four Triadic combinations. Char used one of each of the combinations in each of the vertical columns. The first column on the left uses the secondary triad of violet, orange and green. The topmost block is dominated by the lighter, brighter green, the middle block by the orange and the lower block by orange again. In the column second from the left Char used the tertiary triad of blue violet, red orange and yellow green. In each of the three blocks we see a different one of the colors dominating. In the column that is second from the right she used the primary triad grouping of blue, red and yellow and again, let a different color dominate in each of the blocks. The column on the right uses the remaining tertiary triad of red violet, blue green and yellow orange. These three blocks show how different identically pieced blocks can look depending on the placement of not only color, but also value and intensity.

Tetrad
Four colors equidistant
from each other on the
color wheel.

Tetrad
blue, yellow green,
orange and red violet.

Tetrad

A Tetrad uses four colors, each equidistant from each other
on the color wheel. Begin with one color, skip two colors
take the next one, skip two colors grab the next one, skip two
more colors and pick up the last one. An example would be
blue, yellow green, orange and red violet.

Tetradic schemes use a balance of warm and cool colors
and make very pleasing quilts. Because the colors are so
different from each other, a natural variety is achieved. To
bring unity to this color combination, try to use equal
amounts of the color scale in each color. Vary the value in
each of the colors to add lots of visual interest.

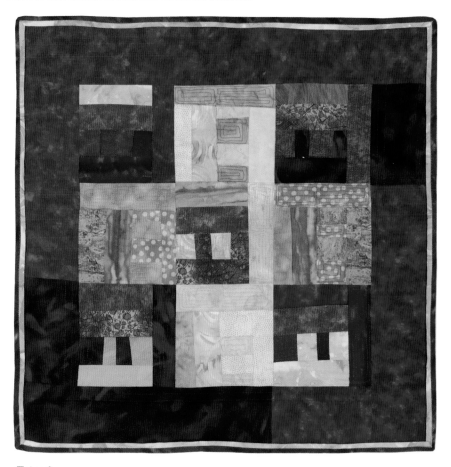

Tetrad

by Lori Nicholson

20" x 20"

Lori's funky, pieced squares quilt features the tetradic combination of blue, yellow green, orange
and red violet. She chose to use a mixture of pure hues, shades, tones and tints. Lori framed all
of the colors with two blue fabrics, one intense, the other darker and duller. She surrounded the
frame with a narrow flange of bright, intense yellow green and orange then finished the piece
with a dark red violet binding.

Polychromatic

A polychromatic scheme contains 70 to 100 percent of the colors on the color wheel.

These quilts can be bright and dynamic or soft and romantic depending on the use of scale, value and intensity in the colors you choose. Neutrals are often added to polychromatic schemes to provide a place for the eye to rest and keep a brightly colored artwork from becoming too dynamic.

This colorway usually has an equal balance of warm and cool color. If you are trying to achieve balance, maintain it with equal usage of high and low intensity colors and light, medium and dark values.

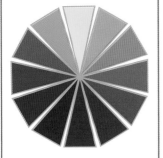

Polychromatic
Contains 70 to 100 percent of the colors on the color wheel.

Polychromatic
Colors used in quilt - violet, blue, green, yellow, orange, red and the tertiary colors were made when these colors blended together in the hand-dyed fabric.

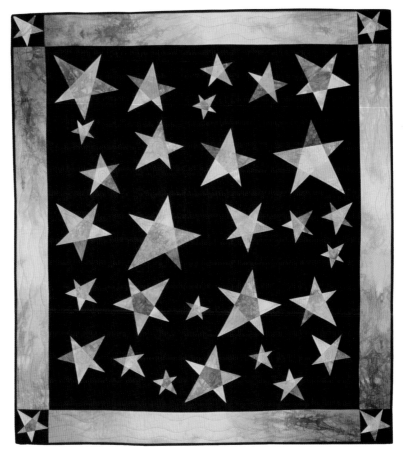

Rainbow Stars

by Heather Thomas

51" x 46"

This fun, bright quilt uses one hand-dyed fabric that was dyed in stripes of color. The colors are violet, blue, green, yellow, orange and red. In between each of these colors, tertiary colors are formed where the two colors meet. In the area where yellow meets green, yellow green is formed. Where blue meets violet, blue violet is formed and so on. I used a flat, matte black as the background so the stars would really shine.

"The concept of design is a basic, abstract, universal visual language." Josef Albers

The Language of Design

The process of learning how to design your own original work begins with an understanding of terms and ideas and how they work together to form something from nothing. Some of us have an innate ability to create universally pleasing designs, while others of us struggle with even the most basic composition. Understanding the building blocks of design can provide each of us the opportunity to create works that are more visually appealing.

The following pages are intended as a guideline to help you understand how the elements and principles of design work together to provide you with a variety of tools that can help you become more adept at creating your own unique work. Gaining knowledge of the elements and principles of design can help set the artist free.

1

2

3

4

5

Women in Prison: From Shame to Freedom

by Susan Brooks

This series of five individual quilts that fits together into one large installation tells a story of moving from despair toward triumph. It is made from Susan's hand-dyed/screen printed/mono-printed fabrics and is machine quilted.

1) **Bars** *26-1/2" x 71"*, 2) **Buried Emotions** *22-1/2" x 28"*, 3) **Mortar Falling** *22-1/2" x 28"*,
4) **Freedom** *22-1/2" x 28"*, 5) **Daisy** *56-1/2" x 22-1/2"*

"There are painters who transform the sun into a yellow spot, but there are others who, thanks to their art and intelligence, transform a yellow spot into the sun". Pablo Picasso

The Elements of Design

From pieced blocks and appliquéd flowers to a weaving structure and its color values, the elements that make up a particular artwork are what we usually see first. These combined elements are integral to the success of a design. Harnessing their power can offer us the opportunity to grow as quilt makers and artists.

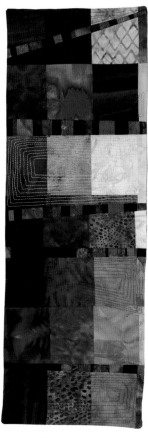
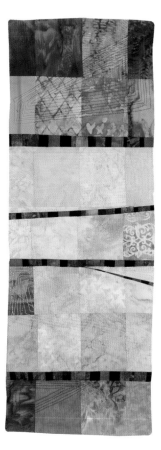
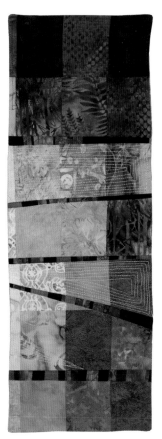

Tryptic Composition

by Tamara Leberer

Each piece is 8" x 22"

In this piece, Tamara uses bold lines to break up a field of rectangular shapes. The tryptic composition adds interest to this simple design.

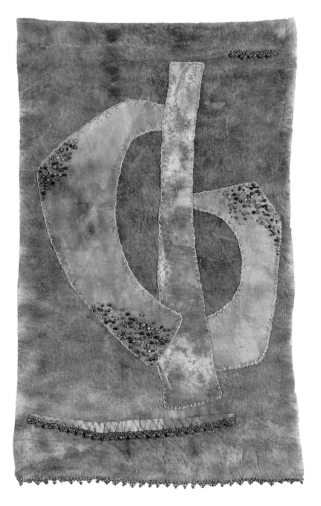

Ankh

by I.V. Anderson

16" x 24"

This bold composition is softened by the simple two color scheme. Beads with a high contrast in color scale and texture add interest to both the central figure and the bar below it.

Line

Line is a design element characterized by length and direction that is used to create contour and form. Lines can point to other design elements and create a sense of direction and movement. Lines can be used to create depth. When grouped together they can create density, texture or value. Line can exist in three different forms, the actual line, the implied line and the mental line. The quilting line is another form of line used in quilt making.

The actual line is present. It is often seen in quiltmaking as sashing and borders. Quilts based on the joining together of long strips also contain a strong physical or actual line. When short lines come together they form shapes. However, the shapes can then begin to dominate and become more physically present than the lines creating them.

Implied lines are created when shapes or forms are lined up in succession, one after the other. For example, one star block reads as a shape alone, but when you sew together several rows of star blocks, lines develop both vertically and horizontally. Sometimes this line is actual, as with a seam line, but other times it is implied.

A mental line is present when the viewer can link together elements in a design in a linear manner. Think of a group of stars scattered across the surface of a quilt. The viewer will put the stars in a linear order according to how they fade away from view thus creating a mental line.

The quilting line is a very powerful tool, one that is often overlooked. So many quilt makers look at the quilting as just a way to finish the quilt and make it functional. For some, little attention is paid to the power the quilting line can provide. When added

Specific types of lines:

- **Outlines** are made by the edge of an object or its silhouette.
- **Contour lines** describe the shape of an object and the interior detail.
- **Gesture lines** are lines that have energy and imply movement or activity.
- **Sketch lines** capture the appearance of an object or impression of a place.
- **Calligraphic lines** are elements of writing and lettering done in a fine hand.
- **Implied lines** are lines created by a group of objects with a visual link.
- **Vertical lines** give a sense of strength and growth.
- **Horizontal lines** are calming and restful.
- **Curved lines** give the feeling of movement or implied motion.
- **Diagonal lines** enhance the sense of motion. These lines can be contained if they end within the design field or can feel endless if they end at the edge of the design field.
- **Radiating lines** give a sense of non-stop motion. They are exciting and exhilarating and provide an added sense of balance.
- **Angled lines**, especially when repeated in a consistent pattern, create a sense of anxiety and discomfort and are well used when creating a negative mood.

to the two dimensional surface of a quilt top, quilting lines add three dimensionality enhancing the shapes and lines already present on the surface by providing a sense of depth. Heavy quilting in the negative design spaces will push those spaces further back and allow the lightly quilted areas of positive space to push up and away from the surface. Quilting lines can be used to direct the eye across or around the quilt's surface, pushing the viewer from one design element to another. Depth can be achieved or heightened with the use of quilting lines. Parallel lines that get closer together as they move toward the top or side edge of a design add a linear perspective.

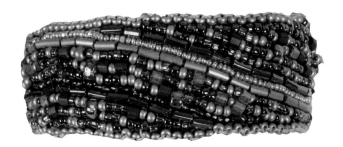

Layers
by Linda Grey
7/8" x 3"
This elegant cuff was made using a selection of beads in violet, golds and tans. It is a series of diagonal rows, each made from one or more similar style and color of beads which helps to define each unique row. Each line is made up of shapes (the beads), but it is the line formed by the repeated shapes rather than the individual shapes of the beads that give the cuff its beautiful design.

Celebration
by Carol Ann Waugh
35" x 24"
This quilt relies on line and color to make its strong visual impact. This quilt has both simplicity and complexity and is a great exploration into the power and complexity of line.

Each line is made by hand or machine using a different specialty stitch.

Line

Winter Aspen Grove

by Tamara Leberer

12" x 26"

This lovely landscape is nothing more than a series of very well placed and
colored lines. The background was stitched to look like horizontal,
undulating stripes of color; white for a foreground of snow, light blue for
rolling hills, medium gray for far off mountains and a pale, blue gray for the
sky. Aspen tree trunks are inserted in a variety of blue and gray values and
in a variety of sizes to give a perception of depth. Stitch lines were used to
show the depth of the snow in the foreground. This is a very successful
landscape made in its entirety with line.

Learning Activity

Try using lines to create a new shape. No outlines are
allowed, instead, rely on the negative space between
the lines to help you form the shape or shapes.

Expand your thinking about using line

Lines come in all sorts of widths and lengths. Lines are differentiated from shapes by being much longer than they are wide. Lines become shapes when the ends meet or overlap. Some lines are straight and some are curvy; some are jagged and some are smooth; some are real and some are perceived. Because shapes have an edge, usually defined by line, they are considered real. However, perceived shapes can be formed by using lines that lay in close proximity to each other but do not touch or overlap.

The two drawings, one of leaves and the other of circles, are made entirely of lines that do not meet to form shape. There are no real shapes in these drawings. There are only lines. The perceived shapes are formed by the negative space left between the areas of line and by the directions in which the lines are moving. We see the leaves and circles because of where the lines begin and end. As you look at the drawing of leaves, note how close together the lines are, where they begin and end and the angles at which they are drawn. Also note the size of the space where there is no line and how this space defines the perceived shape of the leaves. As you look at the drawing of the circles note how the direction of the lines in the circles differs from the direction of the lines in the negative space and how diamonds are formed in that negative space.

note how the direction of the lines in the circles differs from the direction of the lines in the negative space

note how close together the lines are, where they begin and end and the angles at which they are drawn

Line Library

The line drawing examples below can be used as design elements to add texture, movement and direction when quilting.

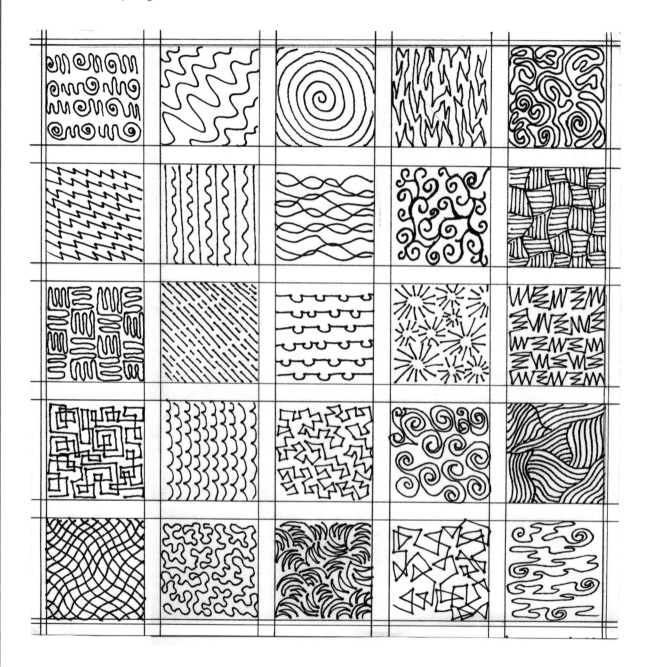

Shape

Shape is a design element defined by the lines forming its perimeter. Shapes are not three dimensional. They have no depth and cast no shadow. Shapes are two dimensional entities created by contrasts with their surroundings. They can contain color, value and texture as well as other elements of design.

Types of shapes:

- **Geometric shapes** include, but are not limited to, circles, squares, rectangles, triangles, stars and diamonds. These types of shapes make up the bulk of the designs in traditional quilt making. They are used alone or together to create blocks and a repetition of design or patterned repeats on the surface of a quilt.
- **Realistic shapes** replicate shapes found in nature. These shapes actually exist and can be copied or recreated. Flowers, leaves, mountains, people, a pair of shoes and rocks in a riverbed are all realistic shapes. Appliqué artists rely heavily on the reproduction of realistic shapes.
- **Organic shapes** are usually taken from nature but are less consistent than realistic shapes and offer more variation. Clouds, flowing water, puddles and spills all have shapes that can be used as design elements. Organic shapes can be linked to both the realistic and the abstract.
- **Abstract shapes** do not fall into the geometric category and are usually an exaggeration or simplification of natural shapes. With these shapes realism goes out the window and improvisation takes over. Blocks and strips of color sewn together to imply rocks and a canyon are a sample of a landscape abstraction taken to the limit. We know the landscape is not filled with squares, rectangles and strips, but when placed together in the right position with the right colors a landscape can be implied. Art quilters often rely heavily on abstract shape and design.
- **Non-Objective shapes** are shapes not found in geometry or nature. These shapes are non-realistic. They are similar to abstract shapes, but they lack any relation to a real idea or object. Free style piecing often features non-objective shapes.

100 Astral Dreams

by Katie Fowler

39" x 39"

Katie likes to paint abstract pictures on cloth. She then cuts them up and reassembles them on a background. Here, she has left very little negative space between the squares. Each square has its own unique color, line and shape but because they all came from the same painting, they have commonality in value, color scale and a repeat in style of shape and line.

Shape

Silk Circles

by Ruth Chandler

13" x 56"

In this lovely wallhanging, Ruth used just three colors of silk and one geometric shape. The circles are all the same size and are set on the background in a grid formation. This consistency of placement yields a diamond with concaved sides in the background or negative space. Notice how the red and the gold circles are set every other color in the center section. The placement designs on each end are opposite of the other, making a very interesting piece.

Learning Activity

Look at your own artwork, artwork in books, magazines or at a gallery or museum and determine how the artist used line, shape, color and value. Is there enough variety to keep you engaged? What kind of energy do these elements of design give off? What do you like or dislike about how the artist used these design elements?

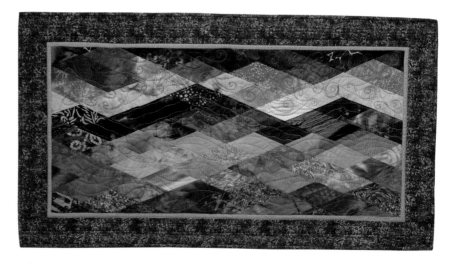

Simple Seascape

by Heather Thomas

36" x 20"

This little wall quilt uses one geometric shape, a diamond, repeated in an analogous colorway to yield the illusion of a seascape. The blue greens in the bottommost section denote water, the violet in the midsection denote mountains and the blue in the top section, sky. Realistic lines were added in the quilting to make the impression of a seascape more real.

Blending Line and Shape

Most art is made by bringing together line and shape and is usually augmented by color. A simple and effective way to begin a composition is to use one repeating style of line with one repeating shape. These compositions are most often contemporary in style, but they can be very traditional too.

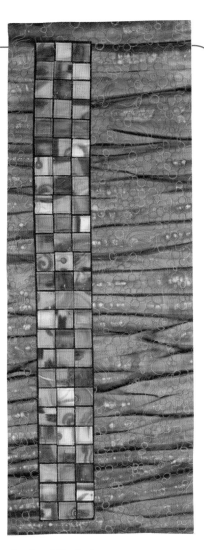

In this piece contrast is created with value rather than color.

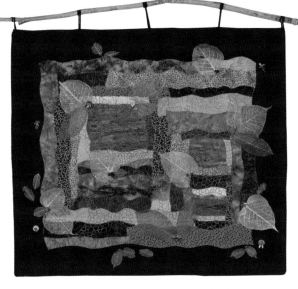

Falling

by Lisa Sullivan

38" x 28"

This elegant quilt utilizes one realistic shape, leaves, set against a pieced background of wavy lines. The artist used nothing but neutrals and dull tones, creating contrast with value rather than color. The background looks like a very abstract landscape and the leaves feel as though they are floating in front of it.

Lady of the Lake

by Katie Fowler

16" x 42-1/2"

This quilt utilizes geometric squares cut from an abstract picture painted on fabric and reassembled on a black background. It is quilted with straight lines onto a striped batik. The background was quilted with hundreds of small circles, thus adding a new shape. The play of the small squares in the very long thin rectangle against the lines of the batik and the change of color in the negative space make this piece interesting and beautiful.

Your Heart

by Wanda Lynne

21-1/2 x 22-1/2

This quilt packs a great visual wallop. It features a large, red, burned heart which sits on a backdrop of ripped and burned strips of neutral colored fabrics. These strips are set vertically so they oppose the small, lighter red horizontal strips that tell the story of the broken heart. This quilt is successful through its simple contrasts of shape and line and color on neutrals.

Shape Library

Below are examples of simple shapes that can be used as design motifs, either alone or in a composition.

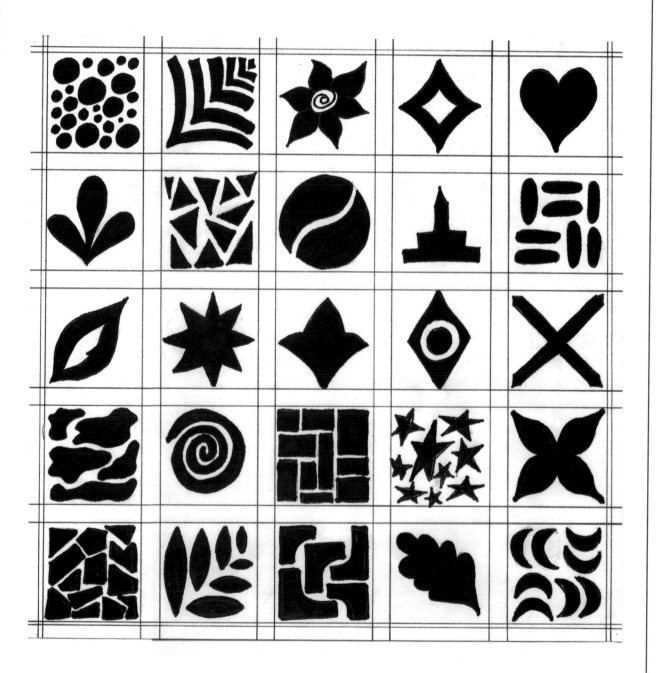

Form

Forms are three dimensional shapes. They can be defined by both depth and perspective. Forms have a top, bottom and sides. They occupy space and are capable of casting a shadow. Sculptures are forms. In quilt making, dimensional appliqué is made of forms. Much of mixed media art contains both shape and form. Garments are forms, as are vessels such as bowls.

Wire and Fabric Forms
by I. V. Anderson
varying in height from 4" to 9"
These whimsical little structures are forms made from decorative bent wire with hand-dyed cotton gauze in a fun and funky array of glorious color.

Vietnamese Orchid
by Nicole Yardley
18" x 21"
This exotic, silk wall quilt features one large, fully dimensional orchid. It is multi-dimensional which makes it look real. The orchid is a form rather than a shape.

Women of Color
by I.V. Anderson
8" tall
These dolls begin with a simple form, stitched from fabric and stuffed. Each one was then dressed with ink-dyed lace clothing. The first doll is wearing an analogous run of yellow orange, orange, red orange, red and red violet. The middle doll is a direct complement in tones of yellow green and red violet. The last doll is also analogous, wearing a gown of violet, blue violet, blue and blue green.

Texture

In art making there are two types of texture. One is real or tactile. This pertains to textures you can actually feel. The other is implied or visual. It has no tactile feel to it, instead it has a print on it which makes the surface look as though it is textured. Historically, painters have added various mediums to their paints or painting surface to add additional texture. This type of texture is tactile. They often add even more tactile texture in their brush strokes. Wood workers and stone carvers carve, engrave, burn and etch textures into the surface of their artwork achieving lifelike animal fur, cracks in rock, wrinkles on faces and more. Though many fabrics have tactile texture, most quilt artists use cotton fabrics made specifically for quilting. These fabrics have a polished surface with no tactile texture. So, as quilters and fiber artists we rely heavily on the visual texture that is derived by the motifs printed on the surface of the fabric.

In the beginning of the new modern quiltmaking era in late 1970 and early 1980, calicos were the only prints available. Small, little flowers and leaves, some plaids and maybe a polka dot or two were what we had to work with. Well, we have come a long way. Currently we have many design houses who employ lots of very talented artists who design several new lines of fabric every year just for quilt makers. There are flowers, big and small, spots, dots, stripes, geometrics, squiggles, checks, zig-zags,

Textural Contrast

The blocks shown have differing amounts of textural contrasts. Both blocks were made using only one color with some value contrast. The fabrics in the block on the left have the exact same motif or visual texture. The block on the right was made with three different fabrics, each with its own unique motif design and scale. As you can see, the greater the textural contrast, the better the spatial delineation. It is easier to see the star tips when the visual texture in them is not the same as the visual texture in the background area.

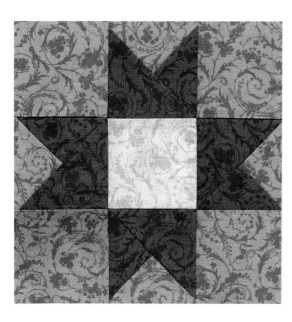 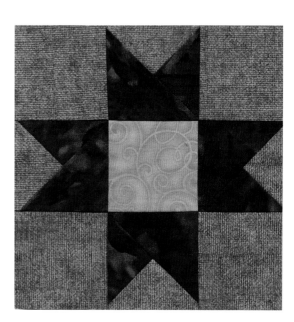

abstracts, Japanese designs, reproduction designs, solids, hand paints and batiks to name just a few. We have at our fingertips a huge variety of visual texture from which to create.

Importance of Texture

Texture provides interest and variety. It can add realism to landscape, portrait and animal quilts. It also helps to delineate space. Spatial delineation is needed in most quilt designs. Simply put, we need to see when the perimeter of one section ends and another begins. We achieve this through contrasts in color and value, as well as contrast of textures.

Understanding Pattern Scale and Design

Pattern scale and design help create unity, variety and balance in your designs. Today, artists have many different mediums from which to satisfy his or her palate. Each media has its own unique characteristics that make it useful and valuable to the individual artist. Whether it is fabric, paper, metal, wood or paint, texture and design play a role in the media itself.

Consider these things when working with printed or textured mediums: **Motif** is the design printed or woven on the fabric or paper such as flowers, swirls and circles. Even wood can have a motif with its regular or irregular

grain. Paint can be textured with brushes, fingers or other implements to give it regular or irregular texture and lines. Motifs can range in size from tiny to large with regular or irregular repeats. Designs can be close together or far apart. The scale of the motif will determine how you use the medium in your work.

Ground Color/Motif Color both play a vital role in how the medium will perform. Many fabrics and papers are printed with color families with which we are familiar—direct complements of red and green for Christmas, triadic nursery prints in pale blue, yellow and pink, analogous schemes of blue green, blue and blue violet. Wood grain is

Understanding Pattern Scale and Design

The fabrics below show lots of various visual textures. Take note of the scale of the designs printed on the surface. A variety of motif styles is important, as well as having a variety in scale or size.

Each square in a square block has a blue violet background and a yellow green center which provides good contrast and spatial delineation. However, the first block is not nearly as interesting as the second block and the second block is not as interesting as the third. The two fabrics in the first block have very similar visual textures and appear almost solid. The two fabrics in the center block have motifs that are different from each other in style and scale. The smaller scale is used in the center and depletes the vibrancy of the large scale print in the background. The block on the right features a background fabric with a bold black print, but it is much smaller than the circles printed on the yellow green center fabric. The circles are getting lots of attention because they are larger than the background print and are in the center of the block.

Texture-graphic

effected greatly by stains and translucent paints. Portions of the grain will cause a color to be lighter or darker in areas. A canvas can be painted with a thick, uneven layer of paint that is filled with high and low points. The high areas can then be rubbed with paint of a different color yielding a bas-relief. All of these elements will effect how each of these mediums could be used in any piece of artwork.

Repeats and Design Specifics relate to how far apart the identical motifs are on the fabric or paper. This space is the length of the design repeat. Is the design directional? Is it consistent or are the motifs spaced randomly across the surface of the medium? The answers to these questions will

determine how the media is used. Being familiar with the specific aspects of the medium's design will make using it in your designing process easier and more enjoyable. To understand how a medium will look cut up, view it through a 2" square cut out of a piece of heavy paper.

Pattern Style is apparant in each patterned fabric, paper or other medium. From floral to striped, dots to grids, formal Victorian to shabby chic each has its own particular style. Having a good mixture of differently styled motifs will add wonderful visual or tactile texture to your artwork. Find textural designs in various values of color to build a good, workable stash.

When making quilts or other forms of stitched art, fabric patterning and

design, as well as quilting give the appearance of a surface texture on your projects making them more visually appealing. Think of a simple nine patch made from black and white solids. Change the solid black to a black with dark gray stripes and the solid white to white with the palest hint of small gray flowers on it and the nine patch jumps to life. Go one step further and use several different printed blacks and whites and the block becomes even more interesting. The patterning on the fabric brings variety, the black and white color scheme allows for unity and the nine patch design provides balance. Everything that is necessary for a good design is present.

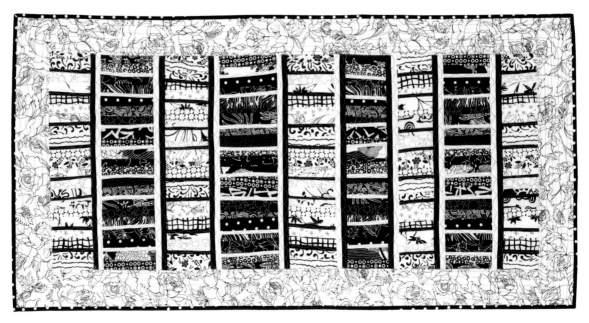

All the News That's Fit to Print

by Heather Thomas

24-1/4" x 47-3/4"

This quilt features more than 80 different fabrics. Some are mostly white with black print and some are mostly black with white print. The design and scale of the motifs range from geometric to floral, modern to vintage, very large to very small. It is the printed surface of the fabrics that gives this quilt its rambunctious personality.

Choose fabric with a tactile texture

The swatches show a nice selection of fabrics that have tactile texture. The designs are raised from the surface creating a three dimensionality that adds interest to the fabric. Some of the designs are stitched on, some are pressed in and others are woven in. All of them would be fabulous in a quilted project, garment, mixed media art or home décor project.

Expand your options

When shopping for fabrics, whether for your next quilt or your stash, step outside your comfort zone and purchase designs or motifs in styles and sizes you would not normally buy. One surefire way to make a quilt that really sings is to include at least 5 different motif styles along with five different sizes.

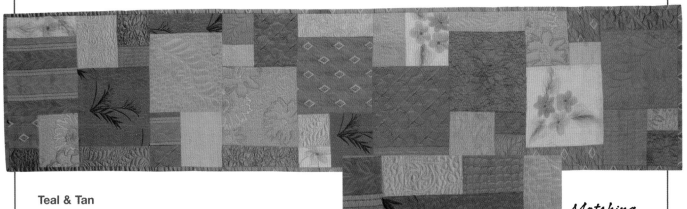

Teal & Tan

by Heather Thomas

13-3/4" x 60"

This beautiful table runner is made from a luscious mix of silks. Some of the fabrics are slick and smooth and others are nubby or painted or machine embroidered. In addition to the tactile texture that was already present, more texture and decorative interest was added with the quilting. Each area is quilted in a different manner.

Matching thread was used in each section to bring out depth in the design.

Using mixed media to add texture

More and more quilters, especially art quilters, are using mixed media techniques in their work. We are constantly borrowing techniques and products from other industries and mediums. Some art quilters have grown to realize they can add interest and variety to their art by adding tactile texture in addition to, or instead of, relying on printed visual texture alone.

Though we may be used to using quilters cottons, there is a bevy of other types of fabric available to us. When I first began wandering away from tradition I started using Dupioni silk in my artwork. I liked it because it had great tactile texture; lines and slubs could be felt on the surface due to the type of fibers used in the weave. It was often very shiny, too, which added to its textural feel.

Recently, Lutradur® has been added to the quilter's pantry. Lutradur® is a spun polyester fabric that is available in a few different weights, most often 70 gram (lighter) and 100 gram (heavier). This fabric can be painted with any acrylic or fabric paint and it can be melted with a heat gun or scored with a soldering tool. It is white in its original form and has a curvy, wispy visual texture that shows through when painted.

Quilters and mixed media artists often use stitch, beads, found objects and other embellishments to raise the surface of their work. What they are really doing is adding another physical layer to the work thus increasing the visual or tactile texture. Use one or more different surface designs and embellishment techniques to increase the surface texture and add more beauty, luster and interest to your overall piece.

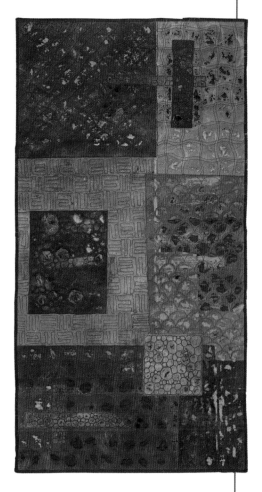

Burgundy Heat
by Heather Thomas
12" x 22-1/2"

I made this quilt using silk and Lutradur®, as well as some velvet. I painted the Lutradur® in seven different colors. It was layered on top of silk and machine quilted. Portions of the Lutradur® were melted away with a heat gun which created all this glorious tactile texture.

Learning Activity

When I first started my color journey, I took an inventory of my fabric stash and learned very quickly that I limited myself to toned and shaded colors. But what really surprised me was that by the looks of it, I also limited myself to small –medium sized prints with very few geometrics and no stripes. Look through your fabric stash, or fiber stash or paper stash or all of your mediums and determine what styles, types and sizes of motifs or textures you currently have on hand. Determine what you lack and make a list of those items and keep it handy for the next time you hit the art/craft/fabric store.

Texture Library

The fabric samples below illustrate visual texture. Note the pattern scale and design differences within each swatch.

Color

Remembering that color is the response of the eye to differing wavelengths within the visible spectrum or what humans perceive as light, the main components used to describe color are hue, value and intensity.

- **Hue** is the color in its pure form. We use names such as red, violet and green to describe hue.
- **Value** is the lightness or darkness of a color. Using the word "light" tells us how close to white the color is. Using the work "dark" tells us how close to black the color is. In some countries and some mediums, value is also described when using the word tone. This can become confusing as it is used indiscriminately to describe all portions of the color scale rather than only color with gray added.
- **Intensity** is related to saturation. The word intensity describes the brightness or fullness of a color. Pure hues are very intense, shades and tints are less so and tones are the least intense.

Quick Key
Hue- full color
Shade- add black
Tone- add gray
Tint- add white

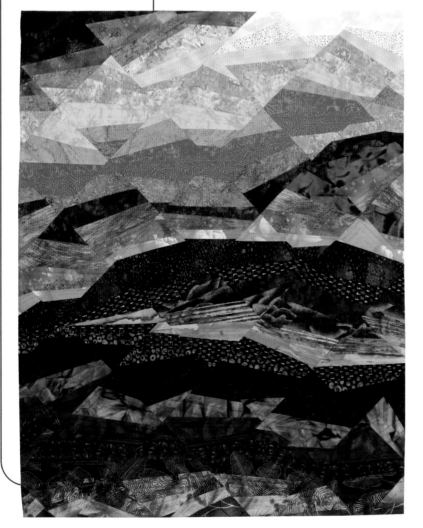

Mountain Landscape

by Nancy Mangen

28-1/2" x 36-1/2"

This awe-inspiring landscape is all about hue, value and intensity. Nancy carefully balanced these three aspects of color as she portrayed the dull land formations in the lower portions topped by a somewhat quiet, less dull, mixed value blue section of sky. All of this is crowned by the glorious, intensely colored portion filled with various values of red and red violet. This abstract quilted landscape has a wonderful painterly quality.

Value

The word value is used to describe the lightness or darkness of a color. Value is entirely relative and a color's value cannot be determined unless there is another color to compare it against. Each color in its pure form, or hue, has its own inherent value, that is, a value compared against all of the other colors on the color wheel in their pure forms.

We know yellow has the lightest value and it is the closest color to white. Violet has the darkest value and is the closest color to black. However, intensity, saturation and color scale can affect value. A dark shade of yellow will have a darker value than a pale tint of violet. We can use value terms to describe intensity and color scale. A pure hue of red appears bright with a medium dark value when compared with a pure hued yellow. However, that same pure red compared with a shade of itself could still be called bright, but its value would be medium or medium light. The red shade would be described as less bright or intense with a medium dark to dark value.

At its core, value is as important as color. It is the most effective tool to use to create depth and support spatial delineation. Value is an aspect of a color's personality and its use can drastically change a composition. Light pure values will advance or come forward, dark dull values will recede or sit in the background. Value affects mood, too. Pure, bright colors will excite while darker colors can lend a sense of mystery. Dull, drab mid tones can make the viewer sad or depressed.

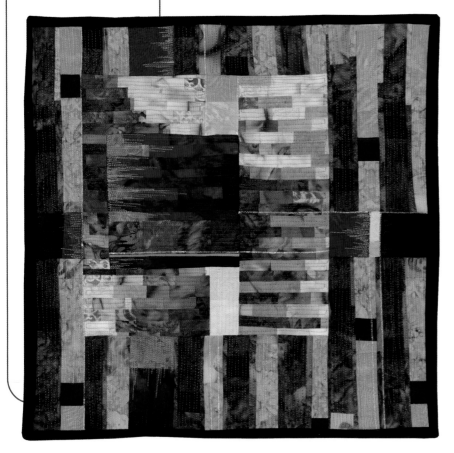

Into the Blue

by Tamara Leberer

18" x 18"

This quilt is visually stimulating. It is pieced from two colors, blue and yellow green. Tamara let value and intensity do the bulk of the work as she paired the two with simple piecing and linear quilting. The mixture of the bright and light blue squares and rectangles plays off well against the linear strips of pure hued and shaded yellow green. All of this value play provides the piece with a sense of depth and the color/value placement is well-balanced.

Size and Scale

Size and scale are words used to describe the physical size that a shape or form has in comparison to other shapes or lines within the design field. Varying the scale of design elements within the design field will yield a pleasing result. It is more difficult to create when keeping the size of the design elements constant as it will affect the rhythm and harmony, often making a work feel stagnant or uninspired.

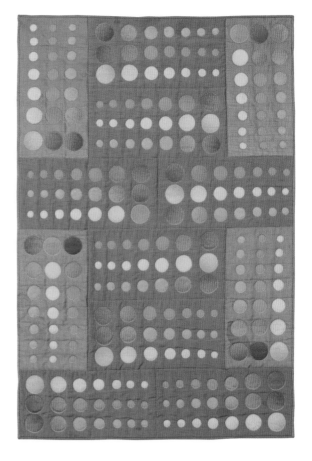

Sizzling Circles
by Ruth Chandler
27" x 41"

This bold and colorful quilt uses only a circle, over and over again. What makes it interesting is the circles gradate in size, in fact there are seven different sizes ranging from dime size to golf ball size. Ruth set the circles identically in 12 rectangles then changed up the pattern by positioning the rectangles in different directions.

Leaves
by Tamara Leberer
18" x 53"

This quilt is filled with luscious color and portions of four giant leaves. The leaves are much larger than life and the artist has cleverly shown us only the lower portions of them. This use of unrealistic scale provides the leaves with a sense of importance. The dimensional use of the bands of intense red that form the leaves add to their eminence. All in all the design and coloration is very effective.

Pattern

When most quilters see the word pattern they think of a plastic baggy with instructions for a quilt inside. When used as an element of design, pattern describes the design or designs formed by the repeat of shape, line or form within the design field. When a shape is repeated three or more times a pattern is formed. The shape does not have to be the same size or scale but it does need to have a consistent feel. Each of the rectangles in Ruth's quilt, Sizzling Circles on page 98, contains the same repeated pattern. Circles in rows starting with the largest and gradating toward the smallest. It is this consistency that helps the quilt feel unified and moves the eye of the viewer from one area to another.

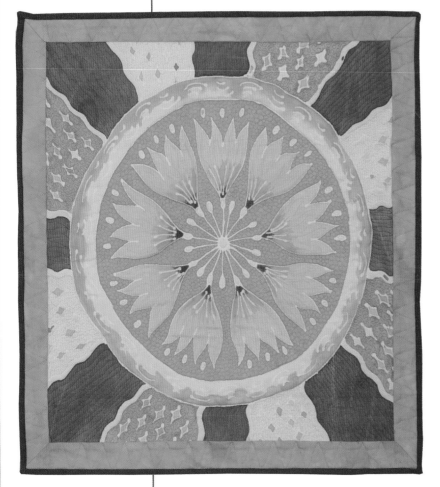

Radiant Batik

by Elana Gunberg

17-3/4" x 19-3/4"

This beautiful, hand-painted batik makes use of several pattern repeats. In the middle portion, there are nine large flowers that are all the same size, shape and color, making the first repeat in shape. There are three white teardrops above each flower adding another repeat. Then, the outer portion of the quilt is divided into 16 sections and a pattern is formed with the colorization as well as in the design details. A solid bold red violet separates the other sections that have diamonds and are colored using an alternating palette of orange and yellow creating yet another pattern.

The Principles of Design

The principles of design put the elements of design into action. As with the elements, the list of design principles can change depending upon who makes the list. Having a working knowledge of the different design elements will help you to understand design principles better. Art cannot exist without the principle of contrast. Creating with unity and variety in mind will help you make artwork that is both easy to live with and has lasting interest. Achieving balance in a composition is essential if you want to create something the average viewer wants to spend time with. The principles of design provide us with a guide that can lead us to making quilts and artwork filled with stunning beauty, visual interest and a common language for story telling.

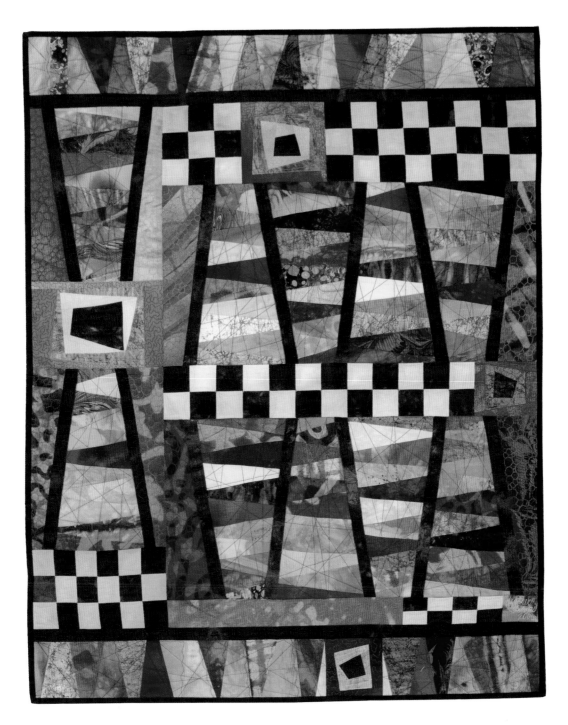

Structures

by Heather Thomas

28" x 36"

With its bold use of shape and line softened somewhat by a shaded and
toned polychromatic color scheme, this quilt has a dynamic design that is
based on traditional patchwork.

Contrast

Contrast is the basis of most art. It is the juxtaposition of differing elements and principles which can provide tension or visual interest. Weak contrasts will yield a piece with little interest or physical strength. Too much contrast can destroy unity and overwhelm the viewer making a piece difficult to live with. Unless you are looking to create a sense of chaos or absence, you must learn to manage the contrasts present in your artwork so as not to overwhelm or bore the viewer.

Each art form has its own type of contrast. A good book or movie often features the contrast of good and evil. A delicious recipe can feature the contrasts of sweet and salty and a woven shawl can have the contrast of smooth and nubby fibers.

Art is at its best when the contrasts included provide managed, well-balanced interest in such a way so as not to fatigue the participants. Both the maker and the viewers of art participate in its being. Learning to manage the various types of contrasts used in your medium requires a familiarity with those contrasts. The unfortunate risk with learning to manage contrast is one can become overly controlling. Too much control in a composition can result in a trite, predictable, redundant piece of work. Learning good management skills without becoming controlling can be difficult but it can be achieved through practice.

In quiltmaking and other fiber arts, the most common contrasts are centered around the interaction of color. Gaining a basic understanding of color traits and characteristics is the perfect lead into learning to manage color, rather than controlling color contrasts.

Types of Color Contrast

- **Contrast of Hue** is the use of pure, intense and undiluted colors.

- **Light and Dark Contrast** is using the values of light and dark such as black and white, with gray being the middle ground.

- **Cold/Warm Contrast** is the color combination of a cold color and a warm color. Red orange versus blue green is the strongest cold/warm contrast.

- **Complementary Contrast** are pairs of colors that lie opposite each other on the color wheel and have a diametric contrast to each other.

- **Simultaneous Contrast** is perceived by the viewer rather than being objectively present.

- **Contrast of Saturation** is the contrast between pure, intense colors and dull, diluted colors.

- **Contrast of Extension** is the contrast between space and size using two colors.

Contrast of Hue

Contrast of hue is possibly the easiest contrast to attain. Simply use pure, intense, undiluted colors. This contrast is greatest when using the primary color combination of red, yellow and blue. It becomes less intense when using secondary or tertiary colors in combination with each other. The addition of black or white placed between or around the colors adds to the separation of the individual colors and intensifies the contrast.

Bold & Beautiful

by Cynthia Jarest

33-3/4" x 42-1/2"

This wonderful, bright quilt uses all the colors of the color wheel in pure hues, slight shades and slight tones. Each color interacts with the colors it is grouped with in different ways. Some blocks show great contrasts between hue, while in other blocks the contrasts are more subtle. The quilt shows how fun it can be to work in pure hues, letting the color, rather than value or texture, provide the necessary contrasts.

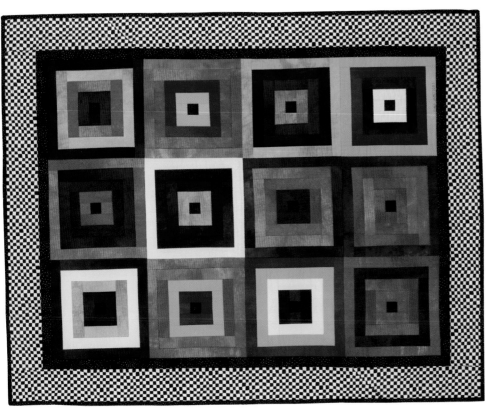

Design Properties

Balance Type
symmetrical

Grid Structure
basic grid with narrow border as frame

Color
bold, pure hues with simultaneously contrasting border fabric

Design Elements
geometric

Variety
color

Rhythm
pulsing

The colors pulse in a pleasing way providing a rhythmic visual appeal.

Contrast

Light/Dark Contrast

The boldest contrast obtainable using light and dark is that of black and white, with gray being the middle ground. Neutral gray is achromatic, or without color. When placed next to a color, gray will behave like that color's complement, absorbing its reactive color. Understanding that gray lies between black and white gives us an idea of what lies between light and dark. When we think about the value gradation of any given color, we can imagine it in its darkest form as having black added and in its lightest form as having white added. However, when we add gray to it, we can vary the amount of gray and have a limitless number of tones.

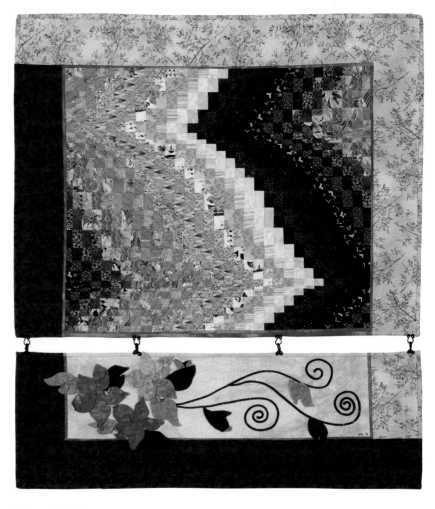

Three Red Flowers

by Heather Thomas

29-1/2" x 33-1/4"

This quilt utilizes the contrast of light and dark. It is a Bargello styled design, with the undulation of the Bargello set on its side. The area of greatest contrast, where the white meets the black, is set in approximately two-thirds from the left side of the quilt, providing a good balance to the piece. The offset borders of light gray and gray black, increase the light/dark contrast. The touches of red in the border along with the red flowers provide additional contrast.

Design Properties

Balance Type
asymmetrical

Grid Structure
divided into thirds vertically and horizontally

Color
neutrals of black and gray with red accents

Design Elements
linear diagonal movement with abstract dimensional flowers

Direction
undulation of the Bargello section; curls of the vine

Black and white represent the boldest light/dark contrast.

Cold/Warm Contrast

The color combination of red orange versus blue green is the strongest cold/warm contrast. Red orange is the warmest color and blue green is the coldest. These colors in their pure hues have a constant temperature. However, when gray is added the color's temperature can be neutralized causing it to vary or decrease. The contrast of temperature is very effective when trying to depict depth, the concept of near and far or three dimensionality. Adding white to the cool blue green color will make it cooler while adding black to the warm red orange color will make it warmer.

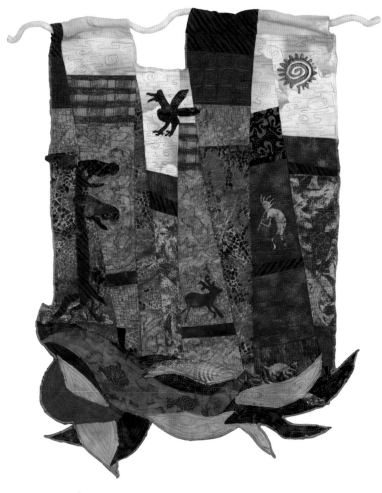

Design Properties

Balance Type
asymmetrical

Grid Structure
divided into thirds
vertically and
horizontally

Color
direct complements
of blue green and
red orange

Design Elements
abstract, figurative with
both line and shape

Direction
bird flying toward tree;
water flowing in the
opposite direction

Message from Sedona

by Susan Westervelt

18" x 26"

This lively little landscape is a great example of using the temperature contrast of warm and cold. Note how the contrast is heightened where the pale blue green sky meets the dark red orange rocks. The artist used duller forms of red orange in the rock formations and purer hues of blue green in the water so the water looks as though it is in front of the rocks.

Red orange versus blue green represents the strongest warm/cold contrast.

Contrast

Complementary Contrast

Complementary contrasts give a sense of equilibrium to the eye of the viewer. The pairs of colors that lie opposite each other on the color wheel have a diametric contrast to each other. They complete one another, but can also cancel each other out. In all six of the possible complementary pairings the three primary colors are always present, either in their pure form or blended with other colors. Just as the mixture of the three primaries is brownish gray, so will be the mixture of any two complements. Complementary contrasts are pleasing to work with and offer the artist the opportunity to hone his or her skills in creating balance.

Design Properties

Balance Type
 linear asymmetry; each unit is balanced individually with gradated background

Grid Structure
 cross formation; light on top, heavy on bottom

Color
 direct complements of yellow orange and blue violet

Design Elements
 abstract sunset with line, value and color contrasts

Direction
 undulating curvy lines

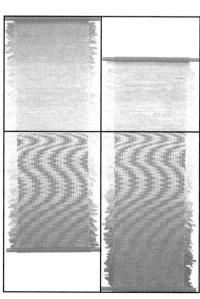

Sunrise

by Janice Ford

20" x 51"

Janice wove this diptych from rolled strips of cotton fabric in the direct complement of blue violet and yellow orange. She used a brown, which is a dark yellow orange, as her warp. This brown warp directly influences how we see the other two colors. As the brown interacts with the yellow oranges and blue violets it tones them down. Notice how gray is formed when the two colors come together. This piece is a nearly perfect example of the contrast of complements.

Simultaneous Contrast

Simultaneous contrast is perceived by the viewer rather than being objectively present. If you stare at a square of color placed on a white ground then look away to a white ground you will see or perceive the direct complement of that color. The eye wants to complete the effect of the color and provides the brain with its afterimage or complement. When a pair of direct complements are used together in their pure hues, exclusive of any other part of the color scale, the line where the colors meet will look as though it is moving. This happens because the colors are contrasting off each other at the same time. Our eye has a hard time discerning where one intensity begins and the other ends, thus causing the sense of movement or 'sizzle'. When colors that are not direct complements are paired together with gray, the colors will seem to generate toward their own complement, thus disturbing their stability. The effects of this type of contrast can help us determine how pure hue pairings will behave.

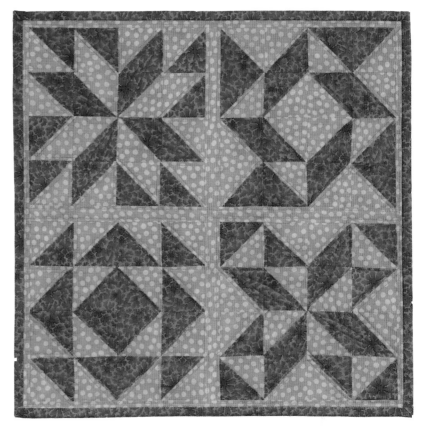

Tropics

by Jerri Bryson

18" x 18"

It is nearly impossible to photograph the presence of simultaneous contrast, but this little quilt is in such constant contrasting motion that the effect can be caught on camera. Jerri used red orange and blue green in near pure hues and nearly equal amounts with no other colors or fabrics included. Notice how the longer you look at the quilt, the harder it is for the pinwheels to stay still. They begin to pulse and give one the sensation of double vision. This is full-tilt simultaneous contrast and is probably more than you would want to look at on a day-to-day basis.

Design Properties

Balance Type
symmetrical

Grid Structure
four patch grid

Color
pure-hued direct complements of red orange and blue green

Design Elements
geometric shapes, implied line

Repetition
shape, color and value

The pinwheels in this piece begin to spin when looked at for a prolonged period of time.

Contrast

Contrast of Saturation

The word saturation refers to a color's degree of purity. Contrast of saturation refers to the contrast between pure, intense colors and dull, diluted colors. Saturation can be diluted in four basic ways - the addition of white, black, gray or a color's complement. These additions can not only change the purity of the color but can also change its inherent temperature, brilliance, behavior, and emotional response. White makes yellow less warm. Violet becomes meek with the addition of white, but add black and it becomes a dramatic night sky. Adding gray to any color always makes it dull and neutralizes its vitality. How dull or neutralized depends on how much gray is added. Mixing small amounts of a color with its complement moves that color toward browned gray.

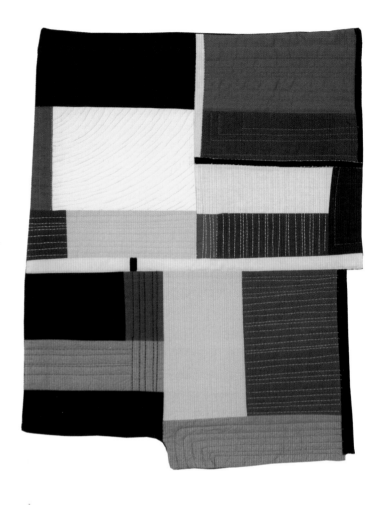

Triadic Forms

by Jan Lapetino

19" x 23-1/2"

This quilt features the triadic coloration of red, yellow and blue with the addition of gray. Jan included red in its highly saturated pure hue along with a mid-toned, less saturated variety, as well as a low intensity, pale version. She used a dark shade of blue, a small bit of pure-hued blue with a high saturation and some tonal blues. The only yellow is pale with a low saturation level. The neutral grays soften the entire palette and heighten the saturation contrast.

Small amounts of gray heighten the saturation contrast.

Design Properties

Balance Type
asymmetrical

Grid Structure
divided near center vertically and horizontally

Color
red, yellow and blue; mix of dull tones with bold, pure hues

Design Elements
geometric shapes, value contrasts

Direction
curved quilting lines in the yellow make it feel like a round sun rather than a rectangle

Contrast of Extension

Contrast of extension is the contrast between space and size using two colors, one light and pure and the other dark or dull. The force of pure color is determined by its brilliance, or light value, and its extent, how much space it occupies compared to space occupied by other colors. Brilliance can be determined by placing the colors on a medium gray ground and comparing them. In the diagram we can see how yellow, the brightest color, extends. Each large square is the same size and each small square is the same size. Note how the yellow square in the center of the black looks as though it is larger than the black square in the middle of the yellow. This is a result of the contrast of extension.

The lighter colors look larger as they advance off the background.

Balance

Types of Balance

- **Visual Weight**
- **Horizontal and Vertical Balance**
- **Formal or Symmetrical Balance**
- **Informal or Asymmetrical Balance**
- **Radial Balance**
- **Crystallographic Balance**

Humans have an almost constant need and desire to find balance in their lives. With each new piece of art we must decide how we will balance the design. Are we to make something uniform and traditional or something informal and "funky"? Balance is the sense that all the elements within the design field are where they should be and are the correct size and import. For a work to appear balanced one must manage all the elements and principles of design being used. Common terms used to describe the types and forms of balance include but are not limited to the following:

Some examples of working with balance

Visual Weight
When using visual weight to balance a composition, place the motif with the heavier weight in the lower half of the design. There, it will grab the eye of the viewer and hold their interest. Place a smaller, less heavy item in the opposite diagonal corner to complete the balance.

Horizontal and Vertical Balance
How is the visual weight distributed? Is it evenly disbursed from top to bottom or side to side in the artwork?

Formal or Symmetrical Balance
This type of balance contains repeats in shape, color, value and intensity on both halves of the artwork. If you were to fold the artwork in half, top to bottom or side to side, the design elements and colors would match up. This type of balance is often found in traditional quilts such as an Irish Chain, Storm at Sea and Snow Ball. It is also found in op art paintings.

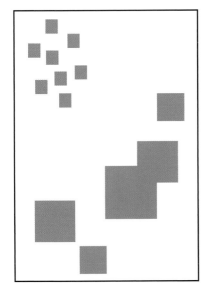

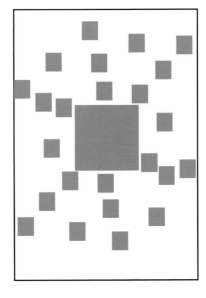

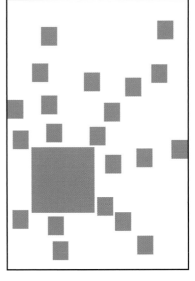

Informal or Asymmetrical Balance

This balance uses unequal visual weight along with varied design motifs dispersed in controlled, yet seemingly random areas across the surface of a design. Balance is achieved through unity of color and a carefully planned selection of value and intensity. Many artists rely on this type of format to make art that is intriguing and holds the viewer's interest.

Radial Balance

This balance is created with a design that radiates from a central point on the artwork. For a more formal design, begin in the middle and work out equally on all sides, such as for medallion-style artwork. For a more informal design, begin off center and cover the entire surface in a radiating fashion.

Crystallographic Balance

This balance is an-all over design with no clear focal point. Shapes, colors, values and intensities are equally dispersed across the entire quilt. Often there is no definitive positive or negative space. Think of abstract paintings or Charm quilts made from only one shape and lots of scraps.

Balance

Structures

by Diana Vander Does

20" x 25"

This is a very unique art quilt due to the way its visual weight has been distributed. It is a split complement using blue violet with yellow orange and yellow green. It is shown hanging in four different directions and actually looks good in all of them, which is very rare. It is asymmetrical in its balance and design. To understand why it manages to hang in any direction we need to look at the elements present and the principles used in its design. The background is a dull yellow green in the center which is flanked on the two long sides with an intense blue violet The dull center provides the perfect negative space for the eye to rest. The sweeping, intense blue violet, pointy wave is set in opposition to the other linear elements and it is the purest hue. This element acts as an equalizer. As it threads its way through the other elements it balances them with its physical weight.

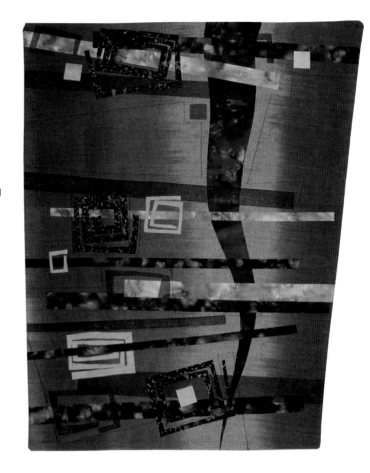

Design Properties

Balance Type
asymmetrical

Grid Structure
divided into thirds
vertically and
horizontally

Color
split complement
blue violet, yellow
orange and yellow
green

Design Elements
geometric, abstract
and non-objective
shapes, line and value

Direction
differential - depends
on the direction it
hangs

The physical weight of the pure-hued wave balances the other elements in the piece as it threads its way through them.

Evaluating balance from all the angles

When the quilt is hanging vertically as in **A** and **D**, the dark blue violet and yellow green strips provide much more depth than when the same strips are running vertically as in photos **B** and **C**. In the vertical position, the quilt is more energetic than it is in the horizontal position where it has aspects of a landscape and therefore a much calmer feel. The mix of geometric, abstract and non-objective shapes provide a lot of variety and help make the quilt very interesting. The three color split complement provides unity and repetition.

A

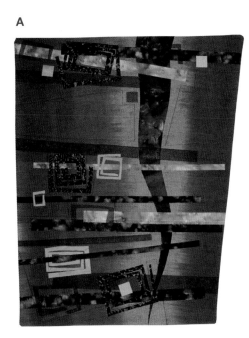

B

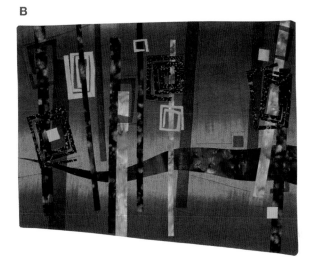

D

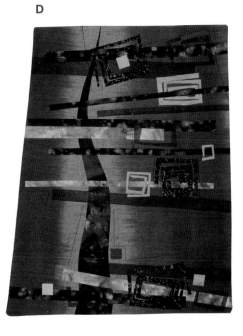

C

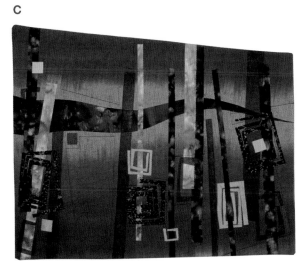

Balance

Green Finch on a Plum Blossom

by Ruth Chandler

11" x 32"

This quilt features a simple design without a lot of excess. Ruth's finch has a vertical setting or balance. The gradated background adds lots of interest and sets the mood. The stems of the plum tree occupy the top left and lower right axis of thirds and divide the design field into vertical thirds. Ruth stuck with tones and light shades to keep the quilt calm and somewhat serene. The direction the bird is facing gives the quilt a sense of movement and direction.

Design Properties

Balance Type
asymmetrical

Grid Structure
divided into thirds vertically and horizontally; background divided horizontally into three unequal portions

Color
foreground -soft tones

Design Elements
figurative, shapes, line and value play

Direction
diagonal elements on a vertical ground with strong horizontal line

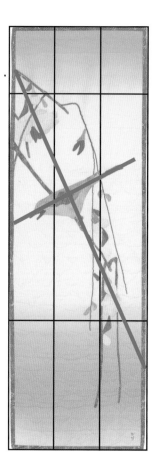

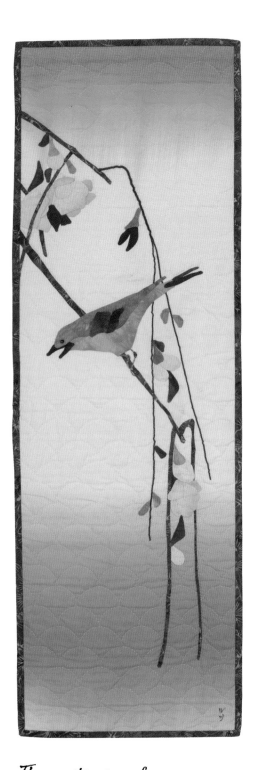

The positioning of the bird gives the piece movement and direction.

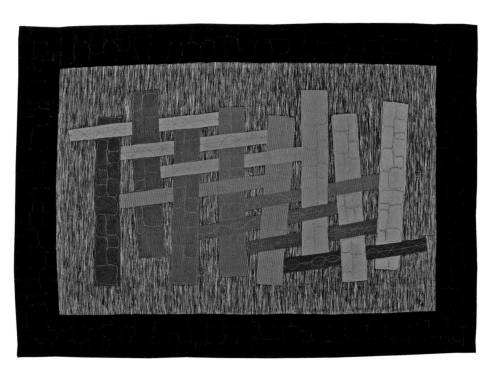

Design Properties

Balance Type
horizontal with a
crystallographic feel

Grid Structure
none evident

Color
analogous

Design Elements
geometric lines
and shapes

Movement
leaning bars and
weaving lines give a
sense of wobbling

Stonehenge?

by Cass Mullane

25" x 17-1/2"

Cass's colorful stones are a simple design set in a row across the horizontal width to provide a nice horizontal balance. The larger stones are standing vertically. The link made by the horizontal bars weaving in between the vertical ones is what gives the quilt its balance. The "less is more" philosophy is evident in the analogous colorway. The crooked placement of the vertical stones makes the design look somewhat fragile, as though the rocks could topple over at any moment.

The horizontal bars weaving between the vertical ones add a sense of depth.

115

Balance

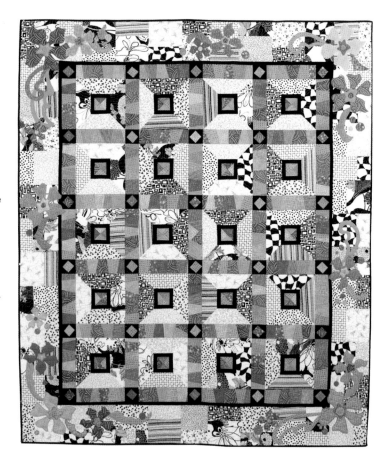

Gala Garden

by Heather Thomas

68" x 78"

This quilt features a symmetrically balanced pieced center surrounded by an appliquéd border. The flowers in the border are randomly or asymmetrically placed. The center is a basic grid. If you fold it in half top to bottom or side to side, the blocks, sashing and corner stones would all match up. It is informal, however, because the colors would not match up. It is the large mix of black and white prints and slightly tinted hues that adds variety to the grid. It is a repeat of those same colors and the same block that give the quilt a unified appearance. The appliquéd floral border repeats the center coloration but also provides added interest as it loosely breaks away from the center's grid.

Design Properties

Balance Type
symmetrical center
with an informal border

Grid Structure
symmetrical grid

Color
Black, white
and polychromatic

Design Elements
geometric, stylized
floral elements

Contrast
pure hue and texture

A repeat of the same block and colors give this quilt a unified, balanced appearance.

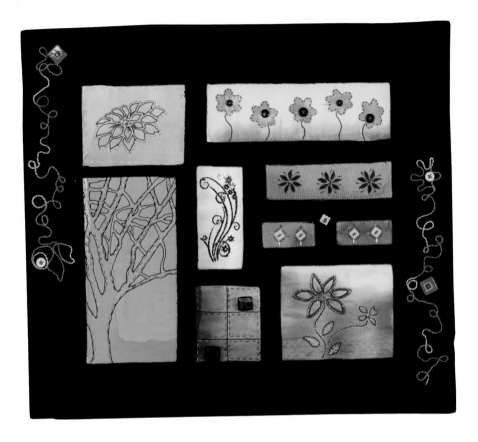

Windows of Light

by Sharon Triolo-Molony

22-1/2 x 20-1/2

This delightful quilt features a very successful asymmetrical
balance. The yellow green and yellow/yellow orange blocks
across the top and left hand side form a large "L". The scale and
color of this "L" is balanced by the remaining blocks, each of
which contains heavy design elements and together form a large
square. The stitching and embellishments along the left hand
side support the weight of the bright, yellow based "L" while the
stitching and embellishments along the right hand side do the
same for the square.

Balance

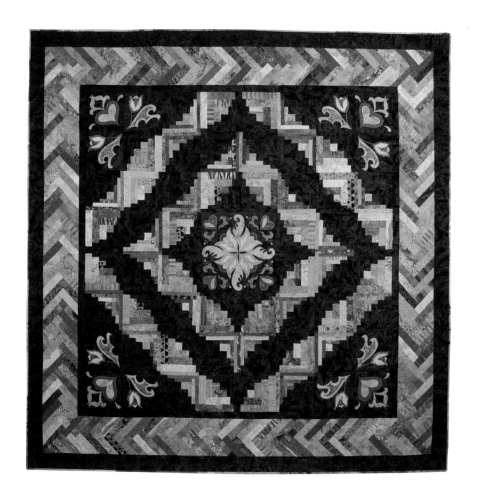

Some Enchanted Evening

by Heather Thomas

88" x 88"

This queen-sized quilt features radial balance. The design begins in the middle with the appliquéd block and radiates out diagonally toward each of the four appliquéd corners. The bold colors in pure hues, shades and tints seem to dance on top of the mottled black background and provide a great rhythm as waves of color undulate. The braided border encircles the center with a clockwise motion. The batiks along with the black background provide great variety with built in unity. The repeat of appliqué motifs and styling adds even more unity.

The design begins in the center and radiates out toward the four corners.

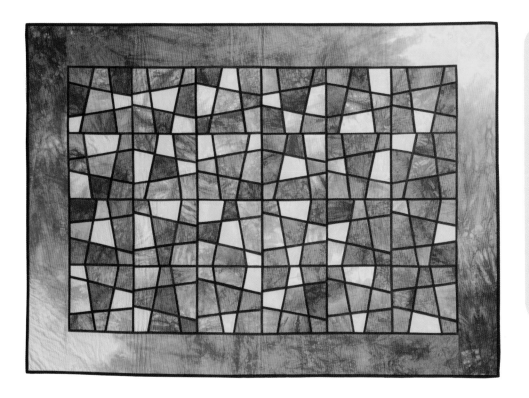

Design Properties

Balance Type
symmetrical,
crystallographic

Grid Structure
basic grid defined by
narrow black strips

Color
warm, bright colors
with black contrasts

Design Elements
geometric, irregular

Unity
color and
geometric shape

Variety
black outline

Crazy Panes

by Heather Thomas

38-1/4" x 52-1/2"

This quilt utilizes crystallographic balance within a
grid base. The colors and shapes are thrown about
the surface somewhat equally and there is no focal
point. No area carries more visual weight than
another. At first glance one might think the balance is
symmetrical, but upon closer examination it is easy
to see that although the blocks are the same, they
are turned every which way. No repeated pattern is
formed by the color placement and when folded in
halves, the piecing lines within the blocks do not
line up.

*This piece has no focal point
and each section carries equal
visual weight.*

Unity

Unity is the quality in a design that pulls it all together, making all the parts look as though they belong. Unity is achieved by balancing the shapes, colors, values and patterns used in a design. Most designs are made from positive and negative space. The positive positions pull forward and jump off the surface of the design and the negative positions recede forming a background from which the positive positions shine. To create true unity in a piece, the positive and negative spaces must look like they belong together, united as one piece to please the eye.

Four Ways of Achieving Unity

- **Arrangement** achieves unity when placing differing shapes near each other to link them, creating a relationship. A mental or perceived line can be formed to move the eye from one place to another.

- **Repetition** links the visual elements of a design, creating a special rhythm by repeating shape, color, value or intensity.
 - **Visual Rhythm** asks the viewer to scan the entire surface of the artwork. The design is often symmetrically balanced with a variety of unified shapes and colors.
 - **Static Rhythm** has little variety in shape and color and repeats itself over and over. It can be difficult on the eyes and is hard to manage in a design.
 - **Alternating Rhythm** uses design elements that move back and forth, rock, roll or undulate.

- **Linked Designs** rely on linking together the elements to achieve unity. This is done by using shapes that when joined with other shapes of the same or different size or color link mentally or physically to form a secondary design.

- **Color** is a great way to add unity. Whether working with just two colors or a dozen, repeat the color scale in the color selections you are working with. If you use the shade of one color, then use the shades of several others. If you use the tones of one color, add tones of the others and so on.

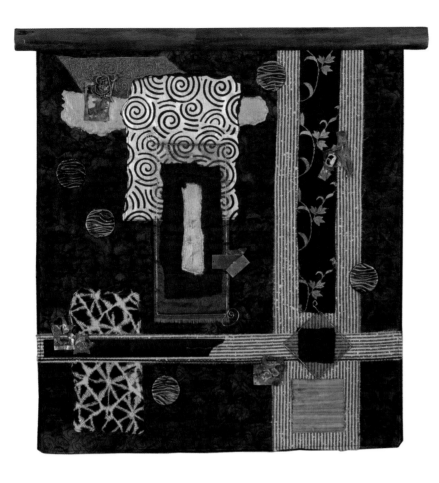

Design Properties

Balance Type
asymmetrical

Grid Structure
divided into thirds
vertically and
horizontally

Color
golds and neutrals

Design Elements
geometric, abstract

Variety
visual textures,
varied materials,
shape and line

Tribe

by Heather Thomas

20-1/2" x 23"

This piece is filled with many different elements including fabric, paper, metal, wire, leather and clay. It has asymmetrical balance utilizing an "L" shape on the bottom and right hand side which crosses the axis of thirds. This "L" is balanced by the large grouping of shapes on the upper left side.

The unifying elements are a repeat in color. All of the elements are black, gold, bronze and brown. Everything has an Asian feel to it and most of the design elements are overlapping or touching to create a physical link.

The background is heavily quilted so the design elements seem to float on the surface.

Variety

Variety is the opposite of unity but works hand in hand with it. Variety gives a work spark and interest and can provide a focal point. Without variety, a balanced and unified piece of artwork is at risk of becoming boring, uninteresting or static. Variety keeps the viewer interested. Balance, unity and variety are all needed for a successful design.

Variety can take even the simplest, uniform design and make it glow. Simply changing the color in a few places can spice up a design, as can slightly changing a shape, making a strip wider or narrower or adding a curve when nothing but straight lines are present. Add elements that are different but similar to give the sense of variety without destroying unity. These additions should be used as accents so as not to overwhelm the viewer.

Learning Activity

Choose two or three quilts or art projects you have made in the past and note what types of contrast you used when making them. Then, determine whether or not they are balanced. If they are balanced, what type of balance is utilized? Finally, determine how you achieved unity and variety. If any of the pieces lack balance, unity or variety, note what you could have done differently to improve their overall appearance.

Ways To Achieve Variety

- **Change the direction of the lines in a design.** Add vertical slashes to horizontal stripes. Make sure that any new lines look like they belong and were not just thrown in to confuse the viewer.

- **Vary the size of similar elements.** Add a few 9" and 6" block design elements with a mass of 12" blocks. Keep in mind how size will effect depth. The closer something is to the top of your design, the farther away it will seem. The closer something is to the bottom of the design, the closer it will seem. For this reason, place larger design elements on the bottom half of your design and smaller elements on the upper half.

- **Change the color.** Put three yellow flowers in a field of violet. Add black and white to a multi-colored field.

- **Change the color value or intensity.** Instead of one medium blue tone repeated over and over, use various blues in light, dark and medium values, as well as dull and intense tones.

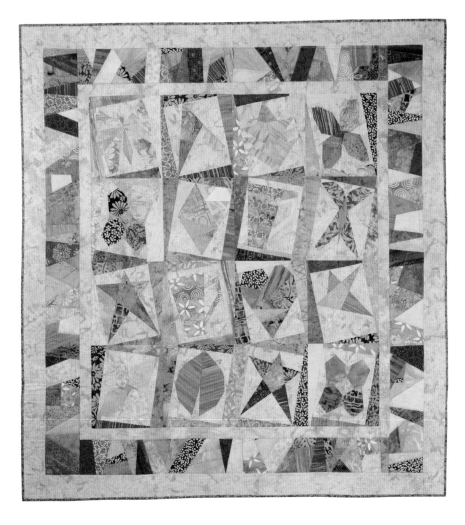

The uniqueness of each block and the polychromatic color scheme add variety while the candy-colored batiks and soft gray background provide unity.

Serendipity

by Heather Thomas

53-1/2" x 59"

This large, throw size quilt was made using 16 different paper pieced blocks that are tilted and surrounded with a crazy pieced border. The gray background and candy-colored fabrics, as well as the fact all the fabrics are batiks, brings unity to the piece. The blocks (no two are the same) as well as the polychromatic color scheme adds great variety. The tilting adds movement and rhythm to the piece. The gray background wasn't quite light enough compared to some of the light fabrics, making some of the shapes in the blocks difficult to see.

Repetition

Design Properties

Balance Type
asymmetrical
crystallographic

Grid Structure
none is evident

Color
bold, pure hues
and shades

Design Elements
geometric shape
with line

Rhythm
musical quality due to
the repeat of bars

We use the word repetition to describe the practice of using design elements over and over again. Repetition is much like pattern, only less obvious. Repetition, rhythm and pattern are all linked. Repetition with variation can be very interesting whereas repetition without variation can become monotonous and stagnant.

Red Structures
by Tamara Leberer
20" x 30-1/2"

Tamara relied on repetition as her main design principle in this intoxicating quilt. The entire piece uses two simple piecing techniques, squares and stripes of varying widths. There is also a repetition of color. Note how the red areas are made almost entirely from three fabrics, one bright red, one mottled red/red violet and one nearly pure-hued red violet. She also repeatedly used a dark multi-colored batik and then threw in an intense, bright blue as an attention getter. Through the use of repeat of line, shape and color, she created a very bold composition.

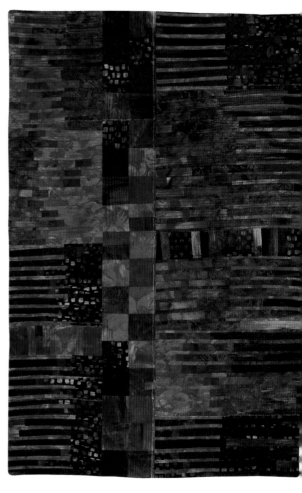

Dominance and Emphasis

Both dominance and emphasis give interest to one entity or area over others present in a design field, however a focal point is not always formed. Giving dominance to, or emphasizing one design element or area will counteract confusion or the risk of monotony. Dominance or emphasis can be achieved through the use of color, value, intensity, size and scale as well as other design elements. Emphasizing one element or letting one area dominate others sends an invitation to the viewer to come in and take a closer, longer look at the work.

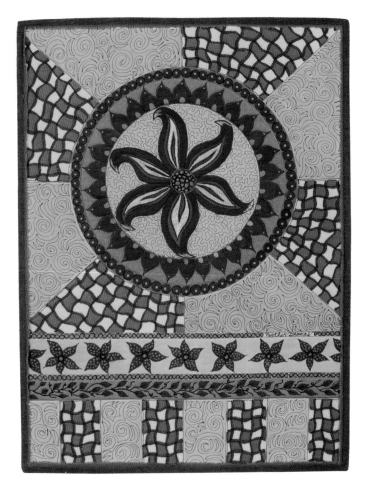

The center flower design dominates due to scale, color and positioning.

A Few Simple Lines

by Heather Thomas

16" x 21-1/2"

The flower in the center is just one of many design elements but it dominates because of its sheer size, centralized position and its surround of clear, bright blue green. The checkerboard sections and bright yellow green sections command attention thus diminishing the flower as a focal point. The flower is still emphasized over the other elements due to scale, color and positioning. Unity is provided by a repeat in design elements and a very limited color palette. The piece is rather small but contains a nice array of design elements and the background stitching adds even more interest. Though the piece is nicely balanced it defies a category.

Design Properties

Balance Type
radial with
vertical aspects

Grid Structure
mix of styles; circular,
horizontal and vertical

Color
direct complements
of red violet and yellow
green with accents
of turquoise and
yellow orange

Design Elements
geometric, stylized floral
elements

Direction
top portion spins like
a pinwheel with the
quilting enhancing
the effect

Design Properties

Balance Type
linear symmetry

Grid Structure
divided at center vertically and horizontally

Color
shades and shaded tints

Design Elements
geometric, stylized floral elements, bold line

Rhythm
floral vine moves directionally around the center

Harmony

Harmonious compositions contain a wise use of balance, unity and variety. Harmonious works include design elements that look as though they belong together. There are no incongruent elements playing within the design field. Though creating a harmonious work is not always desired, knowing how to achieve harmony is vital. Harmony is achieved when variety is balanced with unity within a composition. Movement, direction, repetition and emphasis must be well managed to achieve an harmonious composition.

Fleur

by Heather Thomas

57-3/4" x 14"

Through the use of pattern repeat, a color scheme of rich shades and design elements all created with an elegant, gothic theme in mind; unity and variety are achieved in this painted table runner. Everything present looks like it should be there and the work is very harmonious. The lime green piping around the blocks and binding were added as an accent to add interest and ward off a staccato feeling.

Rhythm

Like harmony, rhythm relies on repetition. Repeating design elements over and over again will create a sense of rhythm within the design field. Rhythmic designs can vary from low to high energy. Rhythm helps to entice the viewer to stay longer and can make an artwork easier to live with. However, if the rhythm of a work becomes too static or monotonous then the work becomes easy to ignore.

Design Properties

Balance Type
asymmetrical

Grid Structure
divided into thirds vertically and horizontally

Color
polychromatic

Design Elements
geometric, abstract

Direction
undulating line sweeps across the horizontal center

Visions 1: Don't Tell Me It's Easier Alone

By Katie Fowler

34" x 20-1/2"

This lovely, whole cloth, hand-painted quilt has wonderful rhythm. The composition is based on the rule of thirds and relies on a repeat of line and shape to create a dancing rhythm. Follow the mountain top on the left hand section as it moves beneath the row of small circles on the right hand section. Those circles are a repeat of the circles that make up the trees on the left and the giant moon above. The undulating red line that passes through both sides forms a rhythmic link between the two disparate sides of the quilt. The repeat of color from one side of the quilt to the other helps bring about unity whereas the mix of shapes, both abstract and geometric, provide variety.

line and shape create a dancing rhythm in this piece.

Movement

Movement implies motion on the surface of a design. This implication is most often made through the use of line. This type of line is called a gesture line. It makes it seem as though something is in motion when it actually isn't. Movement can be very difficult to portray in two and three dimensional art, but it can be done.

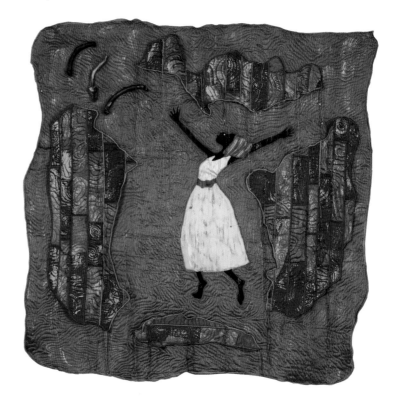

Design Properties

Balance Type
radial

Grid Structure
divided into thirds
vertically and
horizontally

Color
bold hues and shades

Design Elements
abstract, figurative

Direction
upward motion from
the center focal point

Singing in the Rain

by Nicole Yardley

34" x 34"

In this glorious quilt we can see the woman raising her arms and moving her feet in a dancing motion as she sings for joy. Nicole managed to show movement through body language. The arch of the back and the widespread arms give the impression that we have just seen her move into the throes of happiness.

Direction

Elements that show or give the impression of movement will help the viewer see the whole picture. Line and implied line can give a sense of direction to a composition, directing the viewer to see one portion of the work and then another. Directional lines that drive the eye to the interior of the work will keep the viewer with the work longer. Directional lines that drive the eye of the viewer toward the edges of the work are a good way to get the viewer to disconnect with the work.

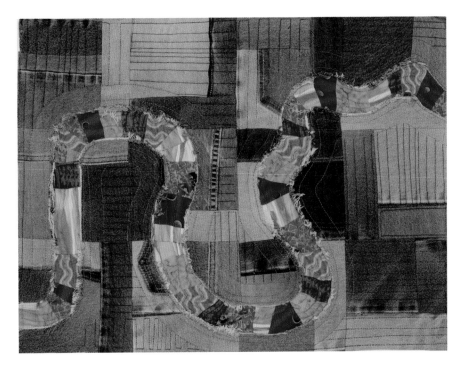

Design Properties

Grid Structure
uneven grid with curves

Color
split complement of blue with red orange and yellow orange

Design Elements
geometric shape with undulating line

Direction
curving line on stagnant background

The Road to Gees Bend

by Lori Nicholson

19" x 24"

This funky, wall quilt made from recycled jeans and quilting cottons features the split complementary grouping of blue with red orange and yellow orange. The variety of blue in the background makes an interesting fieldscape with the meandering river of rich, warm yellow oranges and red oranges wandering through it. The fact that the river begins and ends at the edges of the quilt gives us the impression that it goes on and on.

The yellow oranges and red oranges snaking over the blue background lead the viewer's eye to the edge of the piece.

Space

Design Properties

Balance Type
linear, vertical

Grid Structure
divided into thirds
vertically and
horizontally

Color
bold, pure hues
on black

Design Elements
stylized floral elements

Direction
growth winding its
way upward

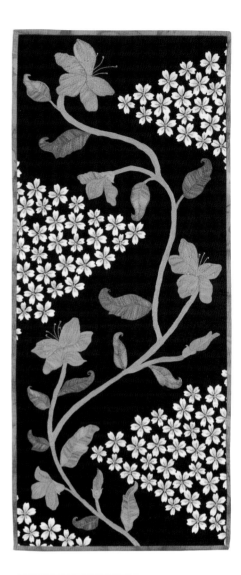

Each composition is filled with positive and negative space. Design elements usually occupy positive space and are surrounded by negative space. The amount of negative space within a design field can greatly impact a composition. With three dimensional art, such as a sculpture, one can see how the object occupies space by walking around it, looking from above, below or from the side. Three dimensional objects have height, width and depth. With two dimensional art, the arrangement of objects on the design field can be crowded with lots of objects or nearly empty with very few objects. These design elements have height and width but no depth. The illusion of depth can be depicted by means of creating perspective. Negative space can have as much or more of an impact as positive space. It can dictate the emotion or feel of a work as well as control the effects of any one or all of the design elements.

Cherry Blossoms and Fuchsia
by Heather Thomas
14" x 32-1/2"

This quilt features thread painted flowers, leaves and stems that dance up the center of a piece of Japanese Yukata. The large red orange flowers have essentially taken over the negative space and filled it with color, movement and direction. The stems lead the eye upward and the leaves push the view toward the white blossoms. Along with the color, the scale of the larger flowers in proportion to the smaller flowers make them the focal point. I added red orange centers to the white flowers during the quilting to make them seem more similar to the large flowers and create a visual link.

Proportion

The word proportion refers to the relative size and scale of the various elements of a motif within the space of the design field. Proportion addresses the issue of the relationship between the object and other objects and negative spaces surrounding it. Where scale refers to the overall size of an object, proportion refers to relative size. When an object is "out of scale" or oddly proportioned, it will create a point of emphasis. Large scale objects create visual weight and are perceived as being closer to the viewer and thusly, more important. Smaller objects seem to be farther away. Proportion also pertains to placement of objects within the design frame. Rarely should a focal point be placed dead center, instead rely upon the rule of thirds. To do this, divide the design field into thirds both horizontally and vertically. Four "axis of thirds" are formed where the lines of this division intersect. Placing your focal point on one of the axis of thirds will yield a pleasing effect.

Design Properties

Balance Type
asymmetrical

Grid Structure
divided into thirds
vertically and
horizontally

Color
double split complement
of blue green, blue
violet, yellow orange
and red orange

Design Elements
line, realistic shape,
abstract shape

Repetition
colors in the
negative space

One Perfect Pear

by Donna McGregor

14" x 18-1/2"

This larger than life-size pear straddles the lower and upper axis of thirds on the left hand side. The hand painted background fabric looks like it may be wallpaper which leads us to think that the red orange bar the pear is sitting on might be a table top. The bold, gold leaves in the negative space on the right balance out the size of the pear. The red orange sections of the pear deplete some of its visual weight. Proportionately speaking, the pear is over-sized for the design field, but without detriment to the piece. It is the focal point and all of the other design elements support it and make the piece a perfectly balanced asymmetrical design.

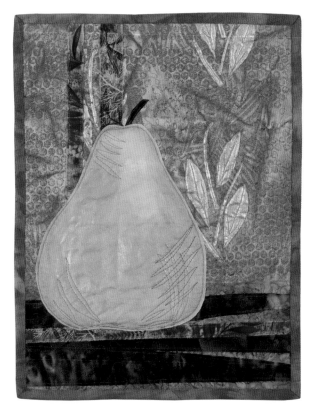

Proportion- the Golden Mean

Choosing the size for your artwork can sometimes be a difficult decision. Nature has provided us with some very simple and pleasing guidelines with both the Golden Mean, also called section, ratio or rectangle, and Fibonacci sequencing.

The Golden Mean

The Golden Mean has been used in architectural design, from Stonehenge to the Parthenon, since the Renaissance through modern times. Artists have also employed its use in painting and sculpture. The Golden Mean is evidenced in the human body, fish, pinecones, sunflowers and throughout nature. This ratio is one of the most visually pleasant formats. Though we may design in squares or near squares, these shapes are not as aesthetically pleasing to the human eye as the Golden Mean. Historically, we have gravitated toward the Golden Mean in everyday items, such as book size to the windows in buildings. This format is both harmonious and visually appealing.

Determining the Golden Mean Proportion for Your Own Work

The ratio is 1:1.618. In art we round partial numbers up or down. To determine the size for your next artwork, simply multiply the length of the short side by 1.618 to get the length of the long side or divide the long side by 1.618 to get the short side. Listed at right are some common dimensions based on the Golden Mean.

8" x 13"	12" x 19"
16" x 25"	24" x 39"
36" x 58"	48" x 78"
60" x 97"	54" x 87"

The dimensions above are all different, but will all produce a rectangle using the Golden Mean proportion.

Another way to find the Golden Mean Proportion

If you feel intimidated by the above formula, here's a quick visual way to produce a Golden Rectangle from any sketch or rough idea:

1. Start with a square
2. Divide the square in half vertically
3. Draw a diagonal line from the lower left corner of the right half of the square to the upper right corner of the square half.
4. Rotate the diagonal of the half square down to sit in line with the bottom of the square. Use the resulting length to establish the length of the long side of the new golden rectangle.

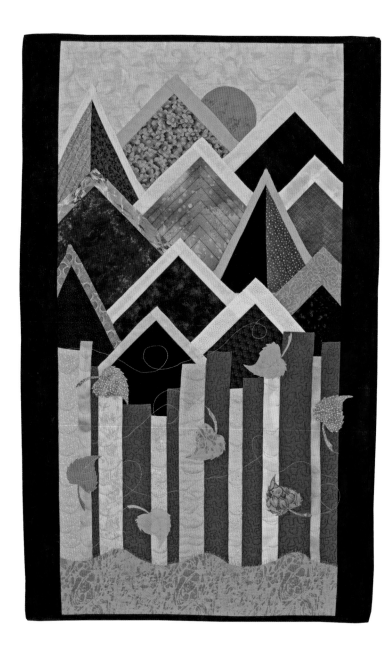

Design Properties

Balance Type
asymmetrical with strong vertical pull

Grid Structure
no grid structure is present

Color
direct complement of blue violet with yellow orange and gray neutrals

Design Elements
strong line with geometric and realistic shape; repeat of motif to create pattern, good use of value

Unity
repeat of shape, line and color

Variety
color, scale and value; mix of size and scale of geometric and realistic shapes

Swirling Mountain Splendor

by Ronda Lambatos

33-1/2" x 20-3/4"

This quilt features a nice blend of the direct complements blue violet and yellow orange. Ronda added pale gray, white and some creamy tans to the composition. The angular blue violet, snowcapped mountains are filled with a myriad of values and color scale and play well off the linear foreground on the lower portion of the quilt. The curving yellow orange ground along the bottom is a perfect counterpoint to the lines and angles above. Ronda added seven leaves blowing just above the ground using a nice selection of yellow oranges, then brought the eye back up to the top of the quilt as she tucked the sun in behind the farthest mountain. The blue vertical bars use Fibonacci sequencing in their width measurements.

The design field is almost a perfect Golden Mean rectangle

133

Proportion- the Fibonacci Sequence

In Fibonacci sequencing, each number in the sequence is determined by adding together the previous two numbers. For example, 0, 1, 1+1=2, 1+2=3, 2+3=5, 3+5=8, 5+8=13, 8+13=21, 13+21=34, 21+34=55, 34+55=89 and so on.

This sequencing is directly related to the Golden Mean as the numbers grow respectively by approximately 1.618 times—2x1.618=3.2, 3x1.618=4.85, 5x1.618=8.4, 8x1.618=12.9, 13x 1.618=21.03 and so on.

The Fibonacci Sequence in Action

Using both the Golden Mean and Fibonacci sequencing can train the artist in the skill of proportion. For example, if you want to float circles of various sizes on a background, begin with a background that resembles a Golden Mean rectangle. Choose circles whose radius increase in size according to Fibonacci sequencing such as 2", 3", 5" 8" and 13".

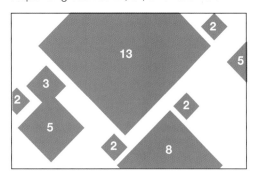

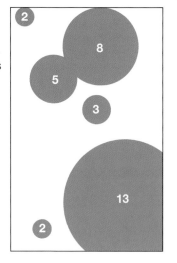

Design Properties

Balance Type
somewhat crystallographic

Grid Structure
divided into thirds horizontally and vertically

Color
polychromatic pure hues and shades

Design Elements
color, geometric and abstract shape and line

Principles
repeat of motif to create rhythm, proportion/scale

Unity
color scale, repeat of circular motif, black line connects all sections

Variety
abundance of color, scale of motifs

Visions II: Dreamscape

by Katie Fowler

44" x 44"

The composition of this quilt follows the rule of thirds. The design field is divided into thirds, both vertically and horizontally, yielding somewhat equal sections. Each section contains a different motif style. The circles in the middle/right section measure approximately 1", 2", 3" and 5" and the large circle in the bottom/middle is approximately 13". These measurements follow Fibonacci sequencing. The quilt is filled with variety and unity is provided with a repeat of shapes and color scale. The use of line links the varied sections together.

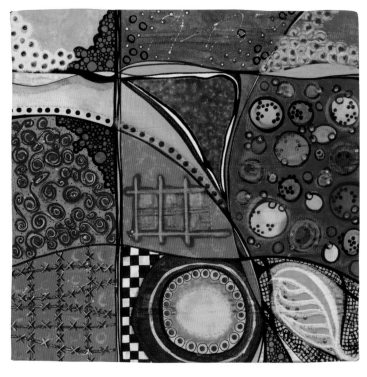

The Rule of Thirds

When working with asymmetrical designs, choosing where to place your focal point or visual weight is often one of the hardest decisions. Use the rule of thirds to visually divide your design in thirds both vertically and horizontally. Position the main design element or visual weight on or near one of the four areas where the lines intersect. These intersections are called the axis of thirds.

> **The Rule of Thirds- not just for rectangles**
> Broaden your design skills by experimenting with the rule of thirds on formats beyond a simple rectangle or square. Think of how this asymmetrical design tool could be applied to a circle, diamond or irregular shape. Also consider deepening your design complexity by dividing some or all of the third sections into thirds themselves.

Some final thoughts before you begin the Workshops

As you begin a new design remember to utilize what you have learned about the elements and principles of design. Try using the Golden Mean and Fibonacci sequencing as well. If you choose to work asymmetrically, as many artists do, pay attention to how color and value can and will affect visual weight. Balance is one of the main things you will want to achieve in a composition. A small bright yellow circle can have as much visual weight as a larger dull blue circle. It may be necessary to group smaller objects together to offset the visual weight of larger objects. Three small circles gathered together will have the same visual weight as one larger circle of the same color.

12 Workshops in Color and Design

Learning about color and design through reading, lectures and the study of existing art are all helpful ventures. However, to truly learn about the interaction of color and how to harness its energy, one must get their hands on color and work with it. The following 12 lessons are ones I have been teaching for more than a decade. Each lesson teaches the user several important aspects of the interaction of color. The lessons depend upon one another and the degree of difficulty grows with each one. It is therefore wise to complete one lesson before beginning the next and to do them in sequential order.

As you make each project, utilize the elements and principles of design as you begin each composition. Keep in mind it is the journey leading you to the finished piece that is important. The piece itself is not the focal point, it is what you learn about the interaction of color, design skill and yourself that really matters. Before you begin, consider forming a group of like-minded artists to join you. Sharing your successes as well as your failures with others can greatly enhance your learning experience.

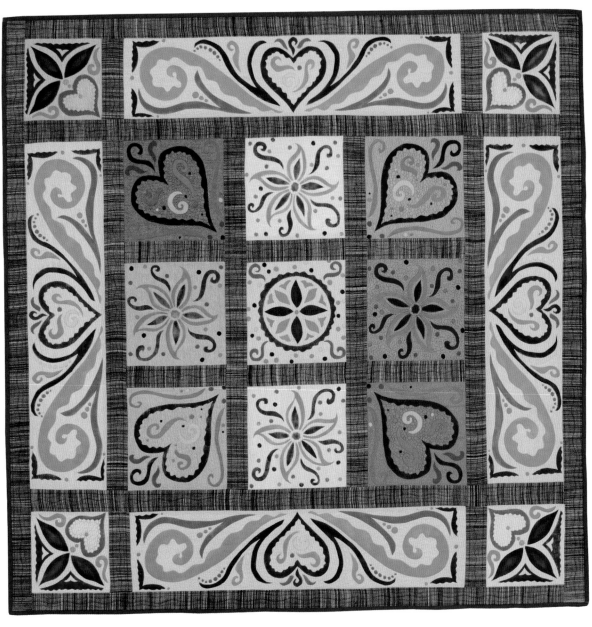

Calpurnia

by Heather Thomas

39-1/2" x 40"

Filled with soft yet rich tones, this painted quilt features formal symmetry and
a large variety of stylized shapes which are unified through repetition.

Getting Started

The Journey of Art Making

As you begin this exciting, perhaps daunting, journey of discovery keep in mind you will want to make a piece of artwork to represent each of the workshops explored here. You can choose to do every lesson in the same medium, the same size, and using the same basic techniques or you can mix it up. It doesn't matter what you do, it matters that you do it and that you do it to completion. Each step of the journey tells you something about the work and something about you as the artist.

The challenge is to look at your life and determine how much time you have in it for creativity. Be realistic and make projects that can be completed in the time frame you have available. If you determine you have about five hours a week for creative work then clearly your projects need to be small or filled with quick techniques. If you have 10 hours per week then those projects and their techniques and level of difficulty can expand. Set yourself up with realistic goals that you are likely to obtain.

Outfitting Your Studio

As you begin this course of study, one of the first things I suggest is to create studio space for yourself. It doesn't have to be anything fancy or even a dedicated room, but it should be dedicated space. Purchase an inexpensive room divider to cordon off your space. This way you won't feel as though you need to clean the area every time you walk away from your work.

> ### From Heather ~
>
> As a colorist, artist and instructor, I know it is difficult if not impossible to learn about color without getting your hands on it. Color must be learned experientially. There are 12 workshops in the book that were originally designed to be taken one month at a time. Use whatever timeline you want, but keep it consistent. We all need deadlines especially if we are trying to form positive, new creative habits. So however you decide to tackle the lessons, keep up with it.
>
> It might be more fun, and certainly a greater learning experience, if you can form a group, large or small, to join you on this journey.

> ### Knowing What Supplies You Need
>
> Most of us know what we need in order to create our work. If you are having a difficult time completing things, it is probably because you are missing something, either a product or a skill set. The best way to determine what you are missing is to make a list of what you have. It does not have to be an exact inventory, but it should be somewhat accurate.
>
> - List the estimated yardage you have in each of the twelve colors on the color wheel. You may also want to note how much of it is from which portion of the color scale and what type, size or style of motif. For example, yellow orange - (21 pieces) about 9 yards, mostly pure or shades, a few tints. Mostly medium, simple shapes, no stripes, no geometrics.
> - Take an inventory of threads and accessories
> - Count paints, stamp making supplies, and batting
>
> Once you know what you have, make notes to know what you need to properly outfit your studio. You can easily determine what you need. Make another list of what you are missing. For example, yellow orange - need just a few tones and tints, some small prints, need stripes and geometrics.
>
> Use this list to shop from over time. Add to it when you use up a large selection of any one color. After your stash is complete, you only need to replace what you use.

Create studio space that is safe, invigorating and inviting. You have to want to be in your studio.

For you to be able to create in a positive way each time you are in your studio, it must be filled with all the things necessary for you to make your artwork from start to finish. Each of us has a group of core ingredients that go into our creations. For our studios to

work for us, they should be filled with these core ingredients.

Skills

After your inventory is complete, you may discover you have all of the product you need to create. If you rarely complete anything, perhaps what you are missing are the skills to finish. If your genre is quilting and you have

tons of tops but no finished quilts, it is probably time to take a machine quilting class or purchase a good book on the subject. If you are a watercolorist and you have tablet after tablet filled with paintings, but none framed, perhaps your money would be well spent on learning framing.

Some people are reluctant or afraid to finish for a few of the following reasons:

- fear of failure

- sadness at the end of the process

- laziness or having to do the part of the process you do not like

Completion is part of the process and gives you the freedom to move on to something new.

Organization

Organization is very important in your studio. Anyone with any budget can get organized enough to yield a welcoming space in which to create. All the products you use on a regular basis should be organized, out in the open and easy to find. They should also be easy to put away. If your storage system requires you to spend long periods of time in re-organization you are less likely to use it, resulting in a rarely entered studio.

Getting Started

Getting started is one of the hardest things. Each new project confronts you with a new set of challenges. For this journey, consider using what you already know and try to grow your skill set. For example, if you are a good illustrator but have never worked in color then keep illustrating but work bigger so there is room for color. If you are a quilt maker or seamstress, keep

Getting Organized

- You will need a blank wall or area to place the work you are creating so it can be seen without the interruption of other visually interesting things. This can be a design wall, design table or workstation. The area should be white or pale, pale gray.

- Organize all fabrics, papers, paints or dyes by color. Store them openly so you can easily see what you have and where it is.

- Consider separating your drawing pens and paintbrushes by type and place them so they are easy to see and easy to get to.

- Embellishments can be stored in clear plastic tubs that are clearly labeled. The containers can be stacked on a shelving unit.

- Threads are best stored in protective, clear, plastic storage containers.

- Cutting tools can be hung on a rack near your cutting table. Batting can be stored underneath.

- Ideally your sewing table should have lots of drawers to store all of the products you use when sewing, such as extra bobbins.

doing what you do, but create from your own imagination and skill set instead of using a pattern that someone else designed. Be brave, you can do it. It is helpful to keep a journal as you work, tracking your successes and failures and remembering we learn more from our failures than our successes.

Draw inspiration from other sources, books, magazines, and local galleries. Use the basic design elements you have learned on the previous pages of this book or break all the rules. You may discover that to design from nothing asks you to set aside the traditions you hold on to in your art medium.

The Importance of Completing Your Project

For each study in this book you are asked to make a project to prove one or more theories about the interaction

of color. Taking that project from beginning to end and completing it is an important part of the journey. What is important in this learning experience, is what is learned while creating the project.

A piece of artwork, whether a quilt, water color or mixed media sculpture, is a learning tool for the artist. Each piece offers us the opportunity to learn new things about ourselves along with the chance to hone our skills or add a new skill set. When we take a piece from design through to completion, we finish the journey.

Finish what you begin and begin what you know you can finish. If you rarely complete your artwork, you are denying yourself a very important part of the creative process and limiting your chances of discovering success.

Changing a Quilt With the Quilting

If you are not a quilt maker, use your imagination and insert the terminology related to your medium while reading this very important little section.

Once a quilt top has been completed, the next choice in designing is the quilting. When we begin to look at this step in a work as part of the process and not just the finishing we open up new realms of possibilities. We can change the line or visual flow of a piece or enhance it with the quilting design. We can embellish or change the color of a design with the addition of beadwork, heavy thread work, paint or bleaching.

As you play with color and shape also begin thinking of the different ways you could finish the project. When finishing techniques become a vital part of a composition's inception, it is more likely the piece will be completed. The only way to become more proficient in quilting is through practice. Practice on pieces you want to finish not on scrap fabric.

Try to let go of the traditional ways of quilting, like in the ditch or simple outline quilting, and find ways to quilt that enhance the design you are working on. For example, a highly graphic, grid based quilt is softened by curved lines in the quilting while a curvy, soft, flowery design is enhanced by straight line quilting. As you choose designs for each space of your quilt top think about what you want each part to say. Do you want it to stand out and be more important than it currently is or do you want it to quiet down. If you want it to stand out, then don't over quilt that area. If you want it to quiet down, then quilt the heck out of it. Choose quilting motifs that will allow the design to speak in ways you want.

Giant Hibiscus
by Margaret Parker
43" x 44"

This quilt, without the quilting would just be a round piece of white fabric. Margaret used the contrast of light and dark as she stitched or thread sketched her bold, black flower. She used gesture lines inside the petals to make them look more lifelike and she used a very heavy stitch line around the outside of the petals to provide spatial delineation. The heaviest quilting is on the center tips of each of the petals. This pushes that area back just slightly which makes the flower look more dimensional.

Quilting Library

Quilting can add texture, direction, depth and movement to a project. Examples of various styles of quilting are shown below. Use them as a springboard to adding something extra to your artwork.

Above are three very distinct quilting patterns. While each is different, they all provide great visual texture. These designs are interesting on their own and are great complements to quilt tops that need added interest.

The three designs above are nature based. The first will enhance areas where water is meant to be. The second design is great to use in trees and the third one is fabulous when creating the illusion of animal hair.

These three designs are simpler and perfect to stitch in areas where you simply want to enhance what is already present rather than adding more visual impact.

Quick Key
Neutral or Achromatic includes true neutrals black, gray and white. It can contain tan, off-white, taupe, and other pale brown based colors.

Workshop 1
Discovering Value and Texture Through Neutrals and Playing with Balance

Color is usually the first thing we see when we look at a piece of art. We then notice design and imagery. Creating art with the absence of color, using neutrals, invites the eye to see the nuance of value in the design at first glance. In this color study we will learn about the concept of value. Value is the lightness or darkness of a color.

Why Work With Neutrals?

One of the simplest ways to understand the interplay of value and texture is to use them both in the absence of color. Neutral or achromatic color schemes rely on value differences to work effectively. When conducting an experiment in neutrals try using a full array of values. If working with black and white, use blacks with different color bases; some with a red undertone, some with a green undertone, some brown and so on. Repeat with the whites. Some can have a slight blue tint others might have a slight yellow tint. Remember that a print with a white base and a thin black print will have a light value, a print that has equal amounts of black and white will have a medium value and a print with a black base and a thin white print will have a dark value.

Using just black and white is limiting and will usually yield a very modern piece of artwork. Adding gray will soften the palette and provide you with more choices. However, gray can be tricky. It can be made with a mixture of black and white which will yield pure grays in a myriad of values. It can also be made by mixing two direct complements. These grays often have a color base that is quite noticeable. When choosing grays

for your artwork, try not to load your palette with too many that share a common color base. If you use lots of blue based grays, you may end up with a piece of artwork that reads blue rather than neutral.

For centuries, quilt makers and other artists have used tan, cream, taupe, brown and other color based entities as neutrals. The addition of these types of color to a truly neutral palette of white, gray and black is alright as long as none of the additions has a noticeable color base. If you want to use a cream color, add it to the pile of neutrals. If it looks like it belongs, it is probably okay; however, if it starts looking more like a color, do not include it. Again, one yellowy cream is okay, but if you use too many of them it will result in color loading and your piece will look yellow instead of neutral.

Playing with Balance

In addition to working with neutrals in this lesson you will also be creating with balance in mind. Look at some of your older work and determine what kind of balance you tend to use. For your neutral piece, choose a type of balance that is unfamiliar to you and create your pieces with that type of balance. If you usually

work in a symmetrical grid style because you like traditional quilts then work with radial balance and make a medallion style quilt. If you are a sculptor and generally work in abstract shape with asymmetrical balance then this time work with symmetry.

Begin with an idea for the design of your artwork then choose the products in your medium that facilitate bringing the design to life. Or, move in the opposite direction and choose the products first then come up with a design to utilize those products. Either way, experimentation is the name of the game. Feel free to add only one accent color to your palette. This color should not take up more than 15 percent of the design space or field. It should be used only as an accent. Keep in mind the accent color will greatly influence your selection of neutrals. If several of your neutrals have a yellowy base and you use any yellow colors as your accent, it will make the yellowy colored neutrals appear even more yellow and you may end up with a yellow colored piece of artwork rather than a neutral colored one. Using the direct complement of yellow would yield the same results. Instead, use something that is three or four colors removed from yellow, such as, green or red.

For a successful neutral design remember to vary the values and the textures you use.

Balance is one of the most important aspects of a good composition.

Ideas to Get You Started

For Quilt Makers -

- **Log Cabin:** Make half of the block in white, bone, taupe or tan and the other half in medium brown, dark grays and blacks. Choose a nice shade for the center of the square, like rust or wine.

- **Nine Patch:** Use black, gray and white and play around with the placement of the values to make secondary designs.

- **Stars:** Chose one or more star patterns and play with value in the foreground and background positions.

- **Square in a Square:** Alternate positions of darks and lights in alternate blocks and see what happens.

For Other Mediums -

- **If painting,** consider mixing grays using black and white and direct complements to form various gray browns.

- **If drawing,** try using charcoal, inks (including walnut), graphite and chalk all together to achieve variety. Use lots of different strokes and mark making to add the interest of visual texture.

- **If doing mixed media,** utilize some of the things found in nature that are neutral including, but not limited to, shells, rocks, dirt/sand/gravel, tree bark and so on. Papers come in a myriad of neutrals with lots of varied visual and tactile choices. The colors of metal are also generally considered neutral so add metal if desired. Remember that anything too shiny will take over, so add with caution.

1

Neutral to the Core

by Eileen King

23" x 23"

This funky little quilt uses black and white prints in mostly geometric styles in a variety of scale. The apple core blocks sit on a solid white background and are outlined by narrow black strips. Placing the stripes in the prints in varying directions adds a sense of rhythm and movement as does the undulation that occurs where the blocks are joined. The sometimes harsh look of bold stripes printed with a high light and dark contrast is softened by the shape of the block. The quilt is a modern rendering of an old-fashioned block. The balance is informal symmetry.

Baa Baa Black Sheep

by Karey Swan

12-1/2" x 12"

This delightful little work is needle felted using a variety of black, white, cream and gray. The center portion is felted onto a white background which acts as a tiny inner border. Karey hand mixed black and white and black and cream fibers to come up with some of the grays. The contrast is low in some of the areas and greater in others. There are many densities of tactile texture created on the surface. These densities create a visual contrast. The balance is pictorial asymmetry with the two sheep counterweighting the large tree.

A Modern Bouquet

by Linda Thompson

20" x 25"

This lively black and white quilt has some added spunk with the addition of red accents. The dimensional folded flowers are made from a selection of black and white prints with different styles and scales of printed texture. There is a small amount of value contrast between the flowers and a lot between the flowers and the background. The solid white background is just large enough to support the design elements. The simple cross-hatched quilting behind the flowers helps to push them forward and show them off. The wavy border print is a perfect, darker valued finish to the straight-edged design of the folded flowers. The balance is radial, with the flowers coming out of the beribboned center.

Keep a Journal
- Materials Used
- Photo of Finished Artwork
- Notes

1

Neutral Grid

by Mona Doering

33" x 32"

The quilt, above, is a great play of old-fashioned and newfangled techniques. The soft white, gray, tan and cream palette works nicely with the torn fabric edges and the vintage buttons. The woven layout and seemingly indiscriminate placement of color and value adds interest and an interruption to what would otherwise be a staccato rhythm. The balance is symmetrical and there is a physical depth present because of the layering.

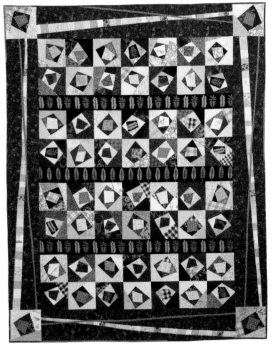

Square Not

by Heather Thomas

53-1/2" x 68"

The quilt, above, uses a broad expanse of neutrals including every possibility but gray. The accent color is a deep tone of red violet. The blocks have three rounds of color. Half are pieced with a dark final round and the other half have a light final round. This allows them to sit next to each other and not get lost. Value drives this quilt's design. It has horizontal balance and an asymmetrical border for added interest.

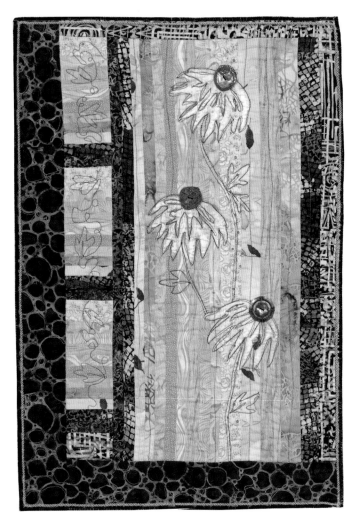

*An expanded
neutral palette
can provide the
viewer with a
sense of color.*

Joyful Fields

by Dona McGregor

17" x 25"

This quilt features a palette of colorful neutrals; off white, tans, creams, taupes and rich browns. The flowers dance up the pieced center providing some nice vertical movement which is countered by the horizontal stripes of the pieced sections on the left. The balance is asymmetrical and a little heavy on the left.

Your Neutrals Project

Your assignment is to create something using a neutral palette. Remember that neutrals include white, black and gray and, if you desire, off-white, tan, cream, taupe and anything that has no discernable color base. The goal for working with neutrals is to learn how to create something interesting that will engage you the maker and the viewer. To do this you must rely on value and texture alone as there will be little or no color present. You can use up to 15 percent of one color as an accent.

Self-analysis

Ask yourself these questions to help you analyze your progress as you work and finish your project.

1. How did I use value in my piece?

2. Did I rely on visual or tactile texture and if so, how?

3. What kind of balance did I use and how did I achieve it?

Workshop 2

Monochromatic Quilts;
Exploring the Use of Color Scale and Contrast

The word monochromatic refers to the use of just one color; mono=one, chroma=color. Creating visually interesting art in a monochromatic color scheme can be a daunting experience. The visual impact of monochromatic quilts relies on elements other than color. When only one color is present, contrast in other forms becomes necessary.

Monochromatic Project

Goal: create your monochromatic artwork including a variety of value, color scale and visual texture while working towards unity

Review:

Quick Key
Monochromatic
One color varied by value, color scale, intensity or saturation

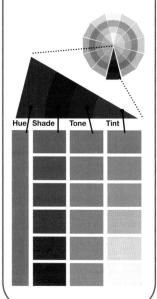

Hue	Shade	Tone	Tint

Choosing a Design

First and foremost, when choosing a design keep in mind that you will not have the luxury of color variances to define your design or help to delineate space. You will be relying on the sometimes subtle, often complex transition of value to do the work for you. Look for designs that require lots of variety rather than ones that need only a few value/color choices. Roses are a great example. They have a lot of value and color scale play amongst their many petals whereas a sunflower is basically a pure-hued yellow orange. Keep in mind also, that you do not have to be realistic. There is no reason you cannot make an entire landscape out of blues or a portrait out of reds. Let your imagination soar.

Creating With Unity in Mind

Though learning about color scale, value and visual texture is your main emphasis with this project, also keep the principle of unity in mind. As you choose all of the fabrics, paints, papers or whatever medium you plan to work with, continually ask yourself, "What do all my choices have in common? How will they work together to form a unified composition?" The challenge with a monochromatic quilt is to include enough variety to make the work interesting, but not forego unity by including too much variety.

Adding the Principle of Contrast

- **As you choose** materials for your monochromatic project, you will want to pay attention to many elements in addition to color. To create a visually appealing piece of art you must have a lot of dynamics working together.

- **In addition to the variety** of value introduced above, you will want a mixture of color intensity as well as a strong variety in texture and pattern. Look for versions of your color which contain a mixture of value or intensity, for example; a medium valued violet, with darker violet swirls, or a dark, smoky violet, with light, clear violet stars. Strive for a mix of color scale and values in your medium with various print sizes. Don't be afraid to include stripes, geometrics, dots, swirls, leaves and florals in the same design. This will add more variety and make the artwork more enjoyable to create and live with.

Keys to a Successful Monochromatic Quilt

- **Use only** one color from the color wheel. If you must "dip" into a color next to your color, that is okay but do not dip into both sides of your color or you will end up with an analogous colorway.

- **Do use** all of the variances of the color you have chosen. If you choose violet, use the entire color scale of violet. Use the light, medium and dark versions of its pure hue along with the light, medium and darks of its shades, tones and tints.

- **If you are confused** as to whether or not a material is the right color, use your color wheel. Find your color choice on the color wheel and lay it on top of the color in question. Does the color more closely resemble your color choice on the color wheel, or is it more like one of the colors on either side of your color choice? Only use it if it closely resembles your color of choice. If you are still in doubt, ask yourself if the color you are considering is your chosen color with black, white, tan or gray added. If so, use it. If not, put it away for another day.

- **You will also need** to decide whether or not to add a neutral color or colors to your palette. Using neutrals in your background can help separate or accentuate the shapes and lines in an artwork and give the eyes of the viewer a place to rest.

Quick Key
Hue- color
Shade- add black
Tone- add gray
Tint- add white

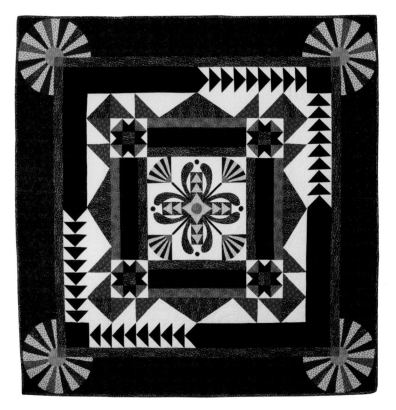

Round the World Robin

by Crystal Zagnoli

57" x 58"

Red violet

This quilt features a red violet and neutral color scheme. Almost every variety of the red violet color scale was used. Pure hues, shades, tones and tints are present. Black, white and brown neutrals were added in some of the negative spaces. The center block includes tints, tones and the pure hue. This is surrounded by tones and shades. The next round includes tones and the pure hue and the round after that is shades. The final border system includes all but the purest hues. Along with color scale, value is playing a major role. There is great unity in the simplicity of motif styles and the abundance of tone and shade. The balance is mostly radial with some asymmetry.

Once Upon a Time

by Susan McClean

15" x 16-1/2"

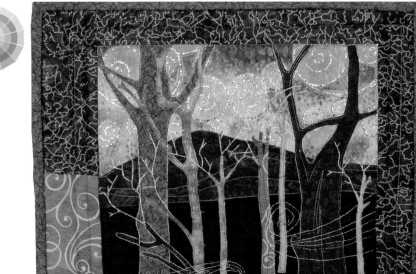

Blue violet

This little landscape is made entirely out of varieties of blue violet. Susan used lots of different values and the complete color scale to portray her fairy tale inspired design. There is little textural play in the fabrics that make up the trees, foreground and mountain, but the sky and the borders are filled with motion because of the textural, printed designs. Susan added even more visual interest with her swirling machine quilting done in metallic, silver thread. This piece is packed with all the necessary variety and unity needed to make a successful monochromatic artwork.

Generations

by I.V. Anderson

8-3/4" x 8"

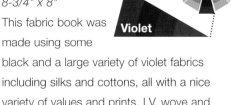

Violet

This fabric book was made using some black and a large variety of violet fabrics including silks and cottons, all with a nice variety of values and prints. I.V. wove and stitched lots of different fabrics and fibers for the book's cover.

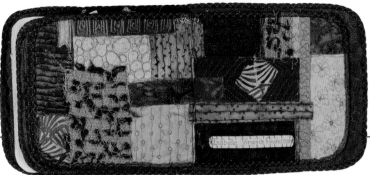

The book's inside pages are filled with crazy quilting and decorative stitch patterns.

Blueberry

by Heather Thomas
9" x 21"

This art shrine was made in remembrance of a lovely cat called Blueberry, so of course, it was made in blue. Silks with different types of tactile texture as well as a photo of the cat printed on sheer organza were used. Blue metal, blue beads and blue buttons were added. The color is mostly in the shade and tone category. Contrasts are evident in texture and value as well as depth and dimension. The balance is unusual. There is a vertical feel to it with the hanging pieces, but the cat is definitely the focal point. The piece integrates the hard embellishments with the soft fabrics.

Blue shades and tones were used heavily in this piece.

Yellow Green & Gold

by Sharon Triolo-Moloney
18" x 20"

Sharon chose to use lots of pure hues and near

Yellow green

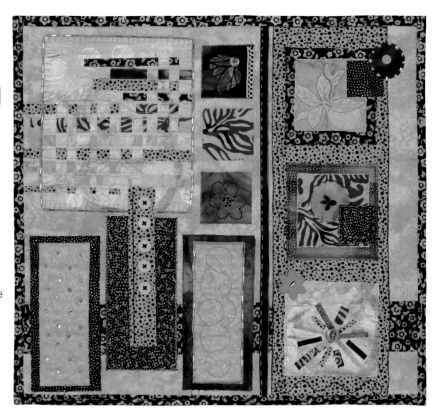

pure hues as she created her yellow green monochromatic quilt. She used a variety of embellishment techniques to add interest and to heighten spatial delineation. Metallic gold paint was used as an accent. The woven section on the upper left balances nicely with the square on the lower right. The imagery, embellishments and value/color scale changes make the piece intriguing and the color makes it fun and lively.

Blooming Out of the Box

by Susan Westervelt
22" x 31"

This piece features a big

Yellow orange

abstract sunflower in full, late summer bloom. It is made from a large selection of yellow oranges, from the pure hue to deep dark brown shades. The color sits nicely on the gray backdrop and is framed perfectly by black. The composition is very well done with portions of the flower positioned out of the design field. A nice light source shining down from the upper left is present in the use of pure hue and white in the upper petals.

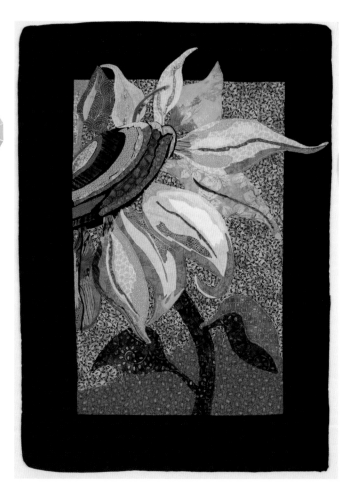

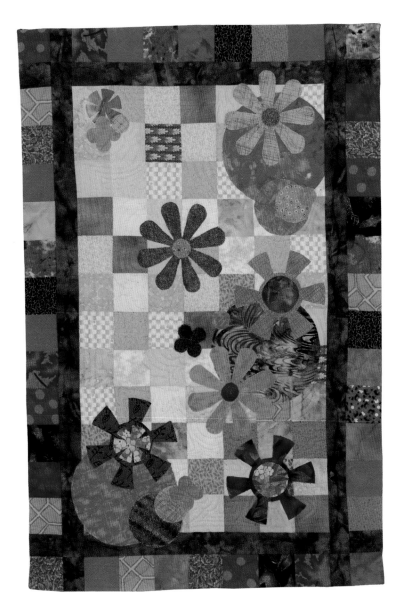

Terra
by Crystal Zagnoli
19" x 29-1/2"

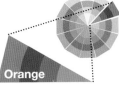

Crystal used a wide array of orange fabrics in her quilt. She included many different versions in light, medium and dark hues, tints, tones and shades. The contrast is well done with a few areas where the flowers or circles get lost in the squares of the background, but without loss of effect. The use of a deep tone as the inner border was just what the quilt needed. The piece is warm and inviting.

Your Monochromatic Project

As you create your monochromatic artwork be certain to include variety while working towards unity. Remember that value changes will help with spatial delineation and visual texture will add interest. Unity without variety can quickly add up to boring.

Self-analysis

Ask yourself these questions to help you analyze your progress as you work and finish your project.

1. What steps did I take to ensure that I had ample variety in my piece?

2. How did I create unity for my piece?

3. Did I have difficulty maintaining a monochromatic color scheme? Did I find it hard to differentiate my chosen color from the colors next to it? If so, how did I overcome this difficulty?

Workshop 3
Managing Complementary Color Schemes

Any two colors that lay directly across from each other on the color wheel are direct complements. There are six possible combinations: red/green, red violet/yellow green, violet/yellow, blue violet/yellow orange, blue/orange and red orange/blue green. The word complement means to complete. In each of the complementary color schemes one color completes the other.

If you stare at a green sheet of paper for a few minutes then close your eyes or look at a white sheet of paper, your eyes will envision an afterimage of red. When mixing two complements together in equal values, as with paints, gray brown will always be formed. This is because these colors not only complete each other, they also neutralize each other. This complementary rule is the basis of harmonious design, as one color visually completes the other, thus pleasing the eye and the psyche.

Great care must be used when creating works in a complementary scheme. In most cases, one color must dominate the other. Using both colors in equal amounts gives the eye nowhere to rest and makes the work distracting rather than pleasing. For full intensity use of the color pairings, that is using them in their purest hues, the classic ratio of use is as follows:

• 3/4 violet to 1/4 yellow
• 2/3 blue to 1/3 orange
• 1/2 red to 1/2 green.

If using equal amounts of red and green in an artwork you must remember to use all the value ranges not just pure hues, or use a pale colored background to give the eye a resting place. This will also take away from the Christmas look. In all of these color schemes, dominating with the cooler color will yield a more harmonious piece.

Direct complement pairs contain all three primary colors
It is important to note that in all six direct complement pairs, all three of the primaries, red, yellow, and blue, are present;

• **Yellow and violet** = yellow + red and blue

• **Yellow orange and blue violet** = yellow and red + blue and red

• **Orange and blue** = yellow and red + blue

• **Red orange and blue green** = red and yellow + blue and yellow

• **Red and green** = red + blue and yellow

• **Red violet and yellow green** = red and blue + yellow and blue

When red, yellow and blue are mixed together a dirty gray black is formed. This also happens when mixing any pair of direct complements. Each complementary pair has its own particular type of contrast in addition to its contrast of hue. Yellow and violet as well as yellow orange and blue violet have a contrast of visual temperature, one being the cool color and the other the warm. Red and green and red violet and yellow green have pairs of temperature neutral colors.

The Relativity of Value and Color

Value, more so than color, will determine which elements dominate and the visual weight in a design. Though value can be a more subtle attribute of a color, it defines how the color will behave in any given spot. Let us use an example of making a star block using two colors and a background. If the background is light and we use two medium valued tones of fabrics, red for the star center and green for the star tips, neither the center or the tips will be dominant. If we change the center fabric to a fully saturated pure red, then the center will dominate, the same would be true if we changed the center fabric to a tint of the pure hue. However, if we left the medium value tone of red in the center and changed the fabric in the star tips to a bright, pure green, then the star tips would be dominant. The colors in the block have not changed, just the values and intensities. Using a "Ruby Beholder", or other value finding tool, to see the values in colors can be very helpful when determining which colors will be best used in which positions in a composition.

- A "Ruby Beholder" or other value finding tool is a piece of thin plastic, colored either red or green. They are this color because these colors are temperature neutral and medium valued. When held in front of your eyes while looking over a selection of colors, they will mask the color and reveal only the value.

- Try placing all the colors you plan to use fanned out next to each other in order of lightest to darkest. Then use a value finder and check to see if you have gauged the values correctly. You may be surprised by the outcome.

- Pure hues can be misleading. If they are truly pure hues they will sit about mid-value, however they are often slight shades and will need to be moved toward the darker end. Tones can also be misleading. Sometimes they are lighter than medium, sometimes darker.

Your Direct Complements Project

In this study your goal is to learn to balance colors that have very high contrast. It is your job to bring out the best in them and get them to play together nicely in the design field. To achieve this you will need to pay attention to the inherent value of each of the colors and rely on the use of color scale and visual texture. As the creator, you are in charge. Pay attention and strive for a balance of color that is pleasing to your eye, creating a work that you want to spend more than five seconds looking at.

Consider balance unity and variety while making your project. Get used to asking yourself how you are achieving each of these principles. Remember the power of value and use it to your advantage. Remember that the warmer, yellow-based colors are capable of more intensity than their cooler counterparts. Take great care when using these colors.

Using Red and Green or Red Violet and Yellow Green

- Red and green in their pure hues are almost equal in value and compete with each other for dominance. You may choose to force one to dominate the other or use them both equally. If dominance is what you desire, then use a mass of the pure hue. In the opposite color, use less of it and only use its shades, tones and tints. If you want to use them in equal values and include a lot of pure hues you may end up with a Christmas piece whether you want one or not.

- If you stay away from the pure hues and concentrate on tones and tints or tones and shades you can get away from the holiday theme.

- With the red violet/yellow green combination, you can use 1/2 and 1/2 like the red and green combination, or you can decrease the yellow green to 1/3 and increase the red violet up to 2/3. With this imbalance percentage, use the red violet in its pure hues and include the rest of the color scale as desired. Steer clear of the pure hue of the yellow green or use it in very small amounts as an accent. If you plan to use the larger percentage of yellow green then use it in tones and shades.

- Yellow green in its pure hue will expand. This means it will look bigger than it actually is. In its pure hue it will also have a natural luminosity. It has a tendency to glow. Use it in ways that will show off its wonderful characteristic rather than trying to squelch its natural tendencies.

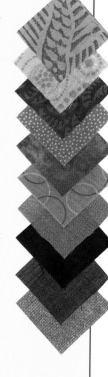

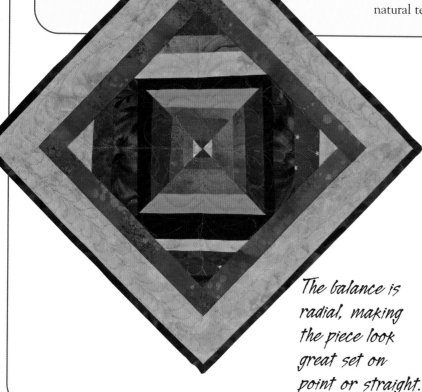

The balance is radial, making the piece look great set on point or straight.

Seeds

by Crystal Zagnoli
12-1/2" x 12-1/2"

This simple little quilt shows a nice way to use the complements of red and green without yielding a Christmas quilt. Crystal used the full array of both colors including lights, mediums and darks as well as the pure hue, shades, tones and tints. She added visual interest by quilting an elaborate feather design.

Nothing But Complements

by Karey Swan

6" x 9"

This is one of six needle felted works in Karey's series of complementary pieces. Karey used a backdrop of black, gray and white to set her red and green geometric forms on. The act of needle felting mixes the base color with the foreground color. Note how the medium green becomes a shade on the upper portion when it is felted onto the black versus how it becomes a tint in the lower portion when it is felted on top of white. This is a very good asymmetrical composition with the white negative space and the only circle on the lower right balancing off the large, pure red rectangle on the left.

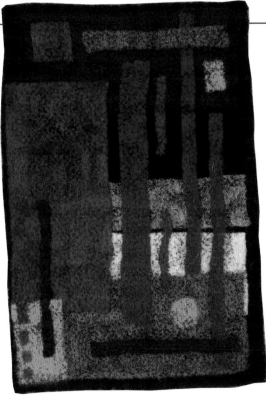

The various values provide a sense of depth and the play of shapes and the lines add visual interest.

Suede Swirls

by Heather Thomas

32" x 18"

This quilt is made from a large mix of red violet and yellow green in shades, tones and tints. The areas occupied by darker tones of both colors seem to blend to gray and it becomes difficult to tell where one color begins and another ends. The center is made of cotton and was quilted then set on top of ultra-suede. The swirls were added in a toned tint of yellow green and the wavy inner border in a dark shade of red violet was added last.

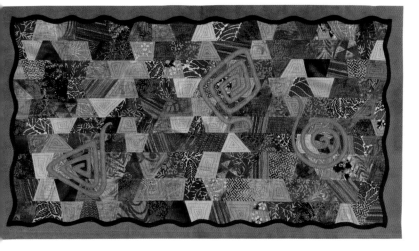

Miss Judy

by Karey Swan

19"

This doll was needle felted using a variety of red violet and yellow green along with a skin-colored neutral and black for hair and accents. Karey led with the red violet and used the yellow green in near pure hues as an accent. Every detail, no matter how small, shows an interaction of the two colors. The deep dark shade of her dress allows all the other varieties of the two colors to get the attention they require. The skin tone and hair color both allow the two complementary colors to shine.

Her shoes, belt, lapels and the flower in her hair all show the interaction of red violet and yellow green.

Using Blue and Orange or Blue Green/Red Orange

- Orange will always try to dominate blue. It is twice as bright and visually hot compared to the cool blue. Blue is the weakest of the primary colors and orange is the strongest of the secondary colors. The contrast between these two colors can be harsh when they are both in their pure hues. Calm the orange down by using it sparingly or in its softened or darkened versions. Use colors such as burnt orange, rust, pumpkin or melon. Adding a background color will also soften the interaction, giving the eye of the viewer a place to rest.

- The mixture of blue green/red orange allows for a gentler complementary combination as it contains two tertiary colors. It also contains an equal balance in warm and cool temperatures. When in their pure hues, red orange is the warmest of colors and blue green is the coolest. In both of these combinations it is a good idea to use a large mix of value and color scale.

An equal mix of red orange and blue green

- In the blue/orange combination, use approximately 2/3 blue and 1/3 orange. Use plenty of the pure-hued blue along with as much of the shades, tones and tints as you desire. As for the orange, stay away from the purest hues or use them very sparingly. Use the orange in its shades, tones and tints.

- You may use the same percentages above with the blue green/red orange combination or take it up to a 50/50 ratio. Try to include equal amounts of the color scale in each color. That is, if you use 50 percent blue green and include all four parts of the color scale equally, then do the same with the red orange.

- Both of these combinations have a great contrast in visual temperature. Use this to your advantage. Choose a design that requires high contrast to really show off not only the contrast in these complements but also the contrast in temperature.

A mix of 1/3 orange and 2/3 blue

Nothing But Complements

by Karey Swan

6" x 9"

This is another piece from Karey's complements series. It is needle felted using a nice combination of oranges and blues on a black base. Note how the colors become slightly shaded due to the black coming through in the felting process. The colors are melding into each other in several areas where blue is on top of orange or orange is on top of blue and we see tones being formed. Karey used a good selection of values and brought about an interesting type of visual texture with the mottling that occurs through the felting process. The composition uses geometric and abstract shapes and has asymmetrical balance.

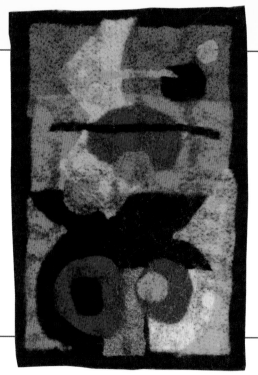

Falling Leaves

by Heather Thomas

17" x 43-1/4"

This quilt features the complementary pairing of orange and blue. The background is a deep shade of blue with heavy black stitching on it. The leaves are rich shades of orange. The borders are a variety of oranges with more shades of blue and black. Each of the two colors is boldly claiming its independence from the other. This is happening in the center of the quilt because of the sheer size and separation of the leaves. It is happening in the border print because so many of the leaves are brighter and more pure hued than the toned and shaded background on which they are sitting. The balance is linear.

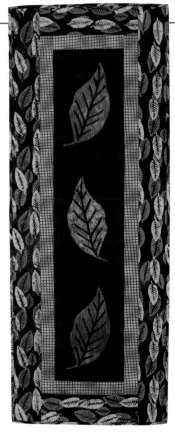

The curve of the leaves gives a sense of motion

The value play creates a nice downward flow and the dark bottom gives the piece needed visual weight

Oak Leaves

by Chris Lawson

15" x 43"

Chris used a wonderful selection of blue greens and red oranges in her oak leaf blocks. The leaves are mostly shades with a few tones thrown in while the backgrounds are mostly tones and tints with a bit of the pure hue. The border print is a lovely tone of red orange with areas of toned blue green. The quilt is a good example of how to balance two equally powerful colors. The blocks contain more blue green than red orange. The red orange border was the perfect choice to bring out the red orange of the leaves. Binding in blue green brings the eye away from the blocks to the outside edge and then back in again.

Gradiance

by Mona Doering

12" x 49"

This fabulous piece features a wonderful gradation of the complementary pairing of red orange and blue green. Mona gradated the colors from dark to light to dark again using a full range of values. Notice where the pale red orange meets the pale blue green and how similar they look when they are that light. Mona used the full color scale including lights, mediums and darks of the pure hues, shades, tones and tints.

159

Using Violet and Yellow or Blue Violet and Yellow Orange

- Violet is the darkest hue on the color wheel and yellow is the lightest. Yellow will become dominate if given the opportunity because it expands. This would be quite jarring to the eye. To make sure violet is dominant, use very little of the yellow or use its shades, tones and tints. Make sure to include pure hues of the violet to insure its dominance, mixing them in various values along with shades and tones if desired. Using complementary color schemes which contain a primary color requires extra care to ensure the primary color does not take over the entire piece. Again remember to use a mix of value and scale. Using color schemes made of secondary and tertiary colors such as the blue violet/yellow orange combination is easier on the eye as neither color, even in its pure hue, is as overwhelming as yellow.

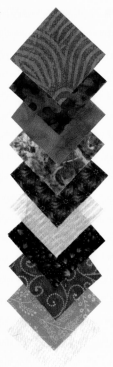

- With the violet/yellow combination, use 3/4 violet and 1/4 yellow. Use plenty of pure-hued violet and little or no pure-hued yellow. Use the shade of yellow which we often call olive, which is really yellow with black added.

- Use the same percentages with blue violet and yellow orange, again steering clear of the pure hue of the yellow orange or use it very sparingly.

- Both yellow and yellow orange when in their purest hues will expand and look like they are larger than they are. This is especially true if they are used with high contrasts surrounding them. Keep this phenomenon in mind when you create around them.

Self-analysis

Ask yourself these questions to help you analyze your progress as you work and finish your project.

1 What skills did I use to balance the power of the two colors in my complementary pair?

2 What kind of impact did the use of value have on my project?

3 How did I achieve balance, unity and variety?

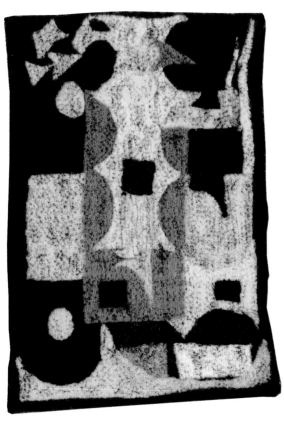

Nothing But Complements

by Karey Swan

6" x 9"

This piece is another portion of Karey's series on complements. It is yellow and violet set on a black base. The violet is so close to black that much of it gets lost. Karey led with a large amount of yellow both in its pure hue and a slight tint. The violet that is included is having a hard time getting attention amongst all the yellow. Though the choice of using more yellow than violet is not suggested, Karey manages to pull it off. Again, because of the needle felting technique, we see texture being formed as some of the black base is brought up through the lighter versions of both colors.

Swirling Mountain Splendor

by Ronda Lambatos

33-1/2" x 20-3/4"

This quilt features a nice blend of the direct complements blue violet and yellow orange. Ronda added pale gray, white and some creamy tans to the composition. The angular blue violet, snowcapped mountains are filled with a myriad of values and color scale and play well off the linear foreground on the lower portion of the quilt. The curving yellow orange ground along the bottom is a perfect counterpoint to the lines and angles above. Ronda added seven leaves blowing just above the ground using a nice selection of yellow oranges, then brought the eye back up to the top of the quilt as she tucked the sun in behind the farthest mountain. The blue vertical bars use Fibonacci sequencing in their width measurements.

The design field is almost a perfect Golden Mean rectangle

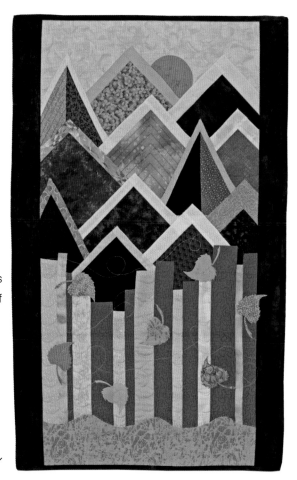

Workshop 4
Complex Complements

Complex Complement Color Scheme Project

Goal: create a piece of artwork from one of the four types of complex complements as you learn to manage complex color combinations

Review:
Direct Complement
 page 67
Contrast page 102
Unity page 120
Variety page 122

Reviewing what you learned in the last study, working with direct complements, will help you move forward with this workshop. Direct complements are colors that lay directly across from each other on the color wheel. With the exception of the red and green combinations, which are temperature neutral, these pairings are all diametrically opposed in temperature. One is warm, one is cool. Violet is cool compared with the warmth of yellow. Blue is cold compared with the heat of orange.

Further work in the field of complements has us adding more visual temperature from one side or the other of the color wheel, and sometimes from both. It also has us playing with three or four colors rather than just two. Choose a different set of colors than you used for your direct complement pairing.

Every time you play with a color you have the opportunity to get to know it better. As you work with it in conjunction with other colors you can begin to understand how it interacts with others and in groups. Colors are like children, they tend to behave like or be influenced by who they are hanging out with. There are four possible complex complement groupings: double complement, double split complement, split complement and analogous complement.

The Double Complement

A double complement is a four color combination. It is achieved by using two colors directly next to each other on the color wheel and their direct complements which yields two pairs of direct complements. When joined together the result is two pairs of very similar colors such as orange and yellow orange with their direct complements of blue and blue violet. Visual temperature is usually weighted evenly in these combinations. This combination is similar to a regular direct complement with high contrasts and contradictions that can be balanced out. However, because four colors are involved rather than two, the grouping is much more complex. Some find it easier to work with two pairs of similar colors because there is an opportunity for greater variety. Use the same principles from the previous workshop regarding percentages of color to be used in your pairings. In this diagram we see yellow and yellow green with violet and red violet all in equal amount and with light, medium and dark values.

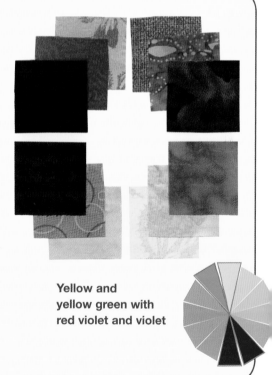

Yellow and yellow green with red violet and violet

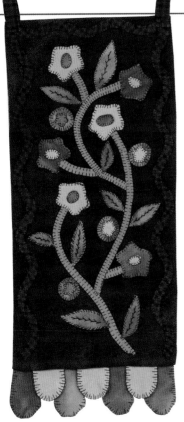

Wool Garden

by Heather Thomas

12" x 29"

This quilt features the double complement of red violet and violet with yellow green and yellow. Wool Garden is mostly tones and shades. It is this matching of the color scale that helps to provide unity. The wool flowers sit on a dark shade of violet. The background helps show off the positive designs in the artwork. The balance is vertical, aided by the wavy red violet on the two long sides and the weight of the "tongues" along the bottom.

Ruby

by Ruth Wolcoff

23-1/2" x 41"

(in the collection of Heather Thomas) Created by one of the first color students I ever had, Ruby is made using the combination of red violet, blue violet, yellow green and yellow orange. She is dominated by the very warm yellow orange background. Ruth used a large variety of yellow oranges in this piece with a small selection of the remaining three colors. You can see how well the four colors work together to form her face. The piece is very abstract, bold and striking. The use of mostly pure hues and shades along with lots of different piecing designs grabs the attention of the viewer and holds it.

The Double Split Complement

This complementary grouping contains four colors. To select four colors, begin by choosing one color such as yellow, skip the color next to it and choose the next color, orange, then choose those two colors' direct complements, violet and blue. This combination is considered by some to be a tetrad. However, after studying color for many years, I agree with the famous colorists Johannes Itten and Josef Albers, that to be a tetrad the colors must be equidistant from each other. Therefore, this combination is indeed a double split complement. This combination is one of the easiest to work with. Though this grouping contains four different colors, the colors that are similar to each other, in this example yellow with orange and blue with green, will blend with each other so there is only one contrast happening, between the yellow/orange pairing and the blue/green pairing.

Yellow orange and yellow green with blue violet and red violet

The Split Complement

A split complement is made by choosing one color and the colors on each side of the first color's direct complement, ignoring the direct complement entirely. An example would be to choose violet then go across to its direct complement yellow, ignore the yellow, but take the colors on both sides of it, yellow green and yellow orange. In this combination, the violet will make the yellow orange and yellow green come together and act like yellow is present creating a subtle yet complex coloration that may feel like an analogous scheme. Again, use the same suggestions for percentages of color from the previous lesson, remembering the overwhelming power of the yellow-based colors and managing them accordingly.

Yellow with red violet and blue violet

Finding Balance

by Gretchen Garnand

30" x 23"

This piece uses the split complement of blue green with red and orange. The negative space was divided asymmetrically with the blue green forming a large "L" around the large rectangle made with deep shades of red. The long rectangles and lines came next, followed by the addition of squares, some layered with more rectangles. The color is distributed quite well with areas of both high and low contrast. The repeat of shape and line along with the placement of color and value provides a nice rhythm that draws the eye from top right down to bottom left and back up again. All in all, it is a very successful composition.

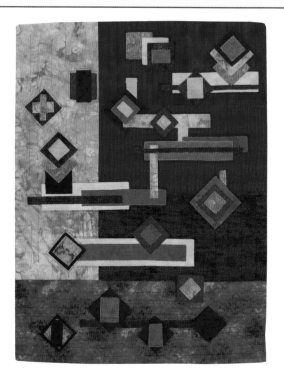

Your Complex Complement Project

Choose one of the four different types of complex complements and create a piece of artwork. Try to show a concentration of one side of your complement and let the other side play a supporting role. Remember to keep balance, unity and variety in mind as you compose. As you think about balancing the disparate colors of the complement, consider using value, not just color, as a balancing tool. With this new project think about what you might like to convey to your audience and see if you can use color to do so.

Self-analysis

Ask yourself these questions to help you analyze your progress as you work and finish your project.

1 In what ways did working with a complex complement differ from working with a simple, direct complement?

2 What criteria did I use to choose the type of complex complement that I worked with? Did I enjoy the process, why or why not?

3 Now that my piece is complete, what would I have done differently?

The Analogous Complement

To get the colors for an analogous complement, choose an analogous color band of three or five colors and then choose the direct complement of the color in the middle of the analogous band. The visual temperature of one of these combinations is usually more one sided, either cool with a little heat or hot with a little coolness. Choose which side you want to be dominant and let the other side play a more submissive role. This color scheme is quite pleasing to the eye as are most analogous based schemes. The analogous colors tend to begin behaving like the center color because of the interaction with that color's complement.

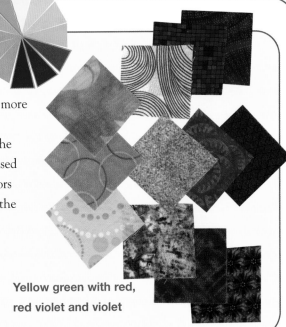

Yellow green with red, red violet and violet

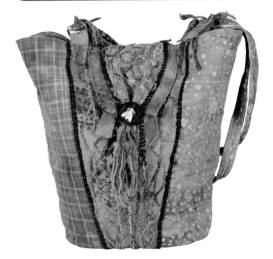

A Bag of Complements
by I.V. Anderson
17-1/2" x 14"

This bag is filled with glorious color; a hot and cold cornucopia! The sides of the bag are pieced from different, pure-hued, blue greens and the center portion is made from a rich shade of red orange. The center section has fibers couched in an array of colors including the analogous scheme of red violet, red, red orange, orange and yellow orange along with more blue green. The colors of the fibers are in pure hues, shades and tones. The couched fibers add loads of tactile and visual texture as well as a focal point.

Undulation
by Carol Ann Waugh
48" x 48"

The lively quilt, below, is filled with bold color and motion. The analogous run of red, red orange, orange and yellow orange provides a hot backdrop for red orange's direct complement, blue green, to dance across. The blue green is a deep shade whereas the remaining colors are present in the full color scale. The placement of the blue green quarter circles provides a wonderful, implied, wavy line moving up and down the surface of the quilt. The blue green looks as though it is behind all of the other colors, due to its cooler temperature. The contrast is a bold and effective use of value, color scale and shape.

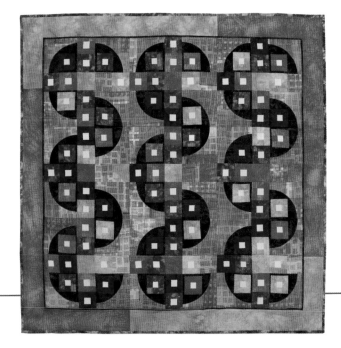

Creating with a Melodious, Analogous Color Scheme

3 Color Analogous Run

5 Color Analogous Run

7 Color Analogous Run

The analogous color scheme can be one of the easiest formats to follow when making art. Many printed mediums, be it paper or fabric, are printed in analogous colorways. The analogous scheme uses three to seven colors that are adjacent to each other on the color wheel without skipping a color. The word analogous comes from the word analogy which means to be alike. For colors to come together and form an analogous run, they must all share one color in common. An analogous run cannot contain more than one primary color, as the primaries share nothing in common with each other.

A Three Color Analogous Scheme

In a true analogous color combination all of the colors included must share a common color. For example, orange, yellow orange and yellow each share the common color yellow. An artwork made from this sparse of an analogous scheme will require lots of variety in value and intensity for it to be both interesting and harmonious. Great care will need to be taken with design and pattern. A three color analogous scheme will most often evoke only one temperature, either warm or cold. Consider using neutrals or a small amount of an accent color for added variety and interest.

A Five or Seven Color Analogous Scheme

If you add more colors to the above grouping to include, red orange, orange, yellow orange, yellow and yellow green the work becomes more interesting and easier to achieve. Add two more colors, green and blue green for a seven color run. All of these colors still have the color yellow in common so a true analogous scheme is maintained. Adding the red orange will intensify the warm temperature, however yellow green and green can greatly cool things down by neutralizing the warmth. The addition of blue green will also cool things down. The colors chosen need to be used in a variety of values, intensities and textures. Remember, interest is added when the colors chosen include clear pure hues and tints as well as the muddier shades and tones.

Choosing a Design for an Analogous Color Scheme

If you have been struggling with an idea for your analogous color study, keep these thing in mind:
• Work on a design that can benefit from a melting together of form, shape and color or a design that does not require great value differences to work, such as Trip Around the World quilts or landscape paintings.
• Consider designs that can rely on minor shifts in value, such as sunsets, water or animals.
• Consider how the color can be manipulated to create secondary designs.
• If you use a design that is best suited to great changes in value, such as a star or Mariner's Compass, consider adding a neutral as a background.

The Analogous Complement

When we look at the colors, blue green and red orange, on each end of the examples below we can see all these colors have the color yellow in common. Green is in blue green and green is made from yellow. Orange is in red orange and orange is also made from yellow.

A four color analogous run of violet, blue violet, blue and blue green shows the cooler side of the color wheel. These colors all have blue in common.

This seven color run includes warm and cool colors; blue green, green, yellow green, yellow, yellow orange, orange and red orange.

The warmer side of the color wheel and a four color run of red, red orange, orange and yellow orange is shown above. These colors all have the color red in common.

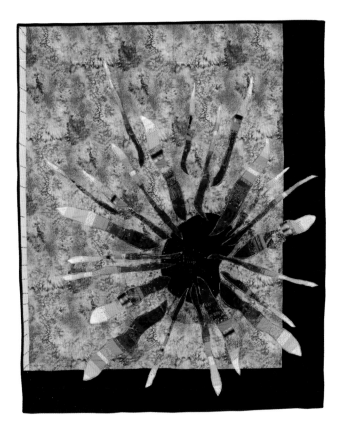

Deep Purple

by Marjorie Eastlund

42" x 34"

This piece has an asymmetrical, radial balance. The explosion of color moves out of a circle that reads as a hole because of its dark, shaded color in comparison to the lighter almost pure hued color surrounding it. The particles that are exploding are made from fabric strips pieced together to make stripes. The colors are red violet, violet and blue violet. Marjorie used a great array of values and radiating quilting lines to create this analogous beauty.

Your Analogous Project

With this project, your goal is to take a group of three to seven similar colors that lay next to each other on the color wheel and bring them together in a harmonious way. The risk, especially with fewer than five colors, is ending up with something without enough contrast and therefore not enough interest. You will need to rely on a mix of values, color scale and textures to add the variety needed to create a work that fully engages you, the maker and the viewer. Keep harmony in mind while composing your design. Use repeats of shape, line, color and value to create a harmonious composition. Remember that movement, direction, repetition and emphasis will effect harmony. Use these principles carefully.

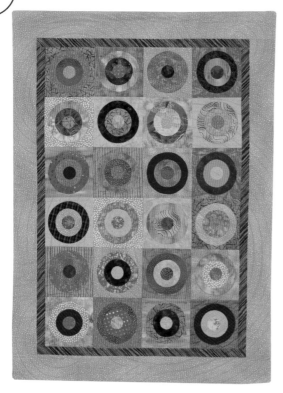

Dot Optic

by Collette Schneider

33" x 24"

This quilt features the analogous run of red violet, red, red orange, orange and yellow orange in a large array of values and portions of the color scale. The repeat of the same block over and over gives it a grid-like, symmetrical balance, but the color play makes it informal. As you look at a set of circles notice how in some sets the outer circle is dominant while in others it is the middle or center circle. It all depends on the intensity, purity and value of the colors at play in the set. The grid is broken up with quilting lines. The stitched, radiating circles help move the eye.

Mom Loved Red

by Susan Westervelt

64" x 64"

The quilt on the right has diagonal bilateral symmetry. If it is folded in half diagonally all of the blocks and colors match up (with a few exceptions). It is made using the short analogous run of red violet, red and red orange. Most of the colors are near the pure hue or are shades. It is an interesting mix of simple blocks and friendship heart blocks with sashing that looks like the soldering in a stained glass window. It has an exotic, Asian feel.

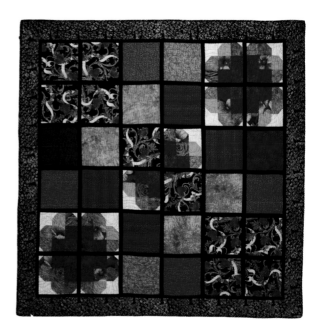

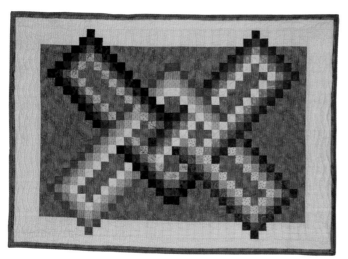

Bargello Knot

by Linda Thompson

28" x 39"

This vibrant Bargello styled quilt features an analogous run that includes both warm and cool colors; yellow orange, orange, red orange, red, red violet, violet and blue violet. Linda cleverly used the direct complements of yellow orange and blue violet for the background and border. Pay special attention to the center of the knot where orange, red orange, red, red violet, violet and blue violet are all working together and getting along splendidly.

An Analogous Color Scheme with Yellow

by I.V. Anderson

8" x 8"

This book is filled with the analogous color scheme of yellow green, yellow, yellow orange, orange and red orange. I.V. made a crazy quilted, embellished block for each page and used ribbons and found objects on the backside of each page. She used a wide range of color scale but led with tones as her backdrop. The book tells the story of the interaction of these colors. With each page she shows us how the colors behave when a different one is taking the lead (the background color). Creating this book allowed her to really explore in depth the interconnectedness of these colors.

Yellow Submarine

by Carol Ann Waugh

25" x 28"

This wonderful piece features the analogous colorway of yellow, yellow green, green and blue green. Carol exploded the color out from the center moving from warm yellow into the neutral greens and on to the cool blue green. The radial balance is made more intriguing with the addition of the vertical spikes of blue green coming up from the bottom and down from the top. The piece has luminosity due to the surround of the bright, intense, pure-hued yellow with duller tones and tints of greens and blue greens.

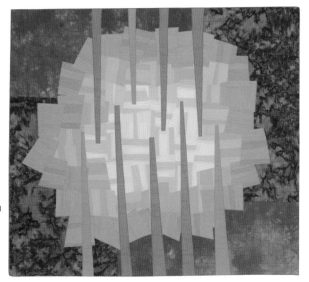

Self-analysis

Ask yourself these questions to help you analyze your progress as you work and finish your project.

1 What elements of design did I use to create harmony in my analogous design?

2 What principles of design did I use to help support the harmony in my design?

3 If my piece has discord rather than harmony, why?

The Harmonious, Triadic Color Scheme

Quick Key
Triad
Three colors. Any three colors that are spaced evenly around the color wheel.

You will need to rely upon your previous experiences with color, value and texture as you begin your triadic creation. Generally speaking, when making quilts using this type of three color combination, only one of the colors should play a dominant role with the other two playing supportive roles.

With this idea in mind you may want to choose the color with the darkest inherent value as your dominant color, use it in its pure hues, shades, tones and tints. The color with the lightest inherent value can be used the least. Do not use its pure hue, rather use plenty of shades and tones. These are only suggestions. There is no reason why you cannot lead with warm shades and tones of yellow and add deep blues and rich dark reds as accent. This is about experiencing the interaction of color, not about right or wrong.

The four triadic schemes

Triads are three colors equidistant from each other on the color wheel. On a twelve step color wheel the triadic combinations are created by choosing every fourth color. The four common triadic schemes are:

- **The primary color scheme** of yellow, blue and red can be very visually strong.

- **The secondary color scheme** of green, violet and orange is softer than the primary triad.

- **The tertiary color scheme** of blue green, yellow orange and red violet and the **tertiary triad** of yellow green, blue violet and red orange are both very harmonious, soft and easy on the eye.

Yellow/Blue/Red

In the primary triadic color scheme, yellow is the brightest color. Red and blue both have a medium dark inherent value. Red however has a bolder personality whereas blue is cool and more reserved. Knowing the characteristics of these colors will help you determine how much of each color to use, as well as which portions of the color scale and values to use.

If you want a predominately blue quilt, choose a wide array of scale, value and intensity to keep the blue interesting. Choose either a bright red or mix it with some of the many shades and tones of red and use them as companions to the blues. Choose a very, very small amount of true yellow for an accent. You may also use soft tones, tints or a smoldering shade of yellow and get away with using more of it.

If you want the colors to play equally in the quilt, you may want to limit the use of red and yellow in their pure hues as they will try to dominate the blue. Adding pure hues of the blue however will keep things lively and bright as they will add sparkle.

Primary
Yellow, blue and red

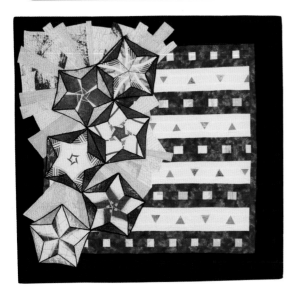

If I Had a Bell
by Collette Schneider
33" x 34"

This quilt, left, is spectacular despite breaking all the rules of working with a primary triad. Collette used pure-hued yellow and red and tones and tints of blue. She featured each color independently using blue as the stars of the flag and yellow acting like the light emanating from them. She used red, pieced with white, as the flag stripes. The bounty of shape and line as well as value makes the piece visually appealing.

If I Had a Yellow Room
by Nancy Mangen
27" x 39"

Nancy broke the rules with her quilt, right, and led with an abundance of yellow in values from very pale to pure hues followed by deep shades. The blue vase adds loads of visual texture and the blue border on two sides adds a nice architectural feel. The roses are the beauty of the piece. They are filled with lots of visual texture and medium and dark values. The leaves are made from dark shades of yellow. The quilting lines help to move the eye of the viewer and aid in dimension.

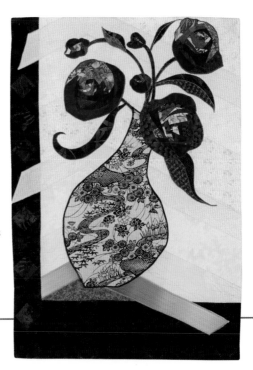

Green/Violet/Orange

This secondary, triadic combination is generally much less dramatic than its primary cousin. Secondary colors are generally less intense than primary colors. Using these colors in a wide array of value, scale and intensity will make an interesting and pleasing creation. Possible combinations to consider are; equal amounts of green and violet in a wide array of values, pure hues, shades, tones and tints. Add a small amount of deep, dark shades of orange or equal amounts of each of the three colors. Use only dark, intense violets, medium shades and tones of green and soft, pale valued tints and tones of orange. Remember, orange is the lightest, brightest color in this combination (warm and close to yellow) so it may try to dominate. Purple is the darkest color and green has a medium intensity. The two will generally not fight for dominance. However, to keep violet from 'shrinking', you may want to include some of it in pure hues or use a good deal more of it in your combination.

Secondary
green, violet and orange

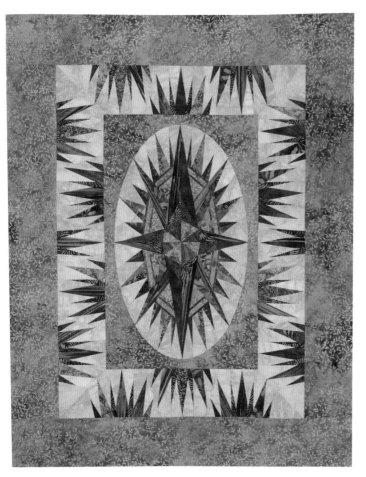

Charting the Heavens
by Heather Thomas
36-1/2" x 46-1/2"

This quilt is a mix of violet, green and orange with a hand dyed background called "parchment" and a lovely batik print filled with light tones of green and violet. Orange is used the least and is present mostly in shades. The violet is the only color used close to the pure hue and the green is shown in shades, tones and tints. Notice how the colors are working together in the center of the quilt. They simply look like they belong together. The parchment background is warm and allows more contrast with the green and violet. The batik repeats the green and violet and strengthens their presence.

The Tertiary Combinations
• Blue Green/Yellow Orange/Red Violet
• Yellow Green/Blue Violet/Red Orange

The two tertiary, triadic combinations can be very soft and are generally the most harmonious of the triadic color schemes. It is easy to make quilts in these two colorways using nearly equal amounts of each of the three colors.

It can be very pleasing to use a different value for each of the colors such as only dark values in shades and tones of blue green with medium values of shades and tones of red violet and only light values of tones and tints of yellow orange. You can also let two of the colors play dominate roles and mix the values and intensities as with red orange and blue violet then use only a tiny bit of an intense, smoky shade of yellow green for an accent.

Whatever you do, remember that any color with yellow in it will try to dominate the other colors. Because yellow is generally the lightest and brightest color, use it carefully and sparingly. The blue green/yellow orange/red violet combination is often called the Florida color mix. It can lead one to think of ocean waters, pink flamingos and the warm sun. The yellow green/blue violet/red orange mix is not commonly used. Most people don't think to use these colors together. However, the three together have a very vibrant energy especially when the pure hues of red orange and blue violet are included with deep shades of yellow green.

Tertiary
blue green, yellow orange
and red violet

Tertiary Triad
yellow green,
blue violet and
red orange

The stitched tree is a wonderful blend of all three colors

Rusted Memories
by I.V. Anderson
5-1/2" x 22"

I.V. is one of the most innovative, talented artists I have ever met. She will make art, good art, from just about anything. With this piece she brings together cotton and velvet fabric with rusted metal, hand stitching, metal objects, beads, wire and buttons. The piece uses the triad of blue green, red violet and yellow orange. The rusted metal base is a deep shade of yellow orange and sets off the soft fabrics and stitch deliciously. The balance in this piece is vertical asymmetry. Each section looks like it is right where it should be.

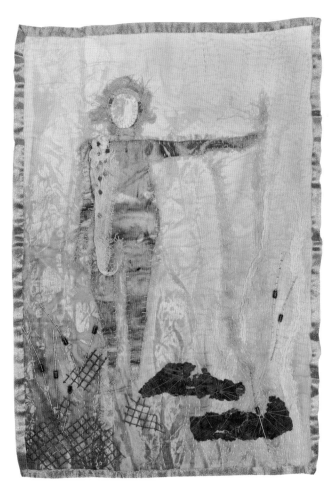

Stitch, fibers, metal and other found objects raise the surface of the piece to add more interest

Remember Who You Are

by I.V. Anderson

12" x 16"

This piece features a very simple mix of the same triad of blue green, red violet and yellow orange. However, the pure hue of yellow orange is the star and the other two colors are playing supporting roles. The shape of the woman is done in a slight shade of red violet and it contrasts well with the purer yellow orange background. The blue green scarf is a tint and it contrasts well with both of the other colors. The balance is asymmetrical with the stitched fibers and metal on the right balancing out the figure on the left.

Your Triadic Project

While working with any of these groups of triads your goal is to manage or balance the colors. Strive to use bold colors in a way that they don't completely overwhelm weaker colors and find ways to get the weaker colors to join in and get the attention they deserve. You are the composer. You have the power to bring the three disparate colors of your triad together and not only make them behave, but triumph. Remember the importance of repeat in a good composition. Use repeat of shape, line or form as well as repeats in color, scale and value to insure good management of your colors. Review the personalities of the three colors so you can better predict how they might influence each other.

Self-analysis

Ask yourself these questions to help you analyze your progress as you work and finish your project.

1 What elements or principles of design did I rely on to manage the three colors in my triad?

2 When I begin a new design do I like knowing exactly what the piece will look like when it's done or do I like to let things happen as they may and why?

3 How do I feel about my finished triad? Do I like it? Why or why not?

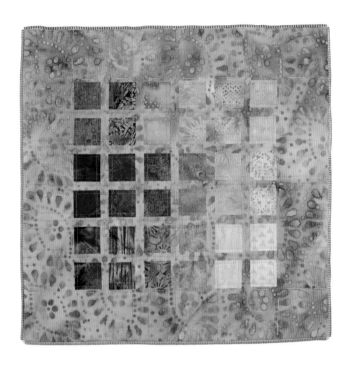

Zippered Triad

by Mona Doering

17-1/2" x 17-1/2"

Mona took her inspiration from a batik that was dyed in the triad of blue green, red violet and yellow orange. She used the simple technique of setting squares in a grid to effectively show off each of the colors in their complete color and value scales. Notice how intense the tint of yellow orange is compared with the tint of blue green. The purest hues of the red violet and blue green are in the background fabric and Mona carefully selected a portion of the fabric that would place them diagonally opposite each other which added interest to the symmetrical, informal grid. She used zippers for the binding, thus the name.

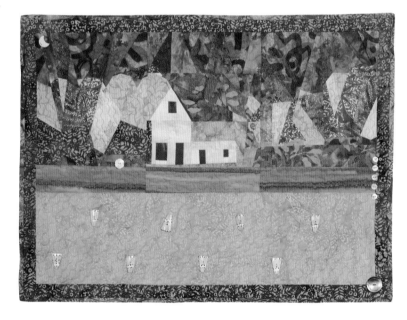

Tribute to Jean Jacks

by Chris Lawson

28-1/4" x 21"

Chris loves to create intricate designs using her own flip and sew, paper piecing methods. In this piece she used the tertiary triad of blue violet, yellow green and red orange and added neutrals for increased contrast. The sky seems turbulent as it is filled with pure hues, shades and tones of blue violet, highly textured fabrics. The visual texture in the prints of the trees make them look like they are swaying and in full bloom. The horizon line is pieced from shades of red orange and provide a peaceful space around the farm house. The foreground with its textured tint of red orange looks like a field just sprouting its seeds. The buttons act like sheaves of grain in the foreground and as decoration elsewhere.

Workshop 7
Tetrads; The Multi-Faceted Four Color Scheme

Tetrad color combinations have a good balance of warm and cool and light and dark. When using this colorway, put to work what you already know. Remember, warm colors pop off the surface and cool colors recede. Also keep in mind how lighter, brighter colors often try to dominate darker, shaded colors.

**Quick Key
Tetrads**
Four colors equidistant from each other. They are pairs of direct complements.

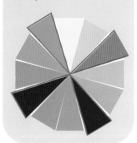

Design choices for tetrad color schemes are limitless. As you begin working in this combination of more colors, find ways to introduce the pure hues, shades, tones and tints, as well as various values of the colors in your chosen grouping. Remember to ask your colors to do what they are capable of and no more. Do not expect a bright yellow to be demure just because you are using very little of it. Likewise, don't expect a pale, dusky, teal to vibrate just because you are using big chunks of it in obvious places.

You may choose a fabric or paper that is a tetrad. A lot of commercial fabrics use this color combination because it is so pleasing to the eye. However do not limit your remaining color selection to only the values present in your main fabric or paper or your end result may be boring. If your main fabric or paper has medium valued varieties of red, green, blue violet and yellow orange, you may want to add some dark shades and light tones and tints of all four colors.

Again, these tetrad groups are made up of pairs of direct complements. Review the information and suggestions given earlier for working with direct complements. Use the percentages given for usage amounts of each of the colors.

This color combination includes built in variety with the color choices. It is your job to create unity. This is best done by matching the color scale with the four colors. This means if you use shades in one color you should use shades in all four colors; tints in one color, then use tints in all four and so on.

Adding Some of the Principles of Design

As you begin designing your tetrad study, look over the principles of design and at your past projects. If there are any of the principles that you have not used, consider using them now. If you have never designed with dominance or repetition or rhythm in mind, now is the time. If you have not yet used the Golden Mean or Fibonacci sequencing, then there is no time like the present. You will never know how these tools can work for you until you start using them. Some of the principles of design will come easily. You may have been using them in your artwork all along but never knew there was a name for what you were doing. Other principles may seem daunting, but they are not, they are merely tools. You can try to determine their efficacy in your artistic journey.

Tetrads

A tetrad is made when using four colors that are equidistant from each other on the color wheel. On a twelve step color wheel, choose every third color. Tetrads are made using pairs of direct complements.

The three possible tetrad combinations are:

1 red/green/blue violet/yellow orange

2 yellow/violet/blue green/red orange

3 orange/blue/yellow green/red violet

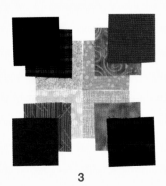

1 2 3

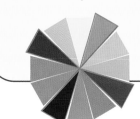
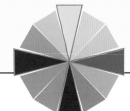
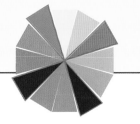

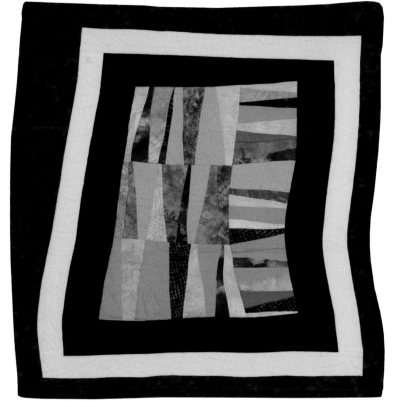

Gee's Curves

by Jan Lepitino

26" x 24"

Jan's funky, little art quilt features the tetrad of red, green, blue violet and yellow orange and a primitive style not unlike the quilts of Gee's Bend. The pieced center is dominated in space by pale tints of blue violet, but the slim segments of bold, bright reds and yellow oranges are getting the most attention. The few green tints are barely noticeable. The wavy borders add movement to the busy center yet manage to calm it down. The sharp points and angles in the piecing are filled with energy and the curved quilting lines moving in all directions pull that energy with them.

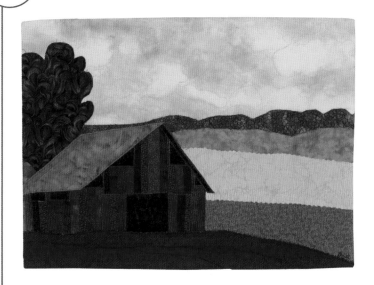

Tennessee Tobacco Farm

by Gretchen Garnand

18" x 13"

This peaceful scene is pieced from the tetrad of red, green, blue violet and yellow orange. Gretchen included a variety of shades and tones of both the red and the green. She has only one blue violet - the pale sky - and one yellow orange - the golden field. The only pure hue is the strip of green just below the far off hills. The piece has a serene, naïve feel to it along with a nice visual depth and great visual texture provided by the quilting lines.

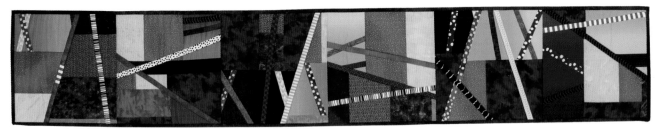

Chopped Blocks

by Collette Schneider

62" x 11"

Chopped Blocks uses a tetrad of red, green, blue violet and yellow orange. They are used in bold pure hues and deep rich shades. The narrow strips and angles add a wonderful playfulness to the piece. It is the yellow orange and red that grab our attention as they pulsate forward. The green and blue violet are more demure and mostly sit in the background.

Sunglow

by Collette Schneider

16" x 38"

This quilt uses the tetrad of violet and yellow (with some yellow orange present) and red orange and blue green. We see the warm pure-hued red orange and yellow/yellow orange before we take notice of the remaining colors. The blue green is getting some attention because it is lighter hued but the violet is sitting deep in the background and is barely noticed. The sheer size of the red orange inner border stifles some of the movement provided by the pieced blocks it surrounds and one wishes it were a little narrower so that the funky blocks could dance more. Still, it is bold, wonderful and colorful.

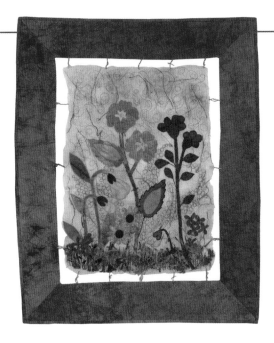

Garden

by Lisa Sullivan

19" x 24"

Lisa used the tetrad of orange and blue with red violet and yellow green. She began her composition with a sheer backdrop of blue and added a bounty of flowers in red violet, orange and more blue. She filled in with an abundance of various yellow greens. She mixes up the color scale as she includes pure hues, tones and tints. The tone of red violet she chose for the outer border is a perfect finish to this delightful little scene. The fibers she used to stitch the center to the border adds to the delicate feeling of the flowers and speaks of Lisa's skill at composition.

At the Center

by I.V. Anderson

12" x 9-1/2"

This mixed media piece features the tetrad color scheme of yellow green, red violet, blue and orange. I.V. skillfully used nearly the full color scale of orange, beginning with the bold copper topped by the dull, rusted tone of metal. She saved the shade of orange for the center to rest the pure-hued blue fiber and beads on. The yellow green painted batting provides a nice ground for the orange and blue to sit on. The red violet surrounding the orange is a pale, dirty tone. The wooden frame is dark brown which is the deepest shade of orange available and the rusted circle of dark orange is the perfect counterpoint to the blue.

Your Tetrad Project

As you can see with these fabulous tetrad samples, this combination is very complex and provides built-in variety with its four disparate colors. It is your job as composer to balance and manage the interaction of your color choices. Matching the color scale will add instant unity. You could start by looking through your stash for a fabric, paper or other media that is made from the four colors in any one of the three tetrad groups. Next gather up loads of other materials in the various values and color scale of the four colors. Remember as you create this new piece of work to use some unfamiliar tools from your list of design principles. Our goal at the end of this study is to be skilled in the use of color as well as the other elements and principles of design. You will never get comfortable with them if you don't use them.

Self-analysis

Ask yourself these questions to help you analyze your progress as you work and finish your project.

1 Before I began my tetrad project had I ever used a tetrad before? Why or why not?

2 After choosing which tetrad group to work with, did I think the four colors included "went" together? Why or why not?

3 What new principles of design did I use with my current project? How did they aid me in my composition?

Workshop 8
Luminosity; Creating with Light

The word luminous means to emit self generated light. In art making this effect can be achieved through the manipulation of color, value and intensity. Each element affects the other and directs or repels light. Essentially, when trying for the illusion of luminosity, the artist is deceiving the eye of the viewer into thinking they are seeing light emerging from, shining through or being reflected off the surface of the artwork. The key to getting this phenomenon to appear is to use contrasts in hue, value, intensity and visual temperature.

Luminosity Project

Goal: create a piece of artwork that uses a light source relying on contrasts of purity and value

Review:
Inherent Value
 page 56
Visual Temperature
 page 58
Intensity page 62
Color page 96
Value page 97

When trying to achieve the special effect of luminosity, include the full color scale. Choose your lights first. The easiest way is to choose colors closest to white on the color wheel. Use pure hues and tints and stay away from the duller shades and tones for the areas you want to glow. Begin adding your darks, including lots of shades and tones. Use your lights in the smaller areas of the design and surround them with darks rather than neutrals. Once you think you have achieved the color/value contrast you feel will make your piece glow, turn off the lights in your studio and look at your combination. The area you want to glow, should be glowing and the rest of the colors should be difficult to see. If this does not happen in the dark, it most certainly will not happen in the light. Adjust your values and intensities as needed.

The tips of a star will glow if they are pale yellow and their background is deep, dull violet. The same tips will fade away if their background is white, cream or gray. Those tips will be easy to see if the background is red, but they probably won't shine. The light, purely colored tips need darkness or dullness to make them shine, much like the stars at night. The stars are still there in the daytime, they simply need the darkness to surround them before they can be seen.

Play around with your color selection before you start creating. Use what you have learned in past lessons and look over any notes you have made. Look through books and magazines and find examples of artwork with areas that seem to glow. Pay attention to the color placement, values and contrasts to see if you recognize what color techniques were used to create the luminosity.

Tools for Working Toward Luminosity

- **Surround.** Surround light pure colors, such as yellow and orange, with dark, duller colors such as violet, navy or black. A pale pure-hued blue green can work in the same manner.

- **Size often matters.** Use light colors in small areas surrounded by dark colors in larger areas.

- **Intensity matters.** Choose purity in the lighter colors and less intense dullness in the darker colors..

- **Temperature matters.** Warm, light-valued colors shine when surrounded by cool, low-intensity colors.

Dream Tree

by Heather Thomas

19-1/2" x 19-1/2"

This piece is filled with luminosity. There is a beautiful glow that emanates from the center, behind the tree. This was accomplished by using very light, yellow oranges in that area and surrounding them with increasing darkness. The tree is made from black silk organza and is transparent, which increases the luminosity in the center. All the fabrics in the outer border area are black and cream batiks. Because of their coloration they have their own luminous quality and draw out the light from the center.

To add interest the inner "L" border is pieced on only two sides

Renaissance Beauty

by Heather Thomas

33-1/2" x 45"

I designed this quilt to look like a stained glass window. It has the dimensions of a near perfect Golden Mean rectangle. Hand-dyed fabrics, which have their own inherent luminous quality because of the presence of light and dark areas, were used throughout. The yellow areas glow more than anything else and the light, blue green areas are a close second. Though the piece contains very little dark, the narrow black "soldering" between the colored sections provides something for the luminous color to reflect off. The balance is formal symmetry.

At the Cross

by Donna McGregor

18" x 28"

This is a very nice example of luminosity created in a very modern, stylized art quilt. Donna used a huge variety of values and most of the color scale along with a contrasting color scheme. She used yellow and yellow orange in bright pure hues, then muted down the edges with a soft patina of gold paint to make the center cross section look both aged and homogenized with its surroundings. The background area is filled with dull, muted varieties of blue green, red violet and red orange. The composition is cleverly done and the implication of a cross is clearly there, but not instantly obvious.

The value changes in each of the rows give the appearance of light shining through from the back

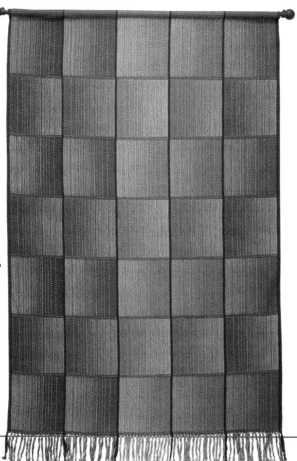

Woven Windows

by Janice Ford

32" x 51-1/2"

This beautiful woven wallhanging has luminosity throughout which makes it look backlit. Notice the value changes in each of the single colored, vertical rows. Janice used a lighter and a darker value of one color in each of the "blocks" in each row; however, she alternated which side was lighter and which side was darker, creating a movement of light across the surface. Here, it is the value play rather than the actual color or the addition of darkness that is making the piece glow. The balance is bi-lateral symmetry. If the piece was folded in half side to side the sections would match up but not the color. However, when folded in half top to bottom the sections, colors and values line up.

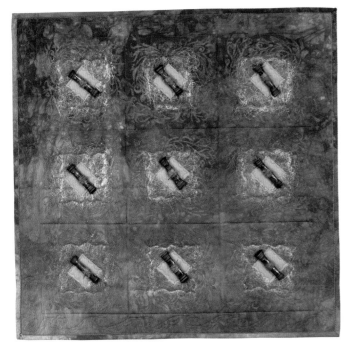

Blue Baroque

by Heather Thomas

19-1/2" x 19-1/2"

This little piece uses materials that contain their own luminous qualities; metallic paint, shiny Angelina® fibers, sheer silk and Textiva® film. The somewhat dull, toned blue background provides the perfect backdrop for the shiny elements layered onto each of the nine squares. The heated Textiva® film around the rolled fabric beads has the look of oil on water with a full color range, highlights, lowlights and areas of burnt-out dullness. The products are layered with lowest luminosity on the bottommost layer up to the highest luminosity in the beads. The balance is symmetrical and the decorative machine quilting in the border adds a nice finish.

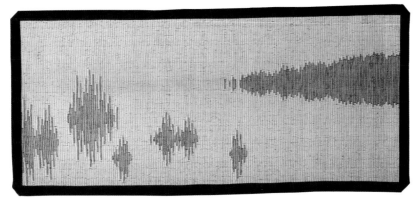

The pale orange color gives the impression of the sun setting on the horizon

Marsh Dawn

by Janice Ford

43" x 19-1/2"

This woven piece uses a very small color range with a large value contrast. There is a nice glow where the pale orange color moves across the horizon line. This luminous quality is enhanced by the areas of simultaneous contrast that occur at the edges where dark meets light. The piece has a serene, yet eerie quality to it. It is asymmetrically balanced.

Your Luminosity Project

Your goal with this workshop is to create a piece of artwork that uses a light source. That light can come from within, from behind or from an external source. You must rely heavily on contrasts of purity and value to achieve this goal. Remember to use the "lights off" test with your materials prior to beginning your project.

Self-analysis

Ask yourself these questions to help you analyze your progress as you work and finish your project.

1 What tools did I use to create my luminous piece? Did the materials I chose behave in the manner predicted? If not, do I know why?

2 Did I use the "lights out" test to see if my chosen materials would illuminate?

3 Do I appreciate the opportunity to learn a special technique such as creating with luminosity? What, if anything, do I think learning to use this tool can do to help me make better art?

Workshop 9
Temperature; The Ever-changing Sensation of Warmth and Cold

Temperature Project

Goal: create a piece of art filled with visual temperature

Review:
Inherent Value
 page 56
Visual Temperature
 page 58
Intensity page 62
Contrast page 102
Balance page 110
Variety page 122

Quick Key
Color Temperature
Warm: red orange, orange, yellow orange, yellow
Cold: blue green, blue, blue violet, violet
Neutral: red violet, red, yellow green and green are temperature neutral colors.

When we think of quilts we often think of the physical warmth they provide. We do not usually think about the way their visual temperatures can affect us spiritually, physically and emotionally. When we begin to view quilts as artwork we free ourselves to experience them in new ways and feel their impact on many levels. Color, line and shape are the controls that evoke feeling in a piece of art. Visual temperature is controlled by color.

Generally speaking, once we remove the red violet, red, yellow green and green from the color wheel we can divide it in two halves, one warm and one cold.

WARM: red orange, orange, yellow orange and yellow

The warm side consists of all the red orange through yellow colors. These warmer colors seem to jump off the surface of a work of art and are called advancing colors.

COLD: blue green, blue, blue violet and violet

The cold side contains blue green through violet. These colors seem to lay back behind the warm colors when used together in a composition, thus they are referred to as receding colors. This relative temperature can only be counted on when the color is in or very near its pure hue and is standing alone or with other colors of the same temperature family.

TEMPERATURE NEUTRAL: red violet, red, yellow green and green

Temperature neutral colors, red violet, red, yellow green and green, tend to behave like the colors they are associating with. They neither advance nor recede, but rather, they sit on the mid-line or mid-plane. They have no strong temperature on their own.

As soon as we begin to change the scale of a color or mix it with colors that have a different temperature, the visual temperature of that color may also begin to change. When black is added to blue to make it a rich, dark navy and that navy is placed next to a dark shade of red, navy will begin to behave like the dark red and meld with it, thus lessening the visual contrast. However if you place a purer hue of blue next to the same dark shade of red, it will recede and play off the red with fabulous contrast. Remember, value is always relative.

The addition of black to any color (shades) will make that color seem warmer. The addition of white to any color (tints) will make that color appear cooler. This is true with background areas too. Cool colors on black will appear warmer and warm colors on white will appear cooler. Adding gray to any color will dull its temperature.

When adding neutrals to a composition, remember they too have a visual temperature. Black is generally warm and white is generally cool. Tans can vary in temperature depending on what has been added to them to make them tan. Some have added yellow and are warm in tone, while some have added blue and are cooler in tone. The warm black will recede when used with bright, pure hues. However, white used with pure hues will vie for dominance.

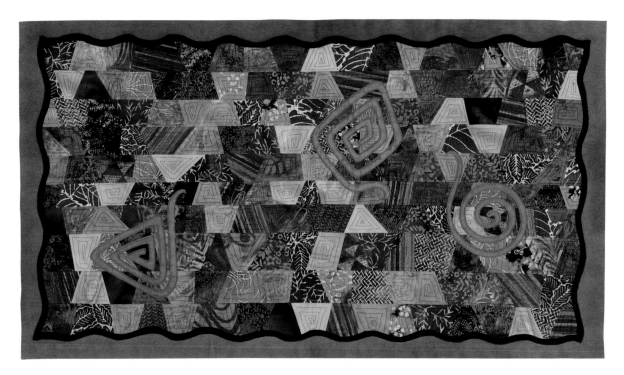

Suede Swirls

by Heather Thomas

32" x 18"

This quilt is made from a large mix of red violet and yellow green in shades, tones and tints. The areas occupied by darker tones of both colors seem to blend to gray and it becomes difficult to tell where one color begins and another ends. The center is made of cotton and was quilted then set on top of ultra-suede. The swirls were added in a toned tint of yellow green and the wavy inner border in a dark shade of red violet was added last.

Your Color Temperature Project

For this lesson it is your goal to create a piece of art filled with visual temperature. You will quickly learn how the visual temperature of a color can change as the color scale changes. Choose one of three modes; a really warm/hot piece, a very cool/cold piece or a piece that has the two temperatures playing off each other. The end result should be a piece that causes the viewer to immediately feel hot, cold or the dichotomy of both.

Self-analysis

Ask yourself these questions to help you analyze your progress as you work and finish your project.

1 Which temperature did I choose to create and why? Do I think my piece is successful?

2 How did I maintain the integrity of the temperature of the colors I chose to work with?

3 As I was working on my piece, did its visual temperature affect my physical temperature in any way?

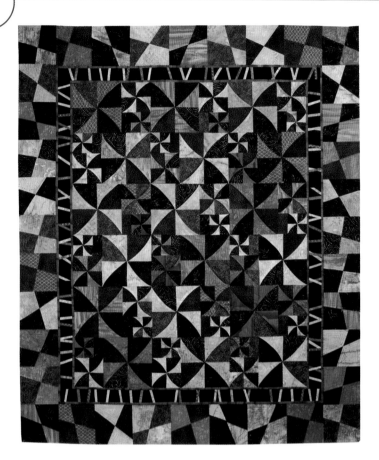

Fandango

by Heather Thomas

67-1/2" x 80"

This large quilt is packed with the warm shades of yellow orange, orange and red orange with a hint of red violet. The background is a mix of warm blacks which support the warm colors perfectly. The accent of a cool blue green in the center and as thin inner borders adds an element of surprise as it breaks up the field of dancing, three dimensional pinwheel blocks. The piece is jam-packed with movement and rhythm. The variety of warm colors as well as the various sizes and placement of the blocks adds variety. The balance is crystallographic with the color scattered about the surface willy-nilly. The inner border adds a nice break with its slashed lines.

Hot! Hot! Hot!

by Heather Thomas

29" x 38-3/4"

I thought this piece was really hot until I made the piece above. This quilt is filled with shades, tones, tints and pure hues of yellow orange, orange, red orange, red and red violet. Though it is certainly warm, it lacks the real heat that the title implies. This is because of the tints, tones and red violet. The tints are not nearly as warm as shades of the same color and the tones dull the heat in the colors around them. The red violet, and there is a lot of it, simply is not taking on the warmth of the other colors. This is probably because their warmth is being depleted in so many other ways. It is a great warm colored quilt, but it is not so hot.

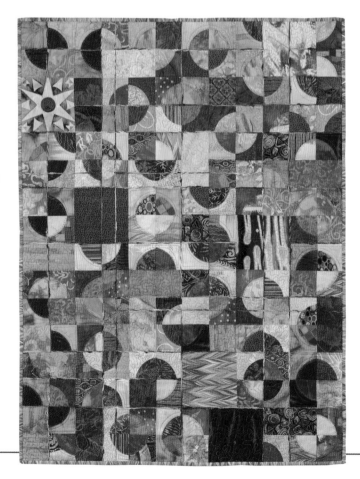

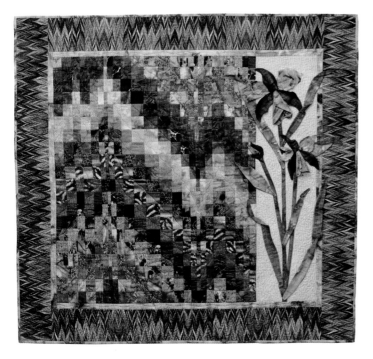

In a Cool Garden
by Heather Thomas
40" x 38"

This piece is nice and cool, but it is not cold. It is filled with all the right colors, blue violet, violet, blue and blue green, but it also includes yellow green and red violet, both of which are temperature neutral. Most of the colors are shades and tones which deplete some of the color's coolness. The outer border contains more tints than the rest of the piece, bringing with it a drop in temperature. However, the tone of red violet behind the tall orchids feels rather warm as does the streak of red violet in the Bargello section. The balance is asymmetrical with the flower on the right balancing the upward movement of the Bargello section on the left. The dimensional flowers add depth.

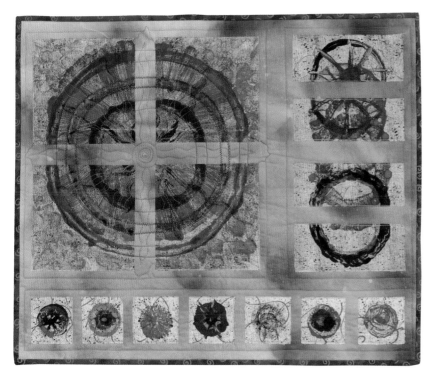

In the Beginning
by Heather Thomas
24" x 20"

This piece is made from hand-painted, dye-painted and mono-printed fabrics. The colors include an analogous range of mostly cool colors, from yellow green to violet. Most are used in their pure hues or tints, but some shades are present and some tones were formed due to the nature of paint mixing which dulled their temperatures. Chopping up the large circle and the three layered circles added interest and negative space. The variety in all the circles heightens that interest. The unity was instant because of the analogous colorway and the repeat of a simple shape. The balance is asymmetrical with the large "L" formed by the row of circles on the bottom and right hand side, balancing off the large circle on the left.

Workshop 10
Transparent Illusions

Transparent Project

Goal: show illusion of transparency with or without using actual transparencies

Review:
Intensity and Saturation page 62
Direct Complement
 page 67
Color page 96
Value page 97

The word transparency implies the ability to see-through. For something to be transparent you must be able to see through it. Most of us are working with cotton fabrics that are not see through, rather they are opaque. So we want to create the illusion of transparency. We want to make our work look as if one color is crossing over another and forming a third color where the two original colors overlap. In quilt making, the illusion of transparency can be achieved when two colors (parents) are seemingly overlapped on top of each other forming a third color or 'child'. Choose a simple pattern that can showcase at least three adjacent areas then choose colors that will give you the desired effect.

Ideas for Creating the Illusion of Transparency

- **Value Transparency -** Use three values of the same color, one light, one medium and one dark. Place the medium valued section between the light and dark sections to give the illusion that the light and dark are overlapping and thus showing through to the medium value.

- **Color Transparency #1 -** Use a three color analogous run such as blue, blue green and green or blue, green and yellow. Place the middle color in the run between the first and third color to make it look as though the other two colors are overlapping and creating the center color. Add to the sense of transparency by making the first color a light value, the middle color a medium value and the third color dark.

- **Color Transparency #2 -** Use a material with two colors as the transparent 'child' and place it between the two 'parent' materials. For the 'parents', use materials that are the two separate colors found in the 'child' material. It will look as though the two separate colors on each side were swirled together to form the mixed color in the middle. An example would be a print with yellow flowers on a blue ground in the middle with yellow on one side and blue on the other.

- **Complementary Transparency -** Use any two direct complements and a brownish gray that has a visual base of either one of the colors in the transparency. Make sure to place the gray between the two complements.

- **Intensity or Saturation Transparency -** Choose one highly intense (pure hue), one mid intense (shade or tint) and one low intense (tone) all from one color family. Position them in high, medium, low order to make it look as though the high and low are overlapping to show the middle.

This is my favorite transparency in the piece since it is a perfect blend of both 'parents'

1

2

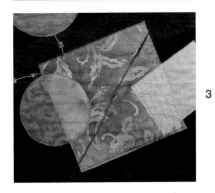

3

Flotsam and Jetsam

by Heather Thomas

17" x 39-1/2"

Using a large variety of batiks in mostly warm colors and a selection of sheer organza strips, I created this stimulating mix of floating shapes. Notice how each small group of circles and squares is made of three or more fabrics. One fabric shape is made to look as though it is overlapping another fabric shape. Where they overlap, a third fabric is used to show the transparency. The addition of the see-through organza adds even more transparencies as the strips physically overlap the fabric transparencies already formed. In the close-ups above it is easy to see how the various transparencies were formed.

1 The first 'parent' is a mottled tone of red violet, the second 'parent' is a pure hue of yellow orange with small angled lines. The middle fabric, the 'child', has both colors with the stronger yellow orange dominating and the weaker red violet used in crosshatched lines—a perfect child for these two parents and a great illusion of transparency.

2 There is a value transparency with the circle and square and a color transparency with the rectangle and square.

3 There is an analogous transparency on the left and an intensity transparency on the right.

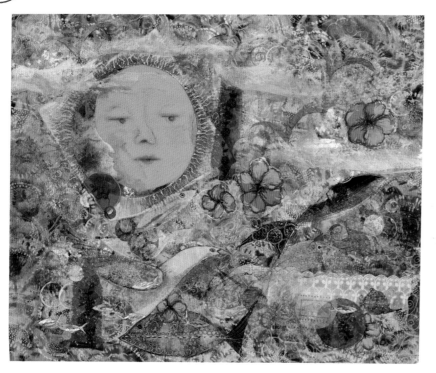

Mother Moon's Migration

by Robin Sruoginis

33" x 27"

Robin's exceptional collage is built upon one transparency after another. The blue/blue green background is made from layers of opaque and sheer fabrics as well as layers of paint and stitch. Note the flying fish, some are entirely see-through, with the blue background melding into their yellow green bodies. The moon is also made of layers, with ink, paint, fabric and piecing. Robin uses the tool of transparency to create a very effective illusion of the dream world. She relies on the collage technique of layering one material on top of another to form new and interesting effects as she tells a complex story filled with luscious imagery.

Child's Play

Maker unknown, in the collection of Heather Thomas

18-1/2" x 21"

This is one of the best transparency projects I have ever seen. So simple and so right. See-through balloons overlap and show the new color formed by the two colors of the balloons.

Your Transparency Project

Before you begin, review the types of transparencies listed in the introduction of this study. Look through your stash of materials and find 'children' and then search out their 'parents'. It is often too difficult to do the other way around. Your goal is to show the illusion of transparency. However, there is no reason you cannot add actual transparencies as well.

Tips to Help You Get Started

Transparencies are hard to produce when using colors not closely related to each other. When working with disparate colors, shades and tones are produced. These new colors are often hard to predict and difficult to find in ready-made form. Working with colored pencils, crayons or watercolors can help you determine what these overlays might look like.

- **Experiment -** If you have a hard time understanding this illusion, try working with see-through organza ribbons. Simply weave several different colors together and you will begin to understand what you are trying to achieve with this exercise.

- **Use Simple Blocks -** Simple blocks to use when studying transparency are Nine Patch, Card Trick (4 colors), Ohio Star and Monkey Wrench.

- **Materials and Techniques -** Work with a variety of materials and techniques such as painting, especially watercolors, weaving and beading with transparent beads.

Transparent Illusions

by Eileen King

21" x 48"

This traditional quilt block is the perfect milieu to show the illusion of transparency. Eileen used four carefully selected fabrics to create the blocks. One 'parent' is seen in the pure-hued blue triangles, the second 'parent' is the toned green and the 'children' are the small squares of shaded blue green. It looks as though a large green transparent square was set on top of the four blue triangles and the smaller squares are where you can see through the green to the blue. Perfection!

Self-analysis

Ask yourself these questions to help you analyze your progress as you work and finish your project.

1 Which type of transparency did I choose to use and why?

2 What elements of color did I need to utilize to build a successful transparency?

3 Can I see the value of learning this skill? How do I think I could use it in my artwork in the future?

Workshop 11
Creating Depth and Dimension

Depth & Dimension Project

Goal: create a piece with perception of depth, perspective and dimensionality

Review:
Visual Temperature
 page 58
Intensity page 62
Value page 97
Size and Scale
 page 98
Contrast page 102

Throughout this color and design journey of discovery you have learned that value and contrast rather than color alone help determine the design in an artwork's composition. Value and visual temperature are also the determining factors in creating a sense of depth in a one dimensional work such as a quilt top or painting.

Remembering what we already know about value, namely that it is relative, as well as what we have discovered about the visual temperature of color, we can use our knowledge to create works that come alive and seem to move forward and back in a three dimensional way.

Once we understand that along with the actual composition, value and visual temperature create depth, then we can look at choosing materials for our creations in a different way. Instead of choosing materials for their color only, we can also choose them according to their value differences. The design elements for a depth-centered quilt are limitless. Some traditional blocks are attic windows and tumbling blocks. Both blocks use a repetition of light, medium and dark values in a constant position to give a sense of depth.

You have probably discovered that many of the 'rules' of color do not always apply. We learn through experience that light colors do not always advance and dark colors do not always recede. We cannot always count on value differences to give us what we need; other factors will likely come into play. Visual temperature can overwhelm value importance in a composition. For example, a warmer dark color may advance while a cooler light color recedes. Intensity of color will also contribute to depth. Bright, pure-hued colors will advance while duller shades and tones will recede. Contrast of extension will also determine depth. Small sections of intense color will advance when surrounded by large sections of less intense color. Size and placement will also play a role in depth perception. A large rock placed near the bottom edge of a quilt will appear to be closer to the viewer than a small rock placed near the upper edge.

Color and Design Elements to Remember When Creating Depth and Three Dimensionality

- **Light advances,** dark recedes.

- **Warm colors advance,** cool colors recede.

- **Pure hues advance,** less intense colors recede.

- **Small sections surrounded by large sections advance,** large spaces recede.

- **Large design elements near the lower edge advance,** smaller design elements near the top edge recede.

- **Value plays a huge role in dimension.** Three-sided objects should be colored with one side light, one medium and one dark.

Wines and Vines D'Italia

by Ronda Lambatos

36" x 27"

This expertly designed quilt shows how to use descending scale to create a sense of depth. Ronda used a decrease in the size of all her design elements as they move farther away from the eye of the viewer. Look at the stone wall on the left and note how the stones become smaller, closer together and less defined as they move toward the innermost arch. The large rocks along the path and the bricks in the path do the same thing. The arches become smaller, closer together and less defined as they move farther back in the picture. Only the arch and leaves closest to the viewer are large and well defined. The physical arch that forms the top of the quilt along with the life-like leaves are a perfect way to add a sense of realism.

As the Moon Glows
Off of Snow and Aspens

by Tamara Leberer

9" x 13"

This quilt is quite small, but its perception of depth is great. Tamara used scale, as well as value and careful positioning in the foreground to create the effect of depth in this small slice of an Aspen grove at night. The quilting lines in the snow correspond with the bases of the trees adding an even greater sense of depth perception.

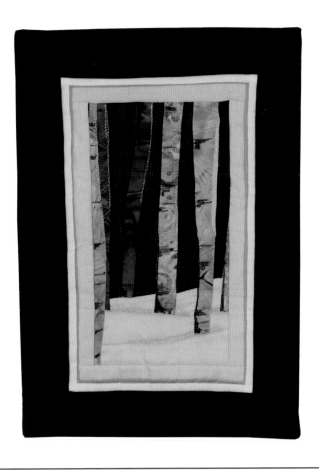

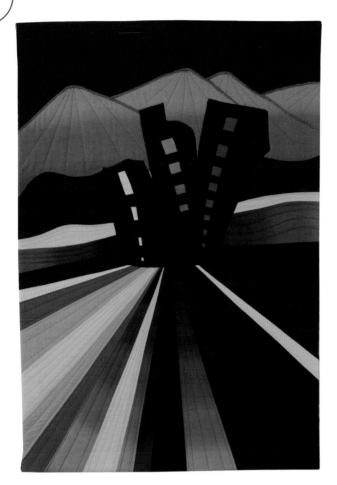

All Roads Lead to Denver
by Nancy Magnen
33-3/4" x 22-3/4"

This thoroughly modern depiction of a city/mountain landscape shows depth through the use of linear perspective. Nancy made all the lines leading up to her city get smaller and closer together the nearer they got to town. This not only creates depth in the picture, it directs our eye. She was also very careful in her choice of colors and values. There is a light source beginning in the lower left hand corner that moves up to and through the windows of the buildings to the mountains behind.

Ode to Ellen Oppenheimer
by Gail Eamon
49" x 28"

There are only two colors in this piece, a pale cream and a dark, mottled brown. It is not color contrast that is creating this wonderful, op art, continually moving 3D piece of artwork. Instead it is the use of descending scale that is driving the illusion. With just two contrasting values and a narrowing and widening of space, this illusion is magically created.

Quilted Cubism

by Eileen King

24" x 24"

Eileen used many different values to create the depth present in her cubist quilt. Looking at just one of the cubes we can see the inside of the cube is a medium brown, the top is a light mottled cream, the right side is a slightly darker cream/gray print and the left side is a darker black/tan print. On the lower inside edges she used a bright white. All of these value changes drive the composition and provide visual depth. The stark black background is the perfect backdrop for the floating cubes.

Your Depth Project

Whether you want to show perspective or three dimensionality, more than color contrasts must be used. You will also need to rely on value and scale. There are many books on the market with instructions for making three dimensional looking quilts or landscapes. Feel free to use any of these as a jumping off point, but remember to use them as reference only and do not be tempted to copy.

As you are working on your piece, step away from it regularly to see it from a distance. This will help ensure that you are actually achieving what you are after; the perception of depth, perspective and dimensionality.

Self-analysis

Ask yourself these questions to help you analyze your progress as you work and finish your project.

1 What tools did I use to create a sense of depth, perception or three dimensionality in my piece?

2 Where did the inspiration for my piece come from?

3 What did I learn about creating a sense of depth?

Workshop 12
Simultaneous Contrast

Depth & Dimension Project

Goal: fatigue the eye into seeing another color formed or into seeing sizzle and movement

Review:
Intensity page 62
Size and Scale
 page 98
Contrast page 102

What is a simultaneous contrast and how can it be used in making art? We have learned about different forms of contrast: hue, light/dark, complementary, saturation and extension. Now we will try to come to an understanding of simultaneous contrast. Simultaneous contrast comes from using two pure-hued complementary colors right next to each other. When complements are used in the same scale and juxtaposed they intensify each other causing the eye to move rapidly from one color to the next resulting in an optical vibration that makes the colors shimmer. This effect can also be evident when using intensely valued colors that are near complements.

The rule of complementary colors is a fundamental of color principles. The eye requires the complementary color and will see it spontaneously even if it is not present. To prove this effect, try looking at a sheet of bright green paper, then at a sheet of white paper. You will see an afterimage of red. Red is the complement of green. This effect is also apparent when using strong pure hues with gray or white backgrounds. A pale, pure gray placed behind a strong, vibrant pure yellow will look violet around the edges of the yellow, because violet is the direct complement
of yellow.

When using two pure hues that are near complements such as orange and green, the inherent personalities of each

color will be changed. Orange will start to behave like red to complement the green or the green will begin to act like blue to complement the orange. This illusion of color change can be best seen where the two colors come together.

All of these effects are sensations in the eye of the viewer and are not objectively present. They are very difficult to reproduce or photograph. The effect is generally only present when colors are used in their pure hues. Shades, tones and tints do not provide the same intensity as pure colors in this form of contrast, but can be used with different effects. Adding white to colors with inherently light values, such as yellow, intensifies the color. Adding white to colors with inherently dark values, washes out that color. The opposite is true with black. Adding black to an inherently light color takes away its brilliance, but adding black to an inherently dark color intensifies its depth. Adding gray to any color will dilute it and make it less intense.

Self-analysis
Ask yourself these questions to help you analyze your progress as you work and finish your project.

1 Which effect did I aim for in my simultaneous contrast piece; eye fatigue with afterimage or eye fatigue with movement/sizzle?

2 Explain how I achieved my end result?

3 Can I live with this piece? Would it be comfortable hanging in my home or office?

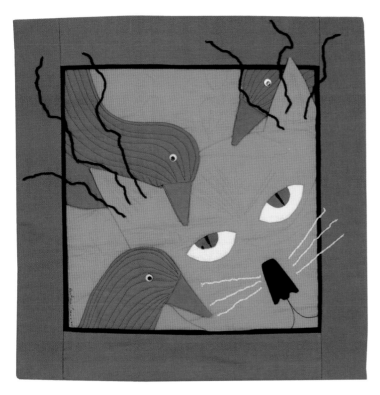

Gotcha!
by Barbara Piano
19" x 19"

In a reversal of roles, the birds have got a cat and it does not look happy! Barbara used the direct complements of orange and blue with a bit of black and white to tell her story. Notice the afterimage of red/red violet that can be seen around the heads of the birds, especially the one in the middle. Barbara used heavy turned edges and stitch to create a sense of three dimensionality. She also relied on color scale. The orange is a slight shade and the blue is a slight tint.

Wild Windows
by Debbie Bosler
16" x 36"

Debbie created this very successful simultaneously contrasting quilt using five pairs of direct or near direct complements. She used mostly pure hues with a few slight shades. The black used between the colored blocks depletes some of the power of the simultaneous contrasts but not

to the detriment of the study. Look at the close up of this block and notice how the edges of the red orange squares seem to reverberate or pulse. This is caused by the fatigue the eye experiences when looking at two pure-hued complements.

Your Simultaneous Contrast Project

With this project, try to attain one or both of the following: fatigue the eye of the viewer into seeing another color formed where the two pure hues come together or fatigue the eye into seeing a sizzle or movement where two pure-hued direct complements meet. Either way, the goal is to create a piece that will have one of the effects, but that won't entirely overwhelm the eye of the viewer and make them want to look away immediately.

Glossary

Abstract or Abstraction - based on realistic shape but morphed into something more simplified with less detail

Alternating Rhythm - achieved by using design elements that seem to move back and forth or undulate

Analogous - three colors with one primary color in common; can be expanded to contain more colors, but must always have a primary color in common

Analogous Complement - four to eight colors; one color and an analogous run whose middle color is the direct complement of the first color

Asymmetrical Balance - unequal visual weight and varied design motifs dispersed in seemingly random areas of a design field

Balance - giving the sense that all elements within the design field are in place and the correct size and import

Black - true neutral color

Blue - primary color

Blue green - tertiary color made by blending blue and green

Blue violet - tertiary color made by blending blue and violet

Brown - considered part of the neutral palette by many artists

Cold/Warm Contrast - achieved by using cold and warm colors; effective in depicting depth or three dimensionality in a piece

Color - main components are hue, value and intensity; color is relative to the viewer

Color Scale - divide colors into four groups with distinct attributes; pure hue, shade, tone or tint

Color Theory - set of scientific based ideas or principles used to create artistic harmonious color combinations

Color Wheel - made up of 12 colors; yellow, yellow orange, orange, red orange, red, red violet, violet, blue violet, blue, blue green, green, yellow green

Complementary Colors - includes the six pairs of direct complements

Complementary Contrast - pairs of colors that lie opposite each other on the color wheel, effective in creating balance in a piece

Complex Colors - formed by mixing three or more colors together

Complex Complements - double complement, split complement, analogous complement

Composition - the bringing together of design elements and principles to form a work of art

Contrast - placement of varying elements, including color, within a design

Contrast of Extension - contrast between space and size using two colors

Contrast of Hue - achieved by using pure, intense, undiluted color combinations

Contrast of Saturation - contrast between pure, intense colors and dull, diluted colors

Cool Colors - blue green blue, blue violet, violet; tend to recede and stay in background

Critique - to analyze an artwork by discerning how the elements and principles of design are being used

Crystallographic Balance - an allover design with no clear focal point

Depth - created by using design, value and visual temperature

Direction - using elements to give the impression of movement which directs the viewer to certain areas of the artwork

Direct Complement - two colors directly across from each other on the color wheel; yellow/violet, yellow orange/blue violet, orange/blue, red orange/blue green, red/green, red violet/yellow green

Dominance - gives interest to one entity or area of a design over the others

Dominant Colors - first colors noticed in a project

Double Complement - four color scheme; two adjacent colors and their direct complements

Double Split Complement - four colors; two pairs of direct complements that are each separated by a color

Elements - physical entities present in art and design work

Fibonacci Sequencing - the relationship of the size or scale of design elements in a composition using the following growth pattern; 1+1=2, 1+2=3, 2+3=5, 3+5=8, 5+8=13, 8+13=21 and so on

Form - three dimensional shapes defined by depth and perspective

Golden Mean - the relationship of the measurement of the long and short sides of a rectangular shape or composition, 1:1.618

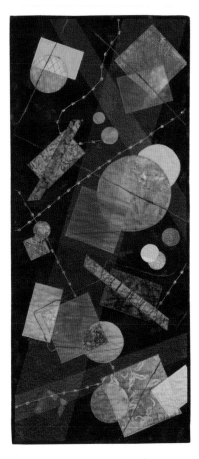

Gray - true neutral color

Green - secondary color made by mixing equal amounts of yellow and blue

Harmony - achieved when variety is balanced with unity in a composition

Hue - another name for color

Intensity - purity of a color

Light/Dark Contrast - achieved by using light and dark colors in a piece

Line - design element characterized by length and direction

Glossary

Luminosity - achieved through the manipulation of color, value and intensity

Monochromatic - one color

Movement - implies motion on the surface of a design, usually through the use of line

Neutral/Achromatic - black, gray and white are true neutrals with tan, off white, taupe and other pale brown based colors often included in the family

Non Objective - not based on anything realistic, more simplified than abstract shape

Orange - secondary color made by mixing equal amounts of yellow and red

Painter's Primary Color Wheel - based on primary colors of red, yellow and blue; used in art, arts education and manufacturing

Pattern - formed by the repeat of shape, line or form within a design field

Polychromatic - 70 to 100 percent of the colors on the color wheel

Principles - results of working with elements of art and design

Primary Colors - red, yellow, blue; colors from which all other colors are made

Printer's Primary Color Wheel - based on magenta, yellow and cyan and is considered scientific

Proportion - relative size and scale of the elements of a design within the space of the design field

Pure Hues - colors are fully saturated and bright

Radial Balance - a design that radiates from a central point on the artwork

Red - primary color

Red orange - tertiary color made by blending red and orange

Red violet - tertiary color made by blending red and violet

Repetition - repeating shape, color or intensity to link the visual elements of a design

Rhythm - repeating design elements over and over to creating a sense of rhythm in a design

Rule of Thirds - visually dividing a design in thirds both vertically and horizontally

Saturation - brightness or dullness of a color

Scale - physical size of a design element in comparison to other elements in a design field

Secondary Colors - violet, orange, green; formed by mixing two primary colors together

Shade - pure hues mixed with black

Shape - design element defined by the lines forming its perimeter

Simultaneous Contrast - achieved by using two pure hued complementary colors next to each other in a design

Space - design elements usually occupying positive space and surrounded by negative space

Spatial Delineation - the separation of one shape or area from another

Split Complement - three color scheme; one color and the colors that lie on either side of its direct complement

Static Rhythm - little variety in shape and color; repeats itself over and over

Symmetrical Balance - contains repeats of shape, color, intensity and value on both halves of the design field, most often grid based; when project is folded in half the design elements and colors match

Temperature Neutral Colors - red, red violet, green, yellow green; sit on midline of composition and behave like colors with which they are interacting

Tertiary Colors - yellow orange, red orange, red violet, blue violet, blue green, yellow green; formed by blending a primary and secondary color together

Tetrad - four colors equidistant from each other on the color wheel

Texture - tactile is texture you can feel; visual is texture implied by the print or pattern on a fabric's surface

Tint - pure hues mixed with white

Tone - pure hues mixed with gray

Transparent Illusion - achieved when two colors are seemingly overlapped to form a third color

Triad - three colors equidistant from each other on the color wheel

Unity - quality in a design that pulls it all together to make all parts look as though they belong

Value - lightness or darkness of a color

Variety - adding new colors or shapes to a piece without destroying its unity

Violet - secondary color made by mixing equal amounts of red and blue

Visual Rhythm - harmoniously balanced design with a variety of unified shapes and colors

Visual Temperature - using color in a design to make the viewer feel warm or cold or to control depth perception

Warm Colors - red orange, orange, yellow orange, yellow; tend to advance and grab attention

White - true neutral color

Yellow - primary color

Yellow green - tertiary color made by blending yellow and green

Yellow orange - tertiary color made by blending yellow and orange

Some of My Favorite Tools

Below are the items you will find in my art quilter's stash. These are my favorite tools to use when I create. As you work, you will develop your own list. There is no right or wrong, use what works best for you.

Threads
For Machine Sewing
Mettler® Art 104, 50/3, silk finish, 100% mercerized cotton
Aurifil™, 50/2, cotton
Colors
Medium gray, tan, black, white
Choose threads that are long staple cotton whenever possible.

Variegated and Multi-colored Favorites
Oliver Twist, size 50, hand-dyed
Valdani, size 40, space-dyed
King Tut™, size 40, similar to Valdani
Signature, long staple cotton

Solid Favorites
Aurifil™ Cotton, 50 and 40 weight
Madeira Catona or Tanne Cotton
Mettler® Art 240, 60/2, ultra-fine machine embroidery thread
Mettler® 50/3, silk finish cotton
Mettler® 40/3 quilting thread

Batting
100% Cotton Favorites
Quilter's Dream Cotton® - Needle punched with no scrim. Comes in four different weights—**Request** is my favorite as it is very thin. **Select** is my next favorite, not quite as thin. Both offer a tight yet breathable bat with exceptional drapability. Great for hand or machine quilting.

Fairfield Soft Touch®-Soft, quilts easily and drapes well. Needle punched with no scrim. Great for hand or machine quilting.
Cotton/Poly Blends
Hobbs Heirloom®-80% premium cotton, 20% polyester, resin bonded. Thin with almost no shrinkage. Great for hand or machine quilting.

Polyester
Hobbs Thermore®-Very thin, very drapable, great for clothing and light weight, summer quilts. Keep in mind that Polyester is HIGHLY flammable.

Wool
Hobbs Tuscany®-Resin bonded, washable; very drapable, warmer than cotton

Silk
Hobbs Tuscany®-Look for silk batts that are resin or thermal bonded. Fine and thin. Extremely easy to hand quilt.

Bamboo
Natures Best-100% bamboo. Mid to low loft, easy to hand or machine quilt.
Fairfield-50% cotton, 50% bamboo, wonderful for wallhangings

PLA
Eco-Batting-Made from corn, this batting turns to water vapor if it catches fire. It is somewhat slippery and requires close basting for machine quilting.

Accessories
Basting Spray
Helmar® 101 with no smell and light tackiness
Sullivan's-vanilla/chemical smell and greater tackiness

Sewers Aid or Sewers Ease-Lubricant for difficult threads. Keeps breakage to a minimum.

Needles
Universal-size 80 for piecing; size 90 or 100 for making quilted bowls etc.
Machine Quilting-sizes 75 and 90
Machine Embroidery-sizes 70, 80 and 90 for thread painting and embroidery
Sharps-sizes 70, 80 and 90 for high thread count fabrics
Metallica or Metafil-size 80 and 90 to use with metallic threads

Bobbins
Keep at least 4 dozen. There are many tools available for storing bobbins. I prefer the round doughnut shaped rubber ones.

Clippers or small scissors
I use small embroidery scissors with a curved end which I keep attached to my machine.

Pins

Ultra fine silk-
for piecing and basting.

Fork pins by Clover-great when
stitching over a thick seam

Flower Head pins by Clover-
great for holding together
thick or heavy fabrics

Rulers

12" x 4" ruler

3" x 18" ruler

12 1/2" square ruler

15" square ruler.

Check to see if the rulers you
currently have are still square. The
edges can get whittled away with
rotary cutter use and become curved,
thus mucking up your cuts.

Rotary Blades

Keep at least one extra blade on
hand for each size of cutter you use.

Consider getting another rotary
cutter and some decorative blades such
as a wavy blade and a pinking blade.

Drawing Tools

Colored pencils, crayons or pastel
chalks-great for auditioning fabric
colors or drawing up designs.

Compass for making perfect circles

T-Square for squaring up corners

Design Board

Needed when laying out the pieces
of your artwork so you can see which
colors and designs work well together.

Embellishment Tools

Heat Gun

Soldering Iron or

Creative Textile Tool™-both are
used to melt Lutradur® and
Tyvek® and to heat metal.

Teflon Pressing Sheets-
have several on hand

Parchment Paper or

Golden Threads quilting paper

Small Iron

Other Notions

120" measuring tape-for measuring
large quilts for borders, etc.

Hinged Mirror Set-to see how
multiples of one block or just
a quarter of a block looks

Masking Tape and Electrical Tape-
for stretching quilt backs
during the basting process
I also use masking tape to remove
any unwanted paint from the
surface of the fabric when I'm
painting with Shiva Paintstiks.

Hera™ Marker-leaves only a creased
line so there are no worries
about whether the marked
line can be removed.

Template Plastic and Iron-able
Mylar-for design work and appliqué

1/4" graph paper-for design work

Flexible Curve-for creating curves
for quilting, piecing or applique

Architectural stencils-for circles,
squares and other shapes

Value Finder-Ruby Beholder is
great for discerning values in a
fabric compilation.

Fine Tulle-good for free-style
appliqué; stock it in black, navy
and green

Embellishments

Fabric Paints

Jacquard-Neopaque, Dye-na-flow
and metallic Lumiere paints

Shiva® oil paint sticks

Fabric Inks

Jacquard-Versatex inks

Tsukinenko® metallic inks

Painting Accessories

Foam brushes-1" and 2" sizes

Eye Droppers

Bent End Syringes

Natural Sea Sponges

Sea Salt

Discharge Paste

Water-based Resist

Batik Frames

Fine-tipped Squeeze Bottles

Fabrics-prepared for dying in
cotton, silk and artist's canvas

Some of My Favorite Tools

Fabric Glues

Tonertex Glue Pen
Dries Clear Fabric Glue
by Art Glitter Intl.

Iron-on Adhesives

Misty Fuse®
Fine Fuse®
007 by Bo-nash

Beads & Baubles

Stock up on glass, metal and wood
beads in loads of different sizes
and configurations. Also keep a
supply of mini glass beads, found
objects, shells, bells, buttons,
and brads.

Fibers

Load up on different fibers including
silk, cotton, rayon, wool, smooth,
nubby, crinkled, braided, eyelash,
and Boucle.

Miscellanous Embellishing Supplies

Fabric and Other Markers

Angelina®, Crystalina® and
Textiva®-heat bondable fibers
and films

Fabric Foil and Foil Adhesive-
to add luster

Fine Gauge Metal & Tools-available
in many different powder
coated colors as well as
aluminum and copper

Lutradur®-industrial interfacing
available in 70grm, 25 grm
and 100 grm; great to paint,
burn, melt and score

Silk cocoons and silk carrier rods-
great for making flowers and
other high relief designs

T.A.P.™, Transfer Artist Paper or
other treated fabrics-for
transferring photos to fabric

Golden and Liquitex® matte
medium, gel mediums, fabric
medium, light molding paste-
great for use with mixed
media work

General Resource Books every quilt maker needs to succeed

There are dozens of technique books on the market. Below you will find a list of some of the most useful
books I can suggest for your reference library.

- General Quilting Technique books that include common measurements for quilt sizes, information on how
 to size blocks, do basic appliqué, cutting and piecing.

- Hand or Machine Quilting Technique books - Look for ones written by artists you admire.

- Technique books covering the techniques you want to learn, such as paper piecing, creating landscapes or
 using paint or embellishments.

- A Block book filled with nothing but blocks and the information you need to make them. Make sure it
 includes cutting instructions.

- Books with beautiful artwork or images of quilts or other art forms to use as inspiration.

Further Studies in Color and Design

Now that you have completed this study in color and design and have formed some really good work habits, you will want to keep your creative momentum going. Hopefully you have discovered you are at your best when you are being creative and want to continue. If you did your color study in a group, encourage the group to continue learning with you. Learning is truly an individual journey, but sharing it with others will help you grow.

Some ideas for continued study are below:

Techniques

Curvilinear Design ~ Working with curved shapes only

Texture ~ Visual or tactile

Thread Play ~ Adding to the surface for three-dimensional effects

Discharge Dyeing ~ Using bleach solution to change the surface of existing fabrics

Format Challenge ~ Choosing a particular size, shape, subject

Layering ~ Using layers of fabric to create a work

The Un-Sewn Quilt ~ Using alternative methods of construction to make a quilt

Group Art ~ Cutting up a photo of a famous piece of art, everybody takes a portion and makes it using whatever techniques they want

New or Different Medium ~ Using unfamiliar materials to create the things you normally make

Collage ~ The word collage simply means "to glue". Imagine the possibilities

Theory

Abstract Form ~ Using Simplified natural shapes

Non-Objective Form ~ Creating with shapes and forms that have no natural reference

Shape ~ Creating whole compositions using just one shape

Self-Portraits ~ Creating a representational work either abstract or objective

Emotive ~ Choose an emotion and present it in a quilt

Working with the Masters ~ Choosing a famous artist to study and emulate

Value ~ Designing a simple composition and creating it three times, changing the way you use value in each one

Suggested Reading

These are books I have read that have taught me about art and being an artist. You will find some of the information in these books referenced in the preceding pages.

501 Great Artists, edited by Stephen Farthing, Barron's

Art & Fear by David Bayles and Ted Orland, The Image Continuum

Art Lessons by Deborah J. Haynes, Westview Press

Art Theory by Robert Williams, Wiley-Blackwell

Bright Earth by Philip Ball, The University of Chicago Press

Color; A Natural History of the Palette by Victoria Finlay, Random House

Concerning the Spiritual in Art by Wasilly Kandinsky, Tate Publishing

Geometry of Design by Kimberly Elam, Princeton Architectural Press

Go to Your Studio and Make Stuff by Fred Babb, Workman Publishing

Josef Albers; To Open Eyes by F. A Horowitz & B. Danilowitz, Phaidon

Lives of the Great Modern Artists by Edward Lucie-Smith, Thames & Hudson

No More Secondhand Art by Peter London, Shambhala

Seven Days in the Art World by Sarah Thornton, Norton

The 20th Century Art Book, Phaidon Press

The Color Star by Johannes Itten, John Wiley & Sons

The Creative Habit by Twyla Tharp, Simon & Schuster

The Elements of Color by Johannes Itten, Van Nostrand Reinhold

The Interaction of Color by Josef Albers, Yale University Press

The Pantone Guide to Communicating with Color by Leatrice Eiseman, North Light Books & Grafixpress Ltd

The Tate Guide to Modern Art Terms by Simon Wilson and Jessica Lack, Tate Publishing

Why Art Cannot be Taught, James Elkins, University of Illinois Press

Contributing Artists

I hope that with the help of this book you have learned a lot about color and design and about yourself. Even though I teach a color and design class regularly, each new group of students teaches me something new. That is the most exciting thing about color and design, it is a never ending journey.

Listed below is a group of friends and students who shared their artwork with me for this book. These pieces were created as they took their own color and design journey. Thank you to them and all the other students I have had the pleasure of teaching over the past 17 years. You have taught me what it means to be an artist and have made me strive to be a better teacher.

Heather Thomas

Thank you to

I.V. Anderson
Susan Brooks
Jerri Bryson
Ruth Chandler
Brenda Diaz
Mona Doering
Gail Eamon
Marjorie Eastlund
Janice Ford
Katie Fowler
Gretchen Garnand
Linda Grey
Elana Gunberg
Cynthia Jarest
Eileen King
Ronda Lambatos
Chris Lawson
Tamara Leberer
Char Lemke
Jan Lepitino
Wanda Lynne

Nancy Magnen
Susan McClean
Dona McGregor
Cass Mullane
Lori Nicholson
Margaret Parker
Barbara Piano
Collette Schneider
Terry Simm
Robin Sruoginis
Lisa Sullivan
Karey Swan
Linda Thompson
Sharon Triolo-Moloney
Diana Vander Does
Carol Ann Waugh
Susan Westervelt
Ruth Wolcoff
Nicole Yardley
Crystal Zagnoli

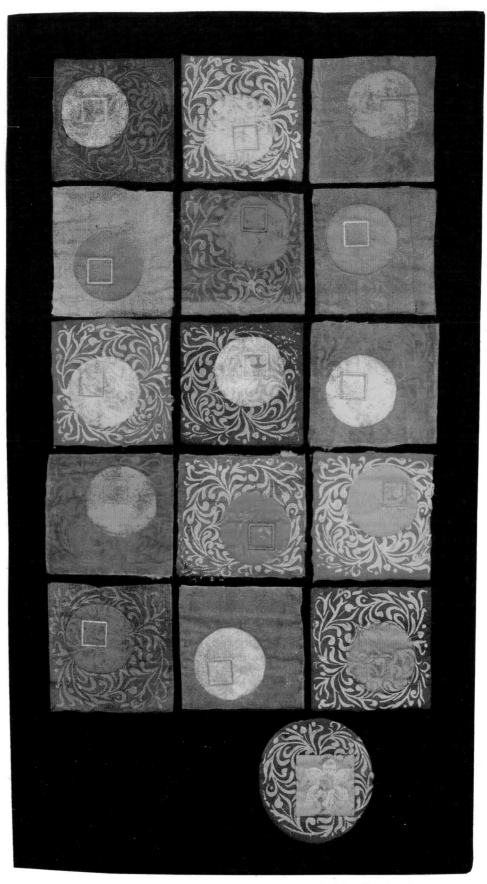

To Live Out Loud

by Heather Thomas

19-1/2" x 35"